# Who's Afraid of the Song of the South?

# Praise for
# Who's Afraid of the
# Song of the South?

Jim Korkis has come up with material that deepens our understanding and appreciation of Walt Disney's work on *Song of the South* and puts it into a proper historical context. I learned a lot I didn't know before, and I'm sure other Disneyphiles will feel the same way.

**– Leonard Maltin**
Film Critic, Historian, and Author of *The Disney Films*

Everything the Disney Company did in its Golden Age is worth watching and discussing — and nobody discusses it better and with such accuracy and passion as Jim Korkis. Korkis digs into the nooks and crannies of the most obscure politically incorrect films not covered by the Studio's approved historians. A must-read!

**– Jerry Beck**
Animation Historian, Author, and Webmaster of CartoonBrew.com

Jim Korkis has accomplished what Disney hasn't done — present us with the facts on *Song of the South*, and let us be the judge. Jim's excellent book should be a poignant reminder that censorship is not the answer.

**– Christian E. Willis**
Webmaster of SongoftheSouth.net

Jim Korkis cuts skillfully through decades of misunderstandings and inaccuracies to confront the positive and negative issues — many of which are emotionally charged and culturally significant — presenting the most comprehensive examination to date of a unique film's odyssey from one century into another.

**– Greg Ehrbar**
Musicologist, Co-Author of *Mouse Tracks: The Story of Walt Disney Records*, and Webmaster of MouseTracksOnline.com

Disney stories are insightful as well as fun, and no one tells them better than Jim Korkis. Jim truly loves his material and so will you. I heartily recommend his new book.

**– Floyd Norman**
Disney Legend and Disney's First Black Animator and Storyman

# Who's Afraid of the Song of the South?

**And Other Forbidden Disney Stories**

## Jim Korkis

Foreword by
Disney Legend Floyd Norman

Theme Park Press
Orlando, Florida

**Editor: Bob McLain**

Cover Photo: A group of integrated protesters march outside the Paramount Theater in Oakland, California, on April 2, 1947. Image from the collection of the Oakland Museum of California, Collections and Information Access Center.

Cover Concept: Pentakis Dodecahedron

Cover Design: Glendon Haddix, Streetlight Graphics [www.StreetlightGraphics.com]

Layout/Typesetting: Bob McLain, Theme Park Press [www.ThemeParkPress.com]

Printed in the United States of America

First Printing, 2012

ISBN 978-0-9843415-5-9

Theme Park Press
www.ThemeParkPress.com

Address queries about this book to queries@themeparkpress.com

*This book, as always, is dedicated to my father and my mother, John and Barbara Korkis, who passed away less than a decade ago but whose unconditional love, constant support, common sense, and good humor continue to inspire me to this day. I wish they were here today for me to give them a copy of this book.*

*Alice: Would you tell me, please, which way I ought to go from here?*
*The Cat: That depends a good deal on where you want to get to.*
*Alice: I don't much care where.*
*The Cat: Then it doesn't matter which way you go.*

– Lewis Carroll, *Alice in Wonderland*

# Contents

# Foreword

Had you visited a black home in the late Forties, it would not be unusual to find a copy of *Ebony* magazine on the family coffee table. I never paid much attention to the monthly publication, but this particular issue caught my eye. A full-page photograph of actors James Baskett, Bobby Driscoll, and Luana Patten was featured next to an opinion piece on Walt Disney's new motion picture *Song of the South*.

To the best of my knowledge, this was the first time in my young life that I took issue with a magazine's editorial, and I regretted not having the writing chops to respond. Even though I was just a ten-year-old kid, I took issue with the editors for their unfair characterization of the film and of Walt Disney in particular. I had recently seen *Song of the South* at our local theater and found the movie delightful. Had they even seen the same film, I wondered?

Many years passed, and when this young artist and others arrived at the Walt Disney Studios in the Fifties, we found ourselves having access to the coveted Disney vaults. This meant any movie we wanted to see was suddenly available for screening. Naturally, one of our first choices was *Song of the South*.

However, I took this a step further. Because employees were able to check out 16mm prints on occasion, I set up a special screening of the Disney film in a local Los Angeles church. The screening of the Disney motion picture proved insightful. The completely African-American audience absolutely loved the movie and even requested a second screening of the Disney classic.

I'll admit I probably bring less baggage to the table than most. I was lucky enough to grow up in affluent, enlightened Southern California in the Forties and Fifties. My hometown of Santa Barbara was hardly the segregated South, and this unique environment influenced my view of society. My parents and grandparents welcomed people of all colors into their home, so my perspective on race might not reflect the average African American's view of society.

I am a cartoonist, not an academic, so this will not be an in-depth analysis of ethnic insensitivity. However, I have had the pleasure of speaking with filmmakers and animation old-timers about this rather touchy subject. It might be interesting to note that the funny images they put on paper and on the screen were there not to denigrate — but to entertain.

It's a long time from Song of the South's initial release and a magazine's strident editorial. Yet even today the film continues to be mired in controversy, and that's a shame. I often remind people that the Disney movie is not a documentary on the American South.

The film remains a sweet and gentle tale of a kindly old gentleman helping a young child get through a troubled time. The motion picture is also flavored with some of the most inspired cartoon animation ever put on the screen. If you're a fan of classic Disney storytelling, I guarantee you'll not find a better film.

I survived three different managements at the Disney Company, beginning in the Fifties when I worked as Disney's first black animator and later as a storyman. My unexpected move upstairs to Walt's story department was something I never anticipated. Not only was I privy to the Old Maestro's story meetings, I had the unique opportunity to observe the boss in action. This included his management style and his treatment of subordinates. Not once did I observe a hint of the racist behavior Walt Disney was often accused of long after his death. His treatment of people — and by this I mean all people — can only be called exemplary.

Over the years, I worked in several different areas. For instance, I was given all sorts of assignments while working as a writer in Disney's publishing department. One of my many assignments was to write what had become known as the Disney Holiday Story. These were comic strip continuities utilizing the Disney characters. Each of these stories would have a holiday theme and would run in newspapers from November to December 25th, when the story would conveniently conclude on Christmas Day.

I had already written stories based on the standard Disney characters, including the wonderful 101 Dalmatians from the film of the same name. But I was getting bored with the typical holiday stuff, and wanted to try something new, different, and perhaps even a little dangerous. Could I possibly convince the powers-that-be at Disney to let me craft a story using the funny, clever, and outrageous characters from Song of the South?

As you might have imagined, Disney was skittish about raising any awareness of a movie it had been trying to bury for years. And, while Disney's view of the South on which Joel Chandler Harris based his delightful stories might be considered naïve, it was never malicious or offensive.

Decades after its first release, I assumed we all lived in a more

enlightened society. The Civil Rights battles of the Sixties had been won, and people of color had taken their rightful place in society. Black people in motion pictures were no longer porters and maids. Funny, confident, and edgy performers like Eddie Murphy had replaced bug-eyed comedic actors like Mantan Moreland. It was now the Eighties, and I hoped that Disney was willing to uncover the wonderful legacy it had kept hidden for so many years. Could delightful characters like Brer Rabbit, Brer Fox, and Brer Bear be enjoyed by a new generation? This was the question I would take to my bosses at Disney.

In the Eighties, Disney was under a new forward-thinking management. Perhaps my timing was right, or maybe I just got lucky. In any case, I was given the go-ahead with my story entitled *A Zip-A-Dee-Doo-Dah Christmas*.

The story opens with the kids, Johnny and Ginny, coming to Uncle Remus with a problem. The chances of a snowfall in the South are pretty slim, they say. How can they truly enjoy Christmas without snow? This gives Uncle Remus the perfect opportunity to spin another of his Brer Rabbit tales. It seems the clever rabbit had a similar complaint, and his quest for a white Christmas led him into a world of trouble. Not surprisingly, that trouble involved another run-in with Brer Fox and Brer Bear. The story wraps up with Brer Rabbit escaping the clutches of his captors and learning his lesson about the real meaning of Christmas.

The story was submitted, and all appeared to be going well. I even removed the southern dialect from Uncle Remus, and allowed only the critters to retain their colorful dialogue. I was willing to give the illiterate former slave some "polish" as long as I could keep the rabbit, fox, and bear in character.

As you can imagine, the editors were aghast when they received the story. How could Disney submit such a racially insensitive story for publication? I wish I could have seen their faces when they were informed that the writer was black.

The story did end up running in newspapers in 1986, with no complaints. Keith Moseley penciled it and Larry Mayer inked it. Yet, four decades after it first premiered, Disney's *Song of the South* was apparently still a very controversial topic. It remains so today, nearly sixty-five years after audiences first enjoyed it.

Why bury the wonderful performances of James Baskett, Hattie McDaniel, and Ruth Warrick? Why deny animation fans

some of the finest cartoon animation to ever come out of the Disney Studios? Hearing the voice performances of Johnny Lee as Brer Rabbit and Nick Stewart as Brer Bear never fails to bring a smile to my face. America has come a long way since a little black kid sat in a movie theater in Santa Barbara and dreamed of a Disney career. Maybe it's not too much to hope that the Disney Company might one day get over its self-imposed fears and finally find its own Laughing Place.

**Floyd Norman**
Disney Legend
June 2012

*Floyd Norman is an African-American animator who worked on the Walt Disney animated features* Sleeping Beauty, The Sword in the Stone, *and* The Jungle Book, *as well as various animated short projects at Disney in the late 1950s and early 1960s. After Walt Disney's death in 1966, Floyd left the Disney Studios to work at a variety of different animation studios.*

*Floyd returned to Disney in the early 1970s to work on the Disney animated feature* Robin Hood *and several projects for Disney Publishing.*

*More recently, he has contributed as a story artist on films such as* Toy Story 2, Monsters, Inc. Mulan, Dinosaur, *and* The Hunchback of Notre Dame. *He continues to work for the Walt Disney Company as a freelance consultant on various projects. He was inducted as a Disney Legend in 2007.*

*Floyd's latest book is* Animated Life: A Lifetime of Tips, Tricks, Techniques, and Stories from an Animation Legend *(Focal Press 2012).*

*His website is http://mrfun.squarespace.com/blog*

# Introduction

This year I was a teaching a class of college students about how Disney tells stories three-dimensionally in its theme parks and resorts. During a break, a young lady came up to me to share how excited she was that, as her birthday present, her parents were taking her to see the theatrical stage production of *Mary Poppins*.

"That's wonderful," I replied. "Have you read the book?"

"There was a book?" she asked incredulously.

"Yes. There were several and some of the elements from them are incorporated into the musical," I responded.

"I just thought it was based on a really old movie," she said with honest surprise.

I smiled while biting my lip. It took me a moment to realize that the movie *Mary Poppins* had premiered almost thirty years before she was born, so for her it was just another old movie. It was as much ancient history as when the dinosaurs walked the earth.

That experience was not unique. More and more, I interact with young people who have little or no knowledge of anything that happened beyond the last ten or twenty years at most. Even worse, when I worked at Walt Disney World, I often saw executives who had little or no knowledge of Disney history nor any desire to know anything about Disney history if it conflicted with what they wanted to do.

I love Disney History.

I love the stories behind the stories. I love the little nooks and crannies that are rarely explored and often forgotten. I love knowing how and why something happened and how it affected other things. I love discovering and documenting these strange tales and sharing them with others.

I often tell people that you can love the Disney Brand, but still have concerns about how the Disney Business operates. Like many other large corporations, the Disney Company wants to control how its business is perceived by today's consumers, even if it means re-writing or eliminating parts of its own history.

The Disney Company has determined that the little stories in this book do not fit comfortably into today's larger story about the happy and magical world of Disney, where every corporate decision is always right. These stories are all true. They are not wild

assumptions, rumors, urban myths, or revelations of scandalous activity. These stories are as well-documented as decades of research allow.

There is no need for salacious or sniggering text because the topics are controversial enough just by mentioning them in the first place. Heated emotions and lengthy passionate discussions can be conjured in mere seconds just by bringing up the subject of the Disney feature film *Song of the South*.

No official Disney book has even a single chapter that tells about the making of *Song of the South*. This book exists so that the history of *Song of the South* finally can be shared with all those interested in the film. Perhaps this information may even spark more intelligent discussions about the film in the future.

Some of the *Song of the South* material in this book first appeared in columns that I wrote over the years under my Wade Sampson pseudonym as well as in a lengthy article I wrote for *Hogan's Alley* #16 (2009), a magazine about comic art. Much of my material has been liberally "borrowed" and used uncredited by others since then.

Some of the other stories appear here because their topics alone would be considered inappropriate in a different historical collection. First drafts of some of these stories were published on the internet and in magazines to garner corrections and additions. However, all of the content in this book, including the *Song of the South* material, has been completely rewritten, updated, expanded, and corrected.

It is not my intent to embarrass or annoy the Disney Company, but simply to record for Disney fans and researchers certain segments of Disney history that have never before been published. These stories and so many others like them are already being "lost" as times change, people die, and the Disney Company readjusts its history to make it more politically correct and appropriate for today's world.

Some people believe that certain history should be hidden or forgotten, that its artistic, technical, or historical value is far outweighed by its current inappropriateness. Other people believe that it is foolish and dangerous to censor history to fit current trends, that only by studying and discussing things now considered uncomfortable can we avoid making those same mistakes, and overcome ignorance.

As a Disney historian, I dance on the thin line between traditional

academic scholarship and presenting material accessible to a more general audience. I have tried to incorporate references directly in the text rather than include a massive amount of footnotes that would distract from the flow of the story.

Please do not be fooled into believing that the stories in this book are the definitive versions. There is always more to tell about any story. I have discovered that, the moment I commit a story to print, suddenly a previously unknown anecdote or insight will magically appear to taunt me, despite decades of research.

The written word is thousands of years old and books were a treasure that provided a gateway to new knowledge and new discoveries. While many of you may be reading this on some electronic device, there is a joy that it also exists in a physical format so that it can be placed on a bookshelf next to other cherished paper companions.

Each individual chapter is a self-contained story, so feel free to open the book to any section and begin reading. I wrote these chapters to be read one at a time and savored, so don't feel the need to gorge on the new information all at once. Think of the book as a box of chocolates with different delights and maybe some tasty hidden surprises to enjoy during a pleasant afternoon.

If you have half as much fun reading these stories as I have had writing them, then I had twice as much fun as you.

I hope you enjoy these stories and share them with others. If you don't enjoy these stories, whatever you do, please don't throw me in the Briar Patch.

**Jim Korkis**
Disney Historian
June 2012

# Part One

# Who's Afraid of the Song of the South?

*Now this here tale didn't happen just yesterday nor the day before, it was a long time ago ... the critters, they was closer to the folks, and the folks, they was closer to the critters — and if you'll excuse me for saying so, it was better all around.*

— Uncle Remus in Disney's *Song of the South*

The story behind the controversy of why the Disney feature film *Song of the South* (1946) has been locked away tightly in the Disney Vault for decades is a sad mixture of insensitivity, misunderstandings, and urban legends. The very mention of this historic Disney film continues to spark heated emotions and effusive oratory from its defenders as well as its detractors.

When reviewing films made during the early 20th century, it is clear that *Song of the South* is not as malicious as *The Birth of a Nation* (1915), nor as racist as *Gone with the Wind* (1939), and it is less bizarre in its depiction of the Old South than the majority of Hollywood films. Certainly, films featuring Shirley Temple and talented black performer Bill "Bojangles" Robinson, including *The Little Colonel* (1935) and *The Littlest Rebel* (1935), which were meant for family audiences with young children, presented an even more fanciful and inaccurate representation of the time period depicted in *Song of the South*.

All of those other films are available for anyone to see and study — yet the Disney Company has denied Americans the opportunity to view *Song of the South* legally since 1986.

There have been far darker chapters in the history of Disney films, including the propaganda shorts like *Der Fuerher's Face* (1942) that were produced during World War II and since re-issued with appropriate context as part of the limited edition, collector-oriented *Walt Disney Treasures* DVD series.

On Wednesday, March 23, 2011, at the Disney Annual Shareholders Meeting in Salt Lake City, Utah, the final question asked of Disney CEO Bob Iger, just minutes from him concluding the meeting, was the yearly query about when the Disney Company might release the live-action/animated movie *Song of the South* to DVD. After all, November of that year would mark the 65th anniversary of the film's release.

Although smiling, Iger seemed irritated that the same question kept coming up at every Disney shareholders meeting. He replied with a sigh and a slight smile:

> We almost got through the meeting! ... I said last year at our shareholder's meeting that I had watched *Song of the South* again ... and even though we've considered it from time to time, bringing it back, I didn't think it was the right thing for the company to do.
>
> It was made at a different time. Admittedly, you could use that as the context. Just felt there are elements in the film ... it's a relatively good film ... that would not necessarily fit right or feel right to a number of people today. Just felt it wouldn't be in the best interests of our shareholders to bring it back even though there would be some financial gain. Sometimes you make sacrifices on the financial side to do what you believe is right and that is an example of that.
>
> I just don't feel that it is right for us to use company resources to make it available whether it's wide or whether it's narrowly available. It is a strong belief that I have. Consulted with other top executives in the company ... they all agree. Remember it as it was and don't expect to see it again at least for a while ... ever.

Obviously, the many Disney shareholders themselves had not been asked whether they would like to see the film released. Many would have liked to replace the easily obtainable bootleg copies of the film in their collections with a more expensive Blu-ray limited-edition package that would have background discussion by Civil War historians, African-American leaders, animation historians, and others who could help make this film a wonderful learning opportunity.

Most Disney theme park guests have enjoyed the Splash Mountain attraction without ever seeing the original film or sometimes not even knowing that the ride and the merchandise associated with it were based on this classic Disney film.

The sad story of *Song of the South* begins almost a decade before it was released.

# Song of the South: The Beginning

In a lengthy publicity release from 1946 accompanying the initial release of *Song of the South*, Walt Disney discussed his feelings about the project:

> There is something endlessly appealing and satisfying in Joel Chandler Harris' droll fables of animals who behave like humans, and in the character who narrates them. For a long time, they have been an open challenge to motion picture showmanship.
>
> I was familiar with the Uncle Remus tales since boyhood. From the time I began making animated features, I have had them definitely in my production plans. But until now, the medium was not ready to give them an adequate film equivalent in scope and fidelity.
>
> I always felt that Uncle Remus should be played by a living person, as should also the young boy to whom Harris' old Negro philosopher relates his vivid stories of the Briar Patch. Several tests in previous pictures, especially *The Three Caballeros*, were encouraging in the way living action and animation could be dovetailed. Finally, months ago, we "took our foot in hand", in the words of Uncle Remus, and jumped into our most venturesome but also pleasurable undertaking.
>
> So while we naturally had to compact the substance of many tales into those selected for our *Song of the South*, in Technicolor, the task was not too difficult. And, I hope, nothing of the spirit of the earthy quality of the fables was lost. It is their timeless and living appeal, their magnificent pictorial quality, their rich and tolerant humor, their homely philosophy and cheerfulness, which made the

Remus legends the top choice for our first production with flesh-and-blood players.

It is important to remember that *Song of the South* came out in 1946, and there was no balance of media images of black people. Since that time, audiences have experienced a wide variety of options as to how black people are portrayed, from the lovable Huxtable family to the dynamic John Shaft to even real African-American leaders like Sidney Poitier, Dr. Martin Luther King Jr., and President Barack Obama. Unfortunately, in the 1940s, black performers often portrayed comic roles where their characters were described as lazy, slow-witted, illiterate, easily scared or flustered, subservient, and worse. That image was what the American public saw and accepted as the norm for African Americans.

In addition, in 1946, the United States was still a highly segregated country with separate facilities for non-whites. The brutal torture and lynching of African Americans was so commonplace that the National Headquarters of the NAACP (National Association for the Advancement of Colored People) would fly a black flag out its window when news of a recent lynching was confirmed.

Often, in the Southern states, a film had to be booked into two different theaters, one for white audiences only and one for black audiences only, or made in such a way that scenes featuring black performers could be cut out.

So, perhaps with a naïve unawareness of this racial inequity, Walt Disney thought that filming the fables of Uncle Remus would save the financially floundering Disney Studios through diversification into live action. In addition, Walt felt the project would bring the well-loved and colorful American folktales to life for new generations of filmgoers.

Coming out of World War II, the Disney Studios was in a dire financial situation. The closure of foreign markets for its animated films during the war years had choked off a vital source of income. Additionally, while a handful of theatrical animated shorts had been produced during the war years, the majority of the labor and creative energy at the Disney Studios had been funneled into the production of military training films that returned only the actual production expenses.

Fortunately, the re-releases of *Snow White* and *Pinocchio*

helped prevent the Disney Studios from showing losses in 1945 and 1946, but that did not prevent the Studio from laying off almost half its total work force in 1946.

The strike against the Studio in 1941 had also shown Walt how vulnerable he was if he were to concentrate solely on animation. Walt realized that for his studio to survive, he must diversify. The expense and time involved in the making of an animated feature was becoming cost-prohibitive, and so Walt looked more closely at how fast a live-action film could be produced and released to the theaters to generate income.

When reflecting in 1956 about his decision to more aggressively pursue live action, Walt said:

> I knew I must diversify. I knew the diversifying of the business would be the salvation of it. I wanted to go beyond even (*Fantasia*). I wanted to go beyond the cartoon. Because the cartoon had narrowed itself down. I could make them either seven or eight minutes long or eighty minutes long. I tried package things, where I put five or six together to make an eighty-minute feature. Now I needed to diversify further and that meant live action.

Walt's distribution contract with RKO stipulated the delivery of animated features. However, the contract also stated that the films could be a mixture of live action and animation, since some of the Disney releases like *Saludos Amigos* (1942) and *The Three Caballeros* (1944) had live-action segments that helped keep down the production costs.

Walt's first Hollywood animated series, the *Alice Comedies* (1923-1927), featured a live-action young girl interacting with cartoon animals and backgrounds. Even before *Snow White and the Seven Dwarfs* (1937), Walt had considered making a feature film combining live action and animation.

One project he explored was *Alice in Wonderland*, with popular silent screen actress Mary Pickford as Lewis Carroll's heroine interacting with animated characters in an animated Wonderland. Walt never seemed to give up on that idea, and so when *Song of the South* was released, he told the press that he was considering making *Alice in Wonderland* with Luana Patten as a live-action Alice exploring an animated Wonderland similar to that planned for the much earlier Pickford movie.

With the success of *Snow White*, the Disney Studios had pur-chased (or attempted to purchase) an option on a variety of family-friendly properties, ranging from *Peter Pan* to *The Wizard of Oz*. Walt did this not only to have a wide variety of subjects to inspire possible future films, but to prevent other studios from obtaining these properties and making films that would compete with his productions. One such property that interested Walt was the Uncle Remus stories by Joel Chandler Harris, which he supposedly recalled hearing as a child.

Walt had two research reports prepared by the Studio, "Background on the Uncle Remus Tales" (April 8, 1938) and "The Uncle Remus Stories" (April 11, 1938), to determine the feasibility of transferring these stories to the screen.

In 1939, Walt Disney bought the rights to the Uncle Remus stories from the Harris family for $10,000, a sizeable sum in those days, but which turned out to be a great investment beyond *Song of the South* itself.

Adding in the revenue of all the books, comics, records, toys, and other items associated with the film, it was estimated that the Disney Company received over $300,000,000 in return for its $10,000 investment by the time the film had its last theatrical release nearly forty years later in 1986. Even without a video or Blu-ray or theatrical release to remind consumers, the Disney versions of the Remus characters that appear in the final film still generate a healthy income from merchandise.

Walt stopped in Atlanta, Georgia, in November 1939 to meet with the Harris family and, as he told the entertainment press, "to get an authentic feeling of Uncle Remus country so we can do as faithful a job as possible to these stories".

According to the publicity for the world premiere of the film, the Harris family had long hoped Disney would dramatize the Uncle Remus stories, perhaps as two-reel animated shorts. But that same release stated:

> [D]uring the years of discussion leading up to final negotiation [in 1939], the idea of full-length animated cartoon pictures interested the Disney Studios and later gripped the public.

Pre-production news items indicated that Disney originally considered producing the film as an all-animation

feature, but by the time production actually began, it was decided to have the picture include live action as well.

In a 1956 interview with writer Pete Martin, Walt said:

> I did it [*Song of the South*] just at the end of the war. I did about thirty minutes of cartoon and filled in with a little over an hour of live action because I didn't have the money to do an hour-and-a-half cartoon. I didn't have the talent. I consider it my first real venture into live action where I told a story. I had done a few live-action things but not with a full story.

Through 1938 and into the early 1940s, when the film was still being considered as a full-length animated feature, many animated segments were being developed, including "Brer Rabbit Rides the Fox" (where Brer Rabbit through trickery rides Brer Fox like a horse to a party) and "De Wuller-De-Wust" (where Brer Rabbit pretends to be a ghost to scare Brer Bear).

One of the early story treatments from 1939 was more connected to the African-American spirituals. Uncle Remus gathers the critters together for a prayer meeting and to encourage their efforts to build a church so that peace could finally exist between the prey animals and their predators. Another storyline showed Brer Rabbit doing battle with the addiction of gambling that was to be the springboard for all his various troubles in his adventures. Versions of some of these tales that the Disney artists developed later appeared in Disney children's books and comics.

Walt's brother Roy was doubtful about the project from the beginning, but not because of any fears of racial retaliation. He shared with Walt in a June 1944 memo his belief that the project was not "big enough in caliber" to warrant its time and budget.

Despite Walt's reported dislike for sequels, if the movie had been successful, it would have been the first in a series of Uncle Remus pictures that would combine live action and animation, utilizing the same live-action cast but with different animated shorts developed from other Remus stories.

In February 1941, after seeing African-American singer-actor Paul Robeson performing on stage in George Gershwin's *Porgy and Bess*, Walt talked to Robeson about playing the role of Uncle Remus, and asked him to review and offer suggestions on a possible outline for the script.

Walt kept in touch with Robeson for years about the project, indicating how excited he was to work with the well-known activist. Speculation exists that Robeson's controversial profile, including his passionate involvement in anti-lynching laws, may have removed him from further consideration for the Remus role in the Disney film.

Walt also talked with several other African-American actors about portraying Uncle Remus, including Rex Ingram, perhaps best remembered as the enormous genie in Alexander Korda's *The Thief of Bagdad* (1940).

It evolved that only a third of the final film would be animated, with the rest live action. Animator Marc Davis recalled:

> Walt had been interested in getting into live action for some time. Here was a way he could do that and have his cartoon, too. I think almost all the animators who worked on it would have to say that they never did anything that was more fun than that. We, as a group, never liked the live-action film particularly. But maybe we're jealous, too.

Several storymen at the Disney Studios, including T. Hee and Ed Penner, who both had attended classes on play-writing, thought they might be called upon to write the screenplay. According to animator Milt Gray's interview with T. Hee in later years, Walt supposedly said: "Aw, hell, we've got to get some real writers. You guys aren't writers; you're just cartoonists."

Unfortunately, Walt's initial choice of a writer to author the screenplay may have doomed the project for all time.

# Song of the South: The Screenplay

In 1889, Mr. Samuel I. Reymond married Miss Effa Shaffer, a daughter of Captain John J. Shaffer, a prominent planter and owner of Magnolia Plantation in Terrebonne Parish.

Reymond founded S. I. Reymond Co., Ltd., a firm that operated a large, modern department store in Baton Rouge, Louisiana. At the turn of the 20th century, the couple had a son, Dalton Shaffer Reymond, who would later pass away in Los Angeles on January 23, 1978.

Dalton Reymond was born in Baton Rouge, and for thirty-five years lived among the "Old South" situations he wrote about in his only novel, *Earthbound* (Ziff Davis 1948), in which the hero is a Louisiana aristocrat who struggles to save his land from the flooding Mississippi River. According to some sources, the novel may be partially autobiographical.

Reymond was a musician as well as a writer. He attended Sewanee Military Academy, University of the South, Louisiana State University, and the University of Southern California. He studied music in Austria and conducted the Philharmonic Orchestra in Baton Rouge.

Reymond joined W.H. Stopher at the Louisiana State University School of Music in 1930, and eventually succeeded Stopher as director in 1933. For the 1935 season, in one of his last productions before leaving for Hollywood, Reymond directed the opera *Carmen*.

Starting in 1936, Reymond lived in Hollywood, where his perhaps self-generated reputation as an authority on the

"Old South" got him work as an uncredited technical advisor and dialog coach on many movie productions, including *Jezebel* (1938), *The Little Foxes* (1941), *Saratoga Trunk* (1945), *The Yearling* (1946), and *Duel in the Sun* (1946).

Reymond's reputation led to Walt Disney hiring him to create the live-action framework for what was to become *Song of the South*, the only film for which Reymond ever received a screenplay credit.

The original story outline (with the working title *Uncle Remus*) prepared by Dalton Reymond is fifty-one pages long and dated May 15, 1944. Walt did only light editing on seven pages. On page 7, Walt wrote that "problems cannot be solved by running away from them" and indicated, "first story to set all characters for other stories to follow". On page 15, Walt wrote in the words "laughing place", wanting the concept introduced earlier than in Reymond's treatment, which doesn't mention it until page 33.

The majority of Walt's other notes concentrate on the story of the puppy and on the relationship between the young children Ginny and Johnny to help build a more sympathetic reaction from the audience. Reymond wrote:

> While this is only a story outline, every effort has been made to follow, with fidelity, the original intent of Joel Chandler Harris, in the development of the story and the characters. Many other ideas for situations and for more intimate bits of characterization have suggested themselves during the writing of this story, but which necessarily cannot be detailed in an outline.

In the preface to the outline, he further stated:

> The Uncle Remus works of Joel Chandler Harris have enjoyed tremendous popularity, exceeded only by the Bible, the Works of Shakespeare, and *Pilgrim's Progress*, and have been published in eleven languages. This fact in itself is enough to challenge the ingenuity of any writer who would attempt to adapt these works for the screen.
>
> Is it possible to explore for today's audience what the Uncle Remus stories did in days gone by? After having read all available works of Joel Chandler Harris and other material bearing upon the subject, the answer, I think, is yes.
>
> Although the popularity of these stories, in book form, is undoubtedly less than when they were first published,

they have, nevertheless, grown into a definite and cherished part of the folk-lore of America. I am convinced that they still possess such outstanding charm and such character that, if adapted to the screen with fidelity and presented in good taste in terms of today's audience, they could be the basis of one of the finest films ever made, and at the same time offer the perfect combination of live action and animation.

What is it about these works which have made them such a standout in public favor? What do they contain which would justify such phenomenal popularity? This, I think, is the answer:

They are stories of a gentle old negro and a little boy; of how an old man, through his stories and his human understanding, brings happiness to a little boy, whose life is troubled.

It should be noted that while the dialect of Uncle Remus is difficult to read, it is easily understandable when spoken.

However, as Reymond continued to work on the script, it became apparent that not only had he never written a screenplay before (and wouldn't again), he needed assistance in handling the sensitive subject matter.

It became especially evident when the African-American consultant that Walt had hired, noted performer and writer Clarence Muse, quit after Reymond ignored his suggestions to portray the African-American characters with more dignity and as more than just Southern stereotypes. Muse had apparently only seen Reymond's work when he began a campaign to alert the African-American community of how Disney was going to portray them in a negative manner.

Movies from 1930 to 1967 were governed by a Production Code administered by the Production Code Administration, which had been organized by the Motion Picture Producers & Distributors of America, Inc. The Code reviewed all screenplays and prevented stories and scenes that were considered inappropriate from reaching American cinemas.

The Production Code file in Los Angeles includes a note dated May 10, 1944, from Spencer Olin, title registrar of Walt Disney Productions. The note states that the name of the project was being changed from *Uncle Remus* to *Song of the South*. Perce Pearce, the associate producer, had

suggested the new title as having greater box office appeal. Disney probably also wanted to evade the building negative connotation of the Uncle Remus title.

It was obvious that another writer needed to collaborate with Reymond to produce an acceptable screenplay.

Born on May 19, 1914, in New York City, Maurice Rapf was the son of Harry Rapf, one of the founders of MGM Studios, so he grew up as Hollywood royalty with access to the inner workings of the film industry. He became a successful Hollywood writer of live-action features and helped to found the Screen Writers Guild, later renamed the Writers Guild of America.

In 1944, while waiting for his commission papers as an ensign in the Navy, Rapf's agent asked him if he wanted to spend five weeks working for Walt Disney. He was reluctant to accept the job because he thought writing for animation would hurt his chosen career writing for live-action films. He also worried about the racist material he saw in the original script for *Song of the South* that Disney had sent him to review.

Walt Disney assured Rapf that most of the film would be live action, and that Rapf was being hired to remove potentially objectionable material from the script. Rapf has said that Walt knew he was Jewish and a radical, and that Walt hoped Rapf could figure out how to avoid the problems in the first treatment of the script. Rapf explained:

> I said he shouldn't make that movie, anyway, because it's going to be an "Uncle Tom" movie. And I told Disney that and he said, "That's exactly why I want you to work on it — because I know that you don't think I should make the movie. You're against 'Uncle Tom-ism' and you're a radical. That's exactly the kind of point of view I want brought to this film."

Rapf worked on the script for several weeks. but quit the project when he found out Dalton Reymond had told a woman in another department that *he* was Rapf, and that if she went out with him, he might get her a good job at MGM.

In an interview with Patrick McGilligan in the book *Tender Comrades*, Rapf recalled:

> I didn't stay on *Song of the South* for very long. I was on that film for only six or seven weeks. I got into a fight with my collaborator, the guy who had written the original story

[Reymond], who was a Southerner. The fight wasn't about the script at all. It was about the fact that my collaborator was pursuing a messenger girl on the lot and pretending to be me. I confronted him with that, and he wouldn't admit it, but I knew it was true because I had seen the girl, who had told me, "You're not the Maurice Rapf I know." So I went to the producer — not to Disney himself — and said, "I can't work with this guy anymore. One of us has to go." And I got fired. But Disney hired me back to work on *Cinderella*.

Rapf would work on *So Dear to My Heart* (1948) during his eventual two-year stay at Disney. He also helped write the animated short *The Brotherhood of Man* (1946), a humorous but articulate case for racial equality based on a scientific pamphlet.

Rapf refused to work on the script for *Alice in Wonderland*, feeling it wouldn't make a good movie, and quit the Disney Studios before he was blacklisted in the film industry. The reported reason for his departure was that Walt refused to give him a raise, claiming Rapf was already the highest paid creative person at the Studio.

Blacklisted in 1947 because of his support for the Communist Party and his unionizing activities, Rapf moved East with his family where he worked as a writer, director, and producer of more than sixty industrial and commercial films. He was also a film reviewer for *Life* and *Family Circle* magazines. In 1967, Rapf returned to Dartmouth to begin a long and fulfilling career as a beloved and respected teacher of film. He passed away April 15, 2003, at the age of eighty-eight. Raph said:

> The guy who succeeded me on *Song of the South* was a fellow "lefty" named Morton Grant. Ironically, when the film was later attacked by the NAACP, I thought the attack was justified — I didn't like the film either.

Morton Grant had spent most of the 1930s working at Warner Bros. on "B" movies. He wrote several Western films during the 1940s until his retirement in 1949.

The considerably older Reymond disagreed strongly with most of Rapf's suggested changes to *Song of the South*, in particular, that it should be made clear the events in the film occur *after* the Civil War. When Morton Grant was brought in, many of Rapf's changes were removed.

Rapf later wrote:

My script was terrible. I've looked at it since. The script is just as racist as the film, although there is also a lot that is different. Disney didn't make it clear that the film wasn't about slavery and that it was set during Reconstruction. In my script, I had the white family poverty-stricken, and that's a lot different from what you see on the screen. Their house in the film is immaculate, very white — it's a white mansion on a plantation. The women wear different dresses every time you look at them. I indicated in my script very clearly that they should be threadbare because they lost the war. Also the whole reason for the father leaving the kid in the first place is very different in the final script from mine. In mine, he leaves because they haven't got enough money to pay the people who are working there; he goes to Atlanta to earn some money so he can pay the blacks who work on the farm. That's different.

He even says [in Rapf's script], "We gotta pay these people. They're not slaves." So when Remus is told he can't read any more stories to the boy, he picks up his things. He's mad. He's not going to get the father; he's leaving. He says, "I'm a free man; I don't have to take this."

Rapf had read the book *The Treasury of American Folklore* (Crown 1944) by B. A. Botkin. In the preface to the book, Botkin's insight into the characters inspired Rapf, who explained:

If you read the fables carefully you find they're stories of slave resistance. Brer Rabbit symbolized the smaller, less powerful Black man. Brer Fox, Brer Bear and Brer Coon were the oppressive Whites, and the stories were all about how to outwit the masters. With that in mind, I thought, "I can make something of this" but it quickly became muddled because Reymond had Brer Rabbit as the alter ego of the little White boy. Walt was not a racist; he was hoping not to offend the Blacks. I constantly tell the story about going to see Disney and him saying to me, "I want you on it to prevent it from being anti-Black." Disney and I talked about it all the time. There was always this great risk.

In Rapf's ending, the boy is in a coma and only comes out of it when he hears Remus tell a story about Brer Rabbit getting hurt and getting better.

In the final script, while there is no white foreman or slave drivers, Uncle Remus is respectful and deferential to

the white people at the plantation. However, at one point, he packs up and walks off the plantation as if he were perfectly free to do so without permission. That is something a slave could never do, since he was a piece of property owned by the master of the plantation. So it is clear by this action that Remus is not a slave.

No one says "massa" (master) in the film, although that term, along with the term "darkey", were prominent in Reymond's original treatment.

Walt sent the script to several people for review, including movie producers Sol Lesser and Walter Wanger, as well as an editor at King Features Syndicate, Ward Greene, who would later write the story that inspired the film *Lady and the Tramp* (1955). While the script received generally favorable reaction, especially from Disney Studios' chief legal counsel Gunther Lessing, who wrote that he could find absolutely nothing to criticize or change, others advised Walt to proceed cautiously.

One such warning, written in a 1944 memo from Disney publicist Vern Caldwell, stated that "there are many chances to run afoul of situations that could run the gamut all the way from the nasty to the controversial".

In its final form, *Song of the South* is based loosely on two of Joel Chandler Harris' later Remus books: *Uncle Remus and His Friends* (1892) and *Told by Uncle Remus: New Stories of the Old Plantation* (1905).

Disney archivist Dave Smith, author of *Disney A to Z: The Updated Official Encyclopedia* (Disney Editions 2006), wrote:

> The story is about a boy learning about life through the stories of Uncle Remus, which are shown in animated segments. Little Johnny is taken to his grandmother's plantation where he meets Uncle Remus and is guided by his stories ... about Brer Rabbit, Brer Fox and Brer Bear. Johnny finds friendship with a local girl, Ginny Favers, but is bullied by her cruel brothers. When he is accidentally gored by a bull, it takes more than Uncle Remus to save him. His parents must reunite, creating a happy family once more.

# Song of the South: The Cast

With work proceeding on the script, Walt needed a live-action director. He had talked to famed director King Vidor about handling the live-action portions of the film. Perhaps one of the reasons this didn't work out was that Walt wanted someone familiar with live-action filming, but he didn't want someone questioning and overriding his opinions and decisions. So, Walt turned to H.C. Potter.

Henry Codman Potter had directed the live-action portion of Disney's *Victory Through Air Power* (1943), so it was natural for Walt to think of him as the director for the live action in *Song of the South*, especially since Potter had worked with Gregg Toland, the cinematographer hired for the film.

In Hedda Hopper's column, "Looking at Hollywood" (*Los Angeles Times*, January 24, 1945), she wrote:

> Hank Potter will not direct after all since he and Walt couldn't see eye to eye on handling of the story. It's to be treated as *The Three Caballeros* was with live characters and cartoons on same screen and actual production gets under way in a week or two.

Apparently, it was not an amicable parting, since the May 2, 1945, issue of *The Hollywood Reporter* had the headline "Potter Sues Disney. Asking $11,000 Salary."

Although Potter seems to have directed some sequences, it is difficult to determine whether any of his work was included in the finished film. According to a May 2, 1945, *Hollywood Reporter* news item, Potter filed the lawsuit

against Disney alleging that "he was fired without cause although his contract with Disney has some weeks to run".

Potter later directed such films as *The Farmer's Daughter* (1947) and *Mr. Blandings Builds His Dream House* (1948).

Harve Foster was then brought in to handle directorial chores, even though he had only done Second Unit or Assistant Director work on *Gone with the Wind* and a handful of other films. *Song of the South* was his first full director credit.

A January 29, 1945, *Hollywood Citizen-News* newspaper item noted that Harve Foster, who had been acting as Assistant Director for the film, would take over as director to help with the continuity of production. He went on to direct episodes of several television series. William McGarry did some uncredited Second Unit work on the live action as well.

Oscar-winning cinematographer Gregg Toland has often been described as the most innovative and influential cameraman of the sound-film era. His work on such films as *Citizen Kane* (1941) and *The Grapes of Wrath* (1940) is still closely studied today. In the same year that he worked on *Song of the South*, he also photographed *The Best Years of Our Lives* (1946), which won several Academy Awards.

Immediately after finishing work on *Enchantment* (1948), Gregg Toland collapsed and died of a massive heart attack at age forty-four, two years after creating the fantasy world of the Old South that existed only in the songs of Stephen Foster and the writings of Joel Chandler Harris. *Song of the South* was Toland's first opportunity to work in Technicolor.

Toland was apparently quite fascinated by the Disney craftsmen and told the press that: [t]heirs is a fantastic world: a world of daring ideas and innovations."

The live actors in *Song of the South* were an interesting mix of seasoned, award-winning professionals and newcomers to the silver screen. Walt said:

> In this case, a living cast was absolutely necessary to get the full emotional impact and the entertainment value of the animated legends.

**Hattie McDaniel**, who played the cook Aunt Tempy (who journeys from Atlanta with Johnny and his parents to the grandmother's plantation), was the first African American ever to win an Academy Award, for her portrayal of Mammy

in *Gone with the Wind* (1939). She was also the first African American to attend the Oscar ceremonies as a guest rather than as a servant.

Over the years McDaniel was criticized for taking subservient roles in her many films, as well as for her part in the popular radio series *Beulah* about a maid who was smarter than her employers.

"Why should I complain about making $7000 a week playing a maid?" she once said. "If I didn't, I'd be making seven dollars a week being one." She died of breast cancer in 1952.

**Luana Patten**, who played Ginny, was born in 1938 in Long Beach, California. A professional model since age three, Patten first caught the attention of Walt Disney when she appeared on the cover of *Woman's Home Companion* magazine with some puppies. Walt invited her to the Disney Studios, and was impressed by her poise when he met her in person.

Patten also starred in Disney's *So Dear to My Heart* (1948) with Bobby Driscoll. She soon dropped out of the movie business, choosing instead to complete her education. She recalled:

> I'll never forget the day I went to audition for him [Walt Disney]. My mother took me to the Hollywood Bowl where there were hundreds of little girls also auditioning. It was narrowed down to me and five other girls. We each had a screen test and I was the lucky one to win the role of Ginny.

In 1956, to earn some extra money while in high school, Patten was working nights in the box office at The Lakewood Theatre in Long Beach, California, when the movie house was robbed. The film playing at the time was the first theatrical re-release of *Song of the South*.

That same year, Patten revived her film acting career. Along with other credits, appeared in two more Disney films: *Johnny Tremain* (1957) and *Follow Me, Boys!* (1966). She died in 1996.

**Bobby Driscoll**, who played Johnny, was born in 1937 and made his film debut in *Lost Angel* (1943), then appeared in several other films before he came to Walt's attention. For his work in *So Dear To My Heart* (1948) and the non-Disney *The Window* (1949), Driscoll was awarded an Oscar as "the outstanding juvenile actor of 1949".

In addition to Johnny in *Song of the South*, Driscoll's best-known roles were Jim Hawkins in Disney's *Treasure Island* (1950) and the voice of (and occasionally the live reference model for) Peter Pan in the animated feature *Peter Pan* (1953).

Unfortunately, as he grew into adulthood, Driscoll had difficulty finding acting work and suffered through a bitter divorce as well as a long and severe drug addiction. He passed away at the age of thirty-one in 1968 from hepatitis. His body was discovered by two children playing in an abandoned Greenwich Village tenement in New York. Unidentified, he was buried in an anonymous grave, and it wasn't until a year later that his identity was discovered through checking his fingerprints.

According to the 1946 program book for the Atlanta premiere, when casting the part of Johnny, Walt "wanted a typical youth in which each male adult could recognize something of himself. Someone not too handsome, not so bumptious, not too brilliant, and not too thoughtless, someone mostly boy … ."

**Glenn Leedy Allen Sr.**, who played Toby, was born December 31, 1935, in Sand Springs, Oklahoma, and moved to Phoenix, Arizona, when he was very young. In the film, he is credited simply as Glenn Leedy. He passed away on April 19, 2004.

A talent scout from the Disney Studios discovered seven-year-old Leedy on the playground of the Booker T. Washington school in Phoenix and recruited him for the role of Toby. "A Disney scout noticed the lad's natural high spirits and mimicry during a school recess," claimed the program for the Atlanta premiere of the film. Afterward, Leedy's family relocated to Los Angeles to help him pursue a film career.

As stated in the 1946 press release for *Song of the South*:

> During the filming he [Leedy] ran to where the producer sat watching the action, and, showing he had mastered the lingo of the business as well as the manner of the actor, asked, "Am I colossal, Mr. Disney?" Reassured, Glenn went on to other triumphs in one of the brightest performances of the picture.

**Ruth Warrick**, who played Johnny's mother, Miss Sally, was a member of Orson Welles' Mercury Theater and had portrayed

the first wife of newspaper publisher Charles Foster Kane in the classic film *Citizen Kane* (1940).

In April 1938, Ruth secretly married actor Eric Rolf, who played her husband, John, in *Song of the South*. They were the parents of two children but divorced in 1946, the same year that the film was released.

Warrick kept her marriage and her children secret during the filming of *Song of the South*. No one knew she and Rolf were married, according to Alice Davis, wife of animator Marc Davis, nor that there was any trouble between them. Warrick was under a seven-year contract with RKO when Walt borrowed her.

In the September 5, 1980, edition of *The Deseret News*, Warrick recalled:

> I'll never forget my first day on the set of *Song of the South*. Walt's first words to me were, "Ruth, you make me nervous, because if you do anything wrong, I can't erase you like one of my cartoon characters."
>
> *Song of the South* will always be a very special movie to me. It was a wonderful experience working for Walt Disney, who had always been one of my heroes and later became a very close personal friend. The movie closely paralleled my own life at the time. At the time the movie was being made, I was married to Eric Rolf in real life, as well as on the screen. We had a son named Jon, like in the film, and we were also having marital problems as in the story. In the end of *Song of the South*, everything worked out and everyone lived happily ever after. It's a shame it doesn't always happen that way in real life. Eric and I separated soon after finishing the film.

Warrick was one of the founders of Operation Bootstrap in Watts, California; an active member of the Martin Luther King Society; and a teacher of Black Studies in Harlem, New York. About the importance of the Remus stories, she stated:

> The Uncle Remus stories are a very important part of Black history. They are really African folk tales brought over by the Blacks in the 1600s and 1700s. Similar to *Aesop's Fables*, they were always my favorite stories as a child. I read the Uncle Remus stories to my children and am now reading them to my grandchildren.

Warrick performed in many films, but in the 1950s she

turned to television, becoming a regular on several soap operas. In 1970, Warrick joined the original cast of the soap opera *All My Children* in the role of Phoebe Tyler. She continued in that role until her death on January 15, 2005.

**James Baskett**, for generations of movie audiences, will always be Uncle Remus. Baskett was born in Indiana on February 16, 1904. He attended Tech High School, where he studied pharmacology. Lacking money, he had to abandon his studies after graduation, and chose to pursue his untrained dramatic talent first in Chicago and then in New York.

"And since then," said Baskett in a 1946 interview, "I've never been out of show business, and pharmacology just became a lost dream."

In California, Baskett met comedian Freeman Gosden of the *Amos 'n' Andy* radio program who invited him to join the cast of that popular show. Baskett's role as the fast-talking lawyer Gabby Gibson earned him a well-deserved national reputation from 1944 to 1948.

Baskett had roles in such African-American-oriented "B" movies as *Harlem Is Heaven* (1932), *Policy Man* (1938), *Comes Midnight* (1940), and *Revenge of the Zombies* (1943). In those movies, he was sometimes billed as Jimmy or Jimmie Baskette. Primarily, however, Baskett was known for his stage work as well as for his performances on radio.

In 1945, Baskett answered an ad to provide the voice of a talking butterfly in Walt Disney's *Song of the South*.

"I thought that, maybe, they'd try me out to furnish the voice for one of Uncle Remus' animals," recalled Baskett.

Upon review of Baskett's voice, Walt Disney wanted to meet him personally, even though Walt was currently auditioning other actors for the part of Uncle Remus. After watching a three-minute film test with Baskett, Walt was convinced:

> In James Baskett, we found a great actor and the very image of Uncle Remus. He had, besides the presence and the manner for the role, the eloquent voice needed for the narration. I believe his impersonation will be accounted as one of the finest ever recorded on the screen.

Walt wrote in a letter to his younger sister, Ruth, on December 5, 1945, that Baskett was "the best actor, I believe, to be discovered in years."

In addition to doing Uncle Remus, Baskett provided the voice for the animated Brer Fox, utilizing the same fast-talking persona of the lawyer he portrayed on the *Amos 'n' Andy* radio show.

James Baskett spoke the part of Brer Fox so quickly that the animators were unable to synchronize their animation with complete accuracy. Animators Frank Thomas and Ollie Johnston calculated that Baskett spoke about eight words per second, or one-eighth of a second per word. Johnston marveled: "He had the fastest voice I have ever worked on, at least two frames a word."

Animator Marc Davis commented:

> The fox in *Song of the South* spoke very rapidly; he had a tremendous scale of speaking levels, which gave an interpretation of movement to him. James Baskett was about the best voice I ever had to work with. He had a great range and could go from slow to fast and from low to high. He could be hysterical, comic, snide or mean. The great variety gives inspiration to the physical movements of the character. He was a very talented and dear man.

Baskett's vocal talent was so extensive that he even filled in for Johnny Lee, the voice of Brer Rabbit, in the Laughing Place sequence when Lee was called away on a USO tour to entertain the troops. Brer Rabbit's laughter during that sequence is reused in *The Jungle Book* (1967) for the scene where Baloo tickles King Louie.

According to Disney author and artist Russell Schroeder, Baskett also did the voice for a Brer Cricket that was dropped from the final film.

Disney Legend Eric Larson stated:

> Baskett had a great appreciation of animation and gave his all. He loved these characters and inspired us with his interpretations. In the Laughing Place segment he does the voice of the rabbit as well as the fox. There was nothing he couldn't do.

Walt Disney wrote a personal letter on January 30, 1948, to Jean Hersholt, President of the Academy of Motion Picture Arts and Sciences, suggesting that James Baskett be awarded a special Academy Award for his work in *Song of the South*.

According to Walt's letter, Baskett had not only brought to life the "immortal folklore character" of Uncle Remus, but

was "a very understanding person and very much the gentleman". Furthermore, Walt emphasized that Baskett "had worked almost wholly without direction", and had himself devised the characterization of Remus.

When Hattie McDaniel won the Oscar for Best Supporting Actress, some critics of *Gone with the Wind* were muted, and it has been implied that Disney sought a similar effect by requesting a special Academy Award for Baskett. No documentation supports this assumption. Walt was quite aware that Baskett was then in ill health, which might have been the reason Walt lobbied for the special Award.

Disney was not alone in his praise of Baskett's performance. Hollywood columnist Hedda Hopper was one of the many journalists who declared that he should receive an Academy Award for his work. Hopper had met Baskett when he recreated the role of Uncle Remus in a thirty-minute radio adaptation of *Song of the South* for *The Hedda Hopper Show* on CBS radio on February 1, 1947. Others in the entertainment field who supported a Baskett award included actress Bette Davis.

Baskett was awarded an honorary Oscar by actress Ingrid Bergman on March 20, 1948, for "his able and heartwarming characterization of Uncle Remus, friend and storyteller to the children of the world". The smiling, white-haired Baskett graciously accepted the award on stage, but his gaunt appearance was in stark contrast to his screen portrayal of Uncle Remus. He was the first African-American male to receive an Academy Award.

Just months later, on September 9, 1948, Baskett tragically died of heart problems and complications from diabetes at age forty-four. His Oscar was honorary. Sidney Poitier was the first African-American male actor to win a competitive Oscar, nearly fifteen years later, for his performance in *Lilies of the Field* (1963).

Baskett is remembered fondly by the Disney animators for his vitality and enormous talent. As an actor, he was a personal favorite of Walt Disney. After the film, Walt stayed in contact with Baskett, even picking up a record of the singer Bert Williams for him in New York because Walt knew Baskett was a fan of Williams. Baskett's widow, Margaret, wrote that Walt had been "a friend in deed and (we) have certainly been in need".

**Horace Winfred Stewart**, who voiced Brer Bear, was born in Harlem, New York, on March 15, 1910, and died in Los Angeles, California, on December 18, 2000. Of his many accomplishments, Stewart founded the Los Angeles' Ebony Showcase Theater in 1950 with some of the money he made playing such stereotypical characters as Lightnin' Jefferson on the *Amos 'n' Andy* television show. It was his lifelong dream to have a theater featuring black actors playing roles other than maids and butlers.

He briefly tried his luck at boxing, took to tap dancing, and later made the rounds as a stand-up comic. Stewart used various names, including Nicodemus Stewart, in a career that began in the 1930s and lasted for decades. He made his first credited movie appearance in *Go West Young Man* (1936).

Stewart was brought back by the Disney Company decades later to record the voice of Brer Bear for Disneyland's Splash Mountain attraction.

**Johnny Lee** (born John Dotson Lee Jr. and sometimes credited as Johnnie Lee), who voiced Brer Rabbit, later joined the *Amos 'n' Andy* television show as the character Algonquin J. Calhoun. He appeared in several movies before *Song of the South*, including *Stormy Weather* (1943). He passed away in 1965 of a heart attack.

**Jesse Cryor**, a black singer, performed the singing voice of Brer Rabbit for the song "Ev'rybody Has a Laughing Place". He was a friend to both Lee and Baskett.

# Song of the South: The Live Action

A November 3, 1946, *Atlanta Journal* article stated that Disney originally considered shooting the live-action footage for *Song of the South* on location in Georgia, but was prevented from doing so by "technical difficulties". That vague reference probably meant that filming with a mixed cast would have caused difficulties in the severely segregated state. Even the movie *In the Heat of the Night*, shot two decades later and released in 1967, had to be shot in Sparta, Illinois, not in Mississippi, where the story was set, to avoid similar problems.

Filming for *Song of the South* began in November 1944, with outdoor shooting in the Phoenix area, where the Disney Studios had constructed sets for the plantation and the cotton field. Some of the interior footage, like Remus talking to Johnny in the old cabin, was shot later at the Samuel Goldwyn Studio in Hollywood. James Baskett sometimes performed on actual sets that were painted to seem like cartoon backgrounds.

The animation was pre-planned in great detail, but the live-action photography was completed first. It was a unique double process that required close cooperation between the live-action and animation directors. The live-action footage was edited to a precise length, then given to the animators to add the cartoon figures.

Bill Peet, who had worked on the animation storyboards, went to Arizona and rode on the camera boom during the shooting of the live action to ensure the camera would be positioned correctly when animation and live action were combined. Peet was born "William Peed" (and is credited by

that name in the final film), but legally changed his last name while working at the Disney Studios because of the incessant teasing he received from his playful peers due to its reference to urination.

Walt himself visited in December 1944. He missed his daughter Diane's birthday, and almost didn't get home in time for Christmas. He later returned to the location for four weeks in February and March to personally supervise the filming.

Disney Legend Wilfred Jackson told Disney historian Michael Barrier:

> Walt got pretty irritated with us on *Song of the South* because of how carefully we were planning [the combination scenes] and how carefully we supervised what was done on the live-action set. ... He thought we were spending too much money on the live-action set. ... He thought we were spending too much money on the live action part of the combination scenes. I think Walt was a hundred percent wrong only that particular time, which is why we went ahead and did it anyway and got scolded.

In a 1985 interview, Disney Legend Ken Anderson remembered that on the location site:

> Walt kept trying to explain to the cameraman that he had to leave enough space for the cartoon figures in front of the live-action cast. Walt would peer through the view-finder and yell, "No. That's not right." And he would hop up on a log and act out the part of the rabbit, and he would be the rabbit.
>
> He was quite an actor. He could act any part. He could be any kind of animal. When we were starting a picture, he would get physically involved. He would be Brer Bear or Brer Rabbit. I saw him do it. He would actually be these characters. You would look at him and he was the rabbit. The next thing he would be a bear. He was doing this thing so we got the idea of these characters. He was the greatest actor we ever saw. He just got carried away with this acting business sometimes.
>
> I remember one time in Arizona where we were doing some live-action shooting for *Song of the South*. We had these outdoor things for the rabbit and the bear and these other characters. This film crew hadn't seen Walt in action. We couldn't afford to take our Hollywood crew over. We picked up a crew out there. We went out on a log. Big ol' log.

Walt said, "Ken, this is just right. This is just what I want." He would get on the log. He would be Brer Bear chasing the rabbit and he would chase the rabbit up and around this log. It was the darndest thing you ever saw. You thought you were seeing a bear chasing a rabbit. Walt had the ability to sell us on these particular characters. He made us believe that these characters were doing these actions.

When Walt visited the set, he did not use the standard canvas-backed director's chair most common on live-action productions. He sat in a rocking chair just like the Uncle Remus character did in the film. Across the back of Walt's rocking chair, the crew had put the words "Uncle Walt" to reference that Walt was a storyteller like Uncle Remus. It was the first time that anyone remembers Walt being referred to as Uncle Walt, a nickname that would get more attention and use almost a decade later, when Walt entered the world of television.

Walt's daughter Diane Disney Miller told me:

I know that dad was very excited about making that picture, and thrilled with James Baskett. Sharon and I visited the set once. We were very excited about meeting Hattie McDaniel. The making of this picture was the reason for the conversion of the downstairs guest room and bath-library wing (of our house) to a projection room with a small wet bar. Dad wanted to be able to watch the dailies [film footage shot on a particular day for later review] at home.

Carol Jean Luske, daughter of legendary animator and director Ham Luske, told me:

Bobby Driscoll and Luana Patten were supposed to skip through the woods, but Driscoll couldn't, so almost everyone on the set including my dad was skipping around to help show him how to do it.

On November 30, 1944, Walt Disney Productions entered a contract with Samuel Goldwyn Studio in Los Angeles, California, to begin filming *Uncle Remus* on January 2, 1945.

When United Artists was formed in 1919, they had a small studio on the corner of Santa Monica Boulevard and Formosa Avenue in Hollywood. As United Artists lured independent producers away from the major studios, many of those producers like Samuel Goldwyn rented offices and stages on

the property. Goldwyn helped finance the expansion of the studio, creating an awkward ownership structure.

When Goldwyn left United Artists under strained conditions in 1940, he renamed the lot the Samuel Goldwyn Studio despite the protest of Mary Pickford, who still owned half the property. This bitter dispute lasted until 1955, when Goldwyn was able to buy the remaining land. The lot provided a home for many independent production companies over the years, and continued to be known as the Samuel Goldwyn Studio until 1980. Among the famous movies filmed there were *Wuthering Heights* (1939), *Some Like It Hot* (1959), and *West Side Story* (1961).

Ken Anderson recalled:

> A huge 150 foot cyclorama which looked like a painted cartoon background was built at the Goldwyn Studio. The positions where Uncle Remus looked were pre-determined by placing concealed sticks which indicated the cartoon character. These sticks were covered later by the addition of an overlay painted cel. The character animation was done later with the animators working with frame blowups of the live-action film.

> Wilfred Jackson directed the sequence where Remus tells Johnny that it was one of those Zip-A-Dee-Doo-Dah days. He realized the problem of making the transition from rear-projection to the actual set. He tried it once and it didn't work. On the last day of the filming at Samuel Goldwyn Studio, Walt arrived on the set and Jackson admitted he had no solution. Calmly, Walt gathered Jackson, cameraman Gregg Toland, and other technicians into a circle for a discussion of the problem.

> None of the proposals seemed practical. Then Walt said, "Why don't we do this? We'll have Jim sitting in front of the fire, and we'll light his face but not the background. We'll be in tight, with a clear area of blue sky behind his head. We'll have the other lights covered with cardboard. When Jim says 'Zip' all the lights will come on, and he'll walk into the bright animation."

> Wilfred Jackson gushed, "It was a simple and obvious solution to the problem. Walt never came up with a poor substitute. He always enhanced the original idea."

Reportedly, it was Walt himself who came up with the expression "Zip-A-Dee-Doo-Dah".

While Walt struggled with the live action, and worried that it was becoming more expensive than originally planned, he was confident about the quality of the animation that would need to be created. His confidence and good humor about it were reflected in the spirits of his artists.

# Song of the South: The Animation

In October 1944, Disney Legend and color stylist Mary Blair was in Atlanta, Georgia, for ten days of conferences and field trips with a local artist and historian "to collect historical and scenic background" for *Song of the South*. She told a reporter that she was "brought up on Uncle Remus stories" by her Maryland-born father, and that Walt:

> ... expected her to bring back to Hollywood many watercolors of the Georgia countryside. ... I want to know what a Georgia cotton field looks like and all about the briar patch. I want to find out about the weather and the terrain and to get the feel of Georgia for myself.

An October 4, 1944, *Atlanta Constitution* article noted that Blair was consulting with Atlanta artists and historians Wilbur G. Kurtz and Annie Laurie Fuller Kurtz on "matters of architecture, costumes, natural background ... and 'just props'". She returned with a sketchbook full of drawings and inspirational sketches that emphasized the red earth typical of the area.

Ken Anderson told me:

> The colors were very raw. They were bright and happy; not subdued at all. Mary's sketches gave us an idea as to how the backgrounds should look since the cartoon and live action had to fit together.

The color in those sequences is probably the brightest and most vivid ever seen in a motion picture.

By spring 1945, Blair moved on to develop concepts for *Alice in Wonderland*. Her artwork for *Song of the South*,

painted with what animation historian John Canemaker described as "a low-key palette and classic water color techniques", helped set the tone for the color schemes used in the film as well as the set and costume designs that helped transform an Arizona location into post-Civil War Georgia.

Claude Coats, who also worked on backgrounds and color styling for the film, stated:

> In the animation scenes in *Song of the South*, it was necessary to blend the backgrounds into the real backgrounds as seen in the live-action portions, so we made backgrounds that reflected Georgia's rural areas, even down to the red clay.

Storyboarding the animated sequences was the work of Bill Peet, who had contributed some outstanding story moments for *Dumbo* (1941). While several of the Remus fables were developed as possible animated segments, supposedly it was Walt himself who selected "Running Away", "Tar Baby", and "Laughing Place" as the three fables to expand into the storyline for the final film. In addition, the song "Uncle Remus Said" describes how the camel got his humps and how the pig got a curly tail. Later, it is explained in the film how Brer Rabbit got his cotton tail.

In his autobiography, Bill Peet wrote:

> When Walt handed me the job of planning the Remus tales, I was both delighted and befuddled. Anyway, developing the characters of the rabbit, the fox, and the bear and working with the quaint old fables was the most fun I'd had since *Dumbo*. ... On the Remus fables, Walt was always in a good humor, full of enthusiasm at every story session, and the animators caught the playful spirit in preparing the fables for the screen.

In their book *Disney Animation: The Illusion of Life*, animators Frank Thomas and Ollie Johnston wrote:

> Bill Peet's great story work seemed to lend itself to this type of casting ... which could have only been done by one person handling both the characters and completely controlling every single bit of action, timing and cutting. He had developed strong character delineation, and the design of the characters inspired the animators to get a very loose handling of their work. But more important, Bill's business called for much personal contact between the bear, the fox

and the rabbit. Also, his relationships demanded split-second reactions between the characters that would have been impossible in co-animation.

Further, in the book *Treasures of Disney Animation Art*, the author states that Peet "not only staged the action; he has suggested props, costumes, motivations, gags, bits of personality business, story continuity, locale, character relationships, and camera angles".

In an interview with animation historian John Province, Peet said:

> I did story-sketch on the sequences with Brer Rabbit based on the Uncle Remus fables. The personalities were so rich and well-defined in the original stories. To me they were funnier than hell!

Disney storymen Ralph Wright and George Stallings also contributed to the gags and story. Six of Disney's fabled Nine Old Men (Marc Davis, Ollie Johnston, Milt Kahl, Eric Larson, Les Clark, and John Lounsbery) were given credit as directing animators.

Wilfred Jackson was overall supervising cartoon director, and it was he who assisted Walt in figuring out how to synchronize audio to the first Mickey Mouse sound cartoon by using a metronome to mark beats.

According to Ollie Johnson and Frank Thomas:

> Jaxon [Wilfred's nickname at Disney] was easily the most creative of the directors but he was also the most picky and took a lot of kidding about his thoroughness.

Jackson did a little animation on *Steamboat Willie* (1928), the first Mickey Mouse short to be released theatrically. He was a sequence director on *Snow White and the Seven Dwarfs* (1937), *Pinocchio* (1940), and *Dumbo* (1941). Jackson also directed thirty-five Disney shorts, including the Oscar-winning cartoon *The Old Mill* (1937).

*The Band Concert* (1935) was the first Mickey Mouse short produced in color and demonstrated director Jackson's continuing interest in the combination of animation and music. Jackson later co-directed several Disney animated features in the 1950s, and was responsible for the direction of several shows for the early *Disneyland* weekly television series. He told Disney historian Don Peri:

I think the happiest time I ever had working on any picture, after the first early years, was on the *Song of the South*. That was a wonderful experience for me. I'll tell you why it was a wonderful experience. Walt was again very closely, personally involved with what we were doing. This was his first venture into live-action features and he was quite interested in the outcome. This meant that Walt was working closely with us and this always made a thing really exciting.

And since this was an important thing to him, he had the cream of the animation crew on it. He had this wonderful story team, Bill Wright and Bill Peet, working together, and we had Perce Pearce as an associate producer. They were a wonderful bunch of creative guys. Ken Anderson was my head layout man. Ken and I didn't get to work together very much through the years, but that was one time we did. All of this, I think, made it the most exciting and interesting and wonderful thing I worked on.

After the constraints of working on military training films with limited animation and mundane stories, Disney's animation staff was excited about working on this new project. They felt they could really let loose, even though the total animation would only encompass about one-third of the film. Actually, the short length was an advantage, as the artists could spend more time on their animation, unlike in the case of a full-length animated feature, where budget limitations would have forced them to produce more footage at a quicker rate. Ken Anderson remembered:

This was the most fun I ever had on a Disney picture. I think that's true for most of the animators who worked on it too. There was more interaction than on previous films and we all worked together to make it really amount to something. It started a whole trend for the films that followed.

To me, the perfect culmination of layout, animation, and art direction happened in *Song of the South*. Every scene was thumb-nailed before it went to layout, checked with the director Wilfred Jackson and storyman Bill Peet. Then the scene was cast for an animator and the animator could redraw the thumbnails if he wanted and we would thrash it out. So we knew exactly what a scene was going to look like before the scene was photographed, before the live actors were shot.

And we could go into a sweat box and know if a scene was right or not. There were plenty of arguments, it was never easy, but I think we got a better result. We pasted all

the thumbnails in a large book so we knew exactly where we were at any given time. There was never that degree of coordination again.

Ollie Johnston did some work on Brer Rabbit, but actually animated all three primary characters. He particularly enjoyed the Tar Baby sequence:

It was one of the most exciting pictures I ever worked on. Each fable was full of action, and with those three great characters you had quite a wonderful triangle there. I really liked the character relationships that developed between the rabbit, fox and bear. This show was so different from the previous film, *Bambi*, which had to be animated true to life and very exact. We could take a lot more liberties with the animals in *Song of the South*. In the scene where the rabbit wrestles with the Tar Baby, we could give him human traits and then exaggerate all the movements. You can't make a character too evil, ugly or stupid because the audience won't accept him. The Bear was one of the dumbest characters I have worked on, but I also found him to be one of the most charming.

Eric Larson, who worked on Brer Bear, added:

The charm of animation is simplicity and pantomime. Where could you find three more clearly defined characters getting into strange predicaments than in *Song of the South*? The characters were especially fun to animate because they showed a lot of thinking going on behind them. Another reason for the enthusiasm that greeted this film was the fact that it was Walt's first feature after the war. We were so happy to be working on this film after so many years of making those dull government films. Also, it was so different from our previous animated feature, *Bambi* (1942). Here we could give the animals human traits and then exaggerate all the movements whereas with *Bambi*, everything had to be animated true to life and very exact.

Marc Davis animated Brer Fox and Brer Bear constructing the Tar Baby. He also contributed story sketches to the live-action/animation combination sequences with Uncle Remus and Brer Rabbit. He was always quick to praise Bill Peet for "a tremendous job" in developing the film's highly "animate-able cartoon situations and vivid personalities". Davis said: "Bill Peet is the one who deserves the credit for that conception ... absolutely an incredible thing."

However, Milt Kahl claimed:

> I probably had more to do with the development of all three of those characters [the three primary Brers] than any one person at the risk of sounding immodest. The biggest enjoyment I've had was working with *Song of the South*. Here were three characters who were all definite and clear cut — the screwball fox who was always fast-talking some wicked scheme; the oafish bear who went along with him, but actually had more common sense; and the rabbit, a sympathetic hero who still was pixyish. The animated scenes were a high for us.

With regard to Kahl's comment, Marc Davis had been brought into the project at least three months prior to Kahl, and seemed to have been responsible for a good deal of the development of the personalities of the animated characters, based on Peet's concepts. Often, individual animators were unaware of other work that had been done on a project, or never saw work done by others.

Thirty-six animators took two years to do the animation for *Song of the South*. The first release of the film emphasized the live action in the hope that this would mark the entry of the Disney Studios into live-action filmmaking. The posters and advertisements promised an almost *Gone with the Wind* style of film, re-telling the romance of the "Old South" with the animated characters visible only in small drawings at the bottom of the image. Re-releases of the film focused on the animation, with pictures of Uncle Remus surrounded by the animated characters featured prominently on the posters and publicity, and the live-action sections given little or no attention.

# Song of the South: The Music

According to an October 27, 1944, *Hollywood Reporter* news item, Disney signed Robert MacGimsey to score *Song of the South*. MacGimsey did eventually contribute one song to the film, "How Do You Do?".

Several songs were developed that never ended up in the final film:

- "I'll Take My Troubles Down to the River", with music by Leigh Harline and lyrics by Ned Washington, was about how an overburdened individual deals with his afflictions.

- "I Ain't Nobody's Fool", again by Harline and Washington, would have tied into a story about how Brer Rabbit fooled Brer Lion.

- "De Wuller-De-Wust", with music by Frank Churchill and lyrics by Ray Kelley, recounted how Brer Rabbit tries to avoid punishment for stealing Brer Bear's honey by pretending to be a spirit.

- "Walkin'", with music by Frank Churchill and lyrics by Larry Morey, had all the animals joining Remus in a lyrical walk to symbolize the journey to the Promised Land.

Close to a dozen other tunes were created but never heard, including "Rang Tang", "The River's Deep", "Look at That Sun" (advertised as appearing in the film but never included), "Inga-Go-Jangle-Jay", and "Uncle Remus Jubilee". It was not unusual for several songs to be developed for Disney animated features and then never used, because a story sequence changed or a character was added or dropped.

The final film features nine songs:

- "Zip-A-Dee-Doo-Dah"
- "Song of the South"
- "Uncle Remus Said"
- "Ev'rybody Has a Laughing Place"
- "How Do You Do?"
- "Sooner or Later"
- "Who Wants to Live Like That?"
- "Let the Rain Pour Down"
- "All I Want"

The musical score for *Song of the South* was split between Paul Smith, who composed the animated sequences, and Daniele Amfitheatrof, a Russian composer who composed the live-action sequences.

Charles Wolcott, the musical director for the film, said:

> Walt wanted this picture to be superior in every way. He was confident that we could handle the animated segments of the film, but he wanted an experienced composer for the live-action portions. Of course, the irony was that here was Danny, a Russian, scoring a picture about the Deep South, an American phenomenon.

The musical score was nominated for an Academy Award but didn't win. However, the song "Zip-A-Dee-Doo-Dah", written by Allie Wrubel and Ray Gilbert, won an Oscar for Best Song. Singer Dinah Shore presented Wrubel and Gibert with the Oscar for the song, which topped the Hit Parade in 1946.

The contribution of a variety of vocalists in *Song of the South* was mostly uncredited. Ken Darby, however, did receive credit. He had served as vocal arranger and music director on several Disney films from 1940 to 1947. Under Darby's direction, his singers created some of the unique voices of the munchkins in *The Wizard of Oz* (1939). The Ken Darby Singers also sang in *Song of the South*.

A famous African-American chorus supplied the richly authentic sound for the film, though they were not credited on the screen. The songs "Uncle Remus Said", "Let the Rain Pour Down" (which the sharecroppers sing as they go out to the

fields and then return at the end of the day), and "All I Want" (sung while Johnny is suffering in bed after the accident with the bull) were performed by the Hall Johnson Choir.

Hall Johnson, a highly regarded African-American choral director, composer, music arranger, and multi-instrumentalist, dedicated his life to preserving the integrity and rich legacy of the Negro spiritual as it had been performed during the slave era. The Hall Johnson Choir, the first professional group of its kind, was formed in 1925 from Johnson's Harlem Jubilee Singers, and enjoyed a successful concert and recording career for several decades in the United States and abroad.

National recognition came when Johnson's choir performed under his direction in Marc Connelly's Broadway production of *The Green Pastures* (1930). In 1935, Johnson took the choir to Hollywood for a performance in the film *The Green Pastures* (1936), an adaptation of the Broadway play.

Johnson and the choir remained in the Hollywood area and appeared in other films, including *Hearts Divided* (1936), *Banjo on My Knee* (1936), *Lost Horizon* (1937), *Tales of Manhattan* (1942), and *Cabin in the Sky* (1943). Their performances included the singing crows in Disney's *Dumbo* (1941) and the field workers in *Song of the South*.

In 1946, Johnson returned to New York, where he organized the Festival Negro Choir of New York. He was posthumously honored for his work in films by election to the Black Filmmakers Hall of Fame in 1975, five years after his death.

The proud, intelligent Johnson would not have put up with overt negative racial content, and apparently found none in what he was asked to do for *Song of the South*. Unfortunately, his choir's association with the black music developed during the slave era may have reinforced audience misperception about the time period of *Song of the South*.

One of the criticisms constantly made about *Song of the South* is that the singing scenes featuring black performers exemplified the abhorrent stereotype common in Hollywood films of blacks so happy about being slaves that they sang.

No one seemed to remember that noted black activist Frederick Douglass, a famous abolitionist, former slave, and respected writer and orator, addressed in the 19th century the cliché of singing slaves:

> I have often been utterly astonished, since I came to the
> North, to find persons who could speak of the singing,
> among slaves, as evidence of their contentment and
> happiness. It is impossible to conceive of a greater mistake.
> Slaves sing most when they are most unhappy.

Certainly, one of the three songs performed by the Hall Johnson Choir in the film is about people not altogether happy about a hard day of work in the fields, while another is an empathetic song expressing deep concern for the well-being of an injured young boy.

The DeCastro Sisters (Peggy, Cherrie, and Babette) were a female singing group. In 1945, the DeCastro family moved to the United States from Cuba, and the sisters became protégées of performer Carmen Miranda. They had a style similar to the popular Andrews Sisters singing trio but with a Latin flavor. It was probably their connection with Miranda, who knew Walt Disney, that got them their first film work doing background vocals for "Zip-A-Dee-Doo-Dah".

Clarence Nash, perhaps best-known for providing the voice of Donald Duck for decades, was also highly proficient in performing real bird imitations. He supplied the chirps for Mr. Bluebird on Uncle Remus' shoulder.

The film's music was the focus of a 1946 lawsuit against the Disney Studios by the Southern Music Publishing Co., which claimed that it had the exclusive rights to publish all works by songwriter Ray Gilbert, who co-wrote "Zip-A-Dee-Doo-Dah", "Sooner or Later", and "Ev'rybody Has a Laughing Place". Disney had assigned all rights to the film's music to the Santly-Joy publishing company. The suit was settled out-of-court in 1948, when the Studio offered Southern a percentage of its royalties from the songs in contention.

In 1980, Judge E. Peterson filed a ten-million-dollar lawsuit against the Studio, claiming that he and his partner, James A. Payton, were the true authors of the song "Zip-A-Dee-Doo-Dah". The Studio denied their allegations, stating that there "was no question Ray Gilbert was the author of the song."

Both the term and the song itself, "Zip-A-Dee-Doo-Dah", are still so instantly recognizable that they have been referenced dozens of times over the last six decades in other entertainment projects, and the song has been covered by many musical artists.

# Song of the South: The World Premiere

The Disney Studios contacted prominent movie critics and arranged for them to travel to Atlanta, Georgia, for the world premiere of *Song of the South*. Four reporters from *The Atlanta Constitution* and *The Atlanta Journal* visited the Studio in early October 1946 to begin a series of stories that would run daily in Atlanta newspapers until the premiere.

Many recording artists released versions of the film's music in advance of the premiere, including Dinah Shore, The Merry Macs, Woody Herman, and The Modernaires, according to a September 25, 1946, *Hollywood Reporter* news item.

The state of Georgia agreed to have a joint holiday celebrating Armistice Day and a tribute to Joel Chandler Harris, since it was in Georgia that Harris' stories had first gained recognition.

Arrangements were made for Walt to dedicate an Uncle Remus cabin at Wren's Nest, Harris' former home. About two weeks before the premiere on November 1, 1946, artists Fred Moore and Dick Mitchell, along with "production expert" Frank Bresson and Clarence Nash (the vocal artist who was the voice of Donald Duck), opened a "miniature studio" at the Belle Isle Building Arcade in Atlanta.

The exhibit included Moore and Mitchell drawing sketches for visitors and demonstrating the animation process. In addition, there were showings of a short preview of the movie as well as scenes from the 1941 Disney film *The Reluctant Dragon* because it contained a live-action tour of the actual Disney Studios. The Disney artists were later joined by Pinto

Colvig (the voice of Goofy) and Adriana Caselotti (the voice of Snow White).

On November 11 (Armistice Day), a gigantic parade moved down Atlanta's Peachtree Street. There were bands and slow moving floats, some of which featured characters from the film, and children cheering since they had been given a school holiday. Flags adorned the buildings. There was a luncheon at the Capital Club and a tea at the Wren's Nest, where a crowd of enthusiastic autograph-seekers got out of hand and knocked Walt Disney to his knees.

The world premiere was set for 8:30 PM on November 12, 1946. The premiere itself was sponsored jointly by the Atlanta Junior League (and the various charities it supported) and the Uncle Remus Memorial Association, which used its portion of the proceeds for the renovation of Wren's Nest. Celestine Sibley, who covered the event for *The Atlanta Constitution*, called it D-Day in honor of Disney.

Prior to the screening of *Song of the South*, radio shows participating in the film's premiere included *Queen for a Day, Bride and Groom*, Art Linkletter's *GE House Party*, and *Vox Pop*. *Vox Pop* conducted live interviews on the Fox Theater stage. The premiere was attended by over five thousand people.

On one radio broadcast, Walt said:

> I first heard the stories of Uncle Remus when I was a boy down in Missouri. And since then they've been one of my favorites.
>
> I believe no folk stories have been better loved than the Joel Chandler Harris tales of Uncle Remus. I've always wanted to do a picture of them. But I had to wait for the development of our new film technique before I attempted it where we combine live acting with animated characters.

Bobby Driscoll, Luana Patten, and Ruth Warrick represented the cast. Walt and Lillian Disney were there, accompanied by Disney Studios' staff including Perce Pearce, Milt Kahl, Bill Peet, Ken Anderson, Claude Coats, and Wilfred Jackson. Other celebrities included actor Bill Williams and his wife actress Barbara Hale, along with Cliff "Jiminy Cricket" Edwards.

The film was shown at the majestic Fox Theater, the South's largest theater with seating for over 5000 people. Not since *Gone With the Wind* had all of Atlanta turned out for a Hollywood movie.

On the night of the gala, Disney took the stage at the Fox and welcomed the sellout audience of five thousand people in the high tenor voice of a Southern-accented Mickey Mouse: "How are y'all?" As soon as the film began, he ducked out of the theater and waited across the street at the Georgian Terrace Hotel, chain-smoking and biting his fingernails.

There was some dissension in the Atlanta papers because the name Uncle Remus wasn't in the title. *The Atlanta Journal* movie editor saw a preview and wrote that people shouldn't worry because it was Uncle Remus' picture from start to finish, and that he was faithfully portrayed. He wrote that it:

> ... was a film that is certain to take its place alongside *Gone with the Wind* as a celluloid piece of Americana.

However, the celebration and good feelings were overshadowed by a dark secret: *Song of the South's* black cast members were not able to join Walt Disney and the white cast members at the movie's premiere in Atlanta, because Atlanta was a segregated city. African Americans could not enter the movie theater or any other public buildings downtown.

In describing the premiere, local newspapers recounted the actions of Atlanta's mayor, William B. Hartsfield, who urged Disney to wire Baskett with news of the city's appreciation for his enactment of Uncle Remus. Although some Southern newspapers claimed Baskett could not be present due to his commitment to the *Amos 'n' Andy* radio show, none of the black cast members attended the premiere.

In an October 15, 1946, article in the *Atlanta Constitution* newspaper, columnist Harold Martin noted that to bring Baskett to Atlanta, where he would not have been allowed to participate in any of the festivities because of the highly strict segregation laws "would cause him many embarrassments, for his feelings are the same as any man's".

There is an urban legend that no Atlanta hotel would give Baskett accommodations because white-owned hotels denied rooms to blacks. That is not entirely correct: there were several black-owned hotels in the Sweet Auburn area of downtown Atlanta at the time, including the Savoy and the McKay.

But even if the black cast had stayed at those hotels, they still would have been denied access to other areas frequented by white cast members, including restaurants and the theater itself.

The sixteen-page program book for the premiere, which was filled with artwork by Mary Blair and Bill Peet, included the remark that Walt chose the stories for their ability to move "easily between realism to fancy, from pathos to comedy. They had action, comedy, variety and outstanding appeal to people of all ages and nationalities."

# Song of the South:
# The Controversy

The National Association for the Advancement of Colored People (NAACP) was formed on February 12, 1909, an event timed to coincide with Abraham Lincoln's 100th birthday, although the name of the organization itself was not officially chosen until 1910.

Appalled at the violence against African-American citizens, including wide-spread lynchings as well as the Jim Crow laws that promoted racial discrimination and segregation, the organization contained both white and black members. In fact, white members initially held key positions on the board.

One of its first protests against the portrayal of African Americans in films occurred during the release of D.W. Griffith's *The Birth of a Nation* (1915), a film that the NAACP felt glamorized the origin of the Ku Klux Klan, and which sparked race riots across the country. Despite nationwide attempts to have the film banned, *The Birth of a Nation* became highly successful, and it is still widely available today as an example of innovations in filmmaking, despite criticisms of its racial misrepresentations.

Throughout the 1940s, the NAACP saw enormous growth in its membership, claiming nearly 500,000 members by 1946. However, it wasn't until 1948 that the NAACP was successful in pressuring President Harry Truman to sign an Executive Order banning racial discrimination by the Federal government.

When *Song of the South* was released, the NAACP was

acting as a legislative and legal advocate, pushing unsuccessfully for a federal anti-lynching law and for an end to state-mandated segregation.

The NAACP attempted to create a Hollywood Bureau to convince Hollywood studios to counter derogatory stereotypes of African Americans in motion pictures and to promote more realistic roles for black performers. There was extensive correspondence with producers such as David O. Selznick, Darryl F. Zanuck, and other major studio moguls about classic films like *Gone with the Wind* (1939), *The Ox-Bow Incident* (1943), *Pinky* (1949), and of course, *Song of the South*.

The Disney Studios had come under close scrutiny when it announced its upcoming film on the stories of Uncle Remus.

Reading the first treatments prepared by Southerner Dalton Reymond, who had sprinkled the work with stereotypes and terminology that were offensive when referring to African Americans, the Hays Office — which regulated the content of films — sent a warning to Disney. It was non-negotiable that those terms, for example, referring to Uncle Remus as an "old darkie") must be removed, but that overall the film was acceptable in meeting the demands of the Production Code.

Nonetheless, the Hays Office strongly suggested:

> ... the advisability of your taking counsel with some responsible Negro authorities concerning the overall acceptability, from the standpoint of Negroes, of this story. ... Our Negro friends appear to be a bit critical of all motion picture stories which treat their people, and it may be that they will find in this story some material which may not be acceptable to them.

Disney hired Clarence Edouard Muse as a consultant in 1944. Muse, born in 1889, was an African-American lawyer, writer, director, composer, and actor. After high school, he earned a degree in International Law from The Dickinson School of Law of Pennsylvania in 1911.

Disgusted with the poor opportunities for black lawyers, he then selected a show business career. Muse appeared as an opera singer, minstrel show performer, vaudevillian, and Broadway actor. In addition, he also wrote songs, plays, and sketches. He appeared in very dignified roles in films made

for all-black audiences, and was so articulate as to be considered a spokesman for the black community.

Muse quit Disney early in 1944 after his ideas to portray the African-American characters as more dignified and prosperous were rejected by Southern writer Dalton Reymond. Once Muse left Disney, he began to inform people about the nature of the Disney feature while it was still in the rough draft form, and before radical leftist screenwriter Maurice Rapf had been brought in to make the script more acceptable.

Muse wrote letters to the editors of black publications informing them that Disney was going to depict Negroes in an inferior capacity and that the film was "detrimental to the cultural advancement of the Negro people". So the pump was already primed for disaster.

Screenwriter Maurice Rapf remembered that Walt:

> ... had a theory that the reason why the film was picketed and particularly attacked by the Los Angeles chapter of the NAACP was because the head of the local chapter was actor Clarence Muse. He knew that Walt Disney wanted to do a Remus story, and Muse wanted to play Remus. He was a standard serious black actor, but Disney got someone else. Now others said that couldn't be true, because Muse was a technical adviser on the film, though I think if that's true he didn't do a very good job advising.

Both Walter White, the executive secretary of the NAACP at the time, and June Blythe, the director of the American Council on Race Relations, had requested to see a treatment of Disney's *Song of the South* when the production was first announced. But they were ignored or politely given the runaround. Neither the NAACP nor the American Council on Race Relations had any opportunity to review the project before the press screening.

This was not an unusual procedure for Walt Disney, who often delayed or ignored requests for an advance look at a screenplay for one of his films. Walt hated yielding control to others, and felt that the screenplay was in a continual state of evolution until the picture was actually made. In later years, Walt found himself in a similar uncomfortable situation when he denied FBI Director J. Edgar Hoover advance access to comedy scripts depicting FBI agents.

Walter White telegraphed major newspapers around the country with the following statement:

> The National Association for the Advancement of Colored People recognizes in *Song of the South* remarkable artistic merit in the music and in the combination of living actors and the cartoon technique. It regrets, however, that in an effort neither to offend audiences in the North or South, the production helps to perpetuate a dangerously glorified picture of slavery. Making use of the beautiful Uncle Remus folklore, *Song of the South* unfortunately gives the impression of an idyllic master-slave relationship which is a distortion of the facts.

White, however, had not yet seen the film himself, and based his statement on memos sent to him by two NAACP staff members in New York who had attended a press screening on November 20, 1946.

One of those staff members, Norma Jensen, wrote that the film was "so artistically beautiful that it is difficult to be provoked over the clichés", but that the film did contain "all the clichés in the book".

She did feel the Uncle Remus stories were commendable, and she found "very touching" the relationship between the rich white boy and the black boy and the white daughter of a tenant farmer, but objected to scenes like the blacks singing traditional songs, since it was an offensive stereotype.

The other staff member, Hope Springarn, listed several objectionable images in the film, including the use of Negro dialect and the "Negroes singing outside the house" when the little white boy was dying.

Both Jensen and Springarn were also confused about the time of the story, which seemed to be during the plantation days of slavery, but which really was set during Reconstruction. It was something that also confused other reviewers who, from the tone of the film and the type of similar recent Hollywood movies, assumed it must be set during the slave era.

So, based on the information in those memos, White released the official position of the NAACP in the telegram that was widely quoted in newspapers, including the December 4, 1946, issue of *Variety*, the trade journal of the motion picture industry.

Ironically, in 1944, Walt had invited White to the Disney Studios to work with him on script revisions, but White, who was located on the East Coast, claimed other commitments and begged off making the trip.

Racially diverse groups of protesters organized to picket movie theaters in major American cities such as New York, Los Angeles, San Francisco, and Boston. The racial "harmony" demonstrated by these integrated groups of protesters was not common in most of the United States at the time. The philosophical make-up of these protestors resembled similar groups that protested and marched for Civil Rights in the 1960s. They were not so much protesting a particular incident or item, but using a high profile film to protest a much larger injustice.

"We want films on Democracy not Slavery" and "Don't prejudice children's minds with films like this" were some of the slogans that decorated the signs of a racially diverse but small group of protesters who marched outside the Paramount Theater in downtown Oakland, California, on April 2, 1947. The protesters included blacks and whites, men and women, old and young.

The location of the protest was significant because in the 1940s, downtown Oakland was an elegant district with fancy hotels, expensive department stores, and several large-scale "movie palaces". It was not a city known for racial harmony and equality.

At the film's New York premiere in Times Square, dozens of black and white picketers, including African-American service-men returned from fighting in World War II, chanted: "We fought for Uncle Sam, not Uncle Tom." Local chapters of the NAACP called for a total boycott of the film, and The National Negro Congress declared that the film "is an insult to the Negro people because it uses offensive dialect; it portrays the Negro as a low, inferior servant; it glorifies slavery" and called on black people to "run the picture out of the area".

Upon the film's release, groups like the National Negro Congress, American Youth for Democracy, the United Negro and Allied Veterans, and the American Jewish Council orga-nized racially integrated pickets at theaters in New York City, Los Angeles, San Francisco, and Boston, as well as in

other cities. In New York, Broadway actors such as Kenneth Spencer and Sam Wanamaker joined the picket lines.

According to a December 12, 1946, *Variety* news item, the NAACP declined to join the National Negro Congress in its picket of a New York City theater "because it feels nothing can be gained by it."

But the Boston chapter of the NAACP did participate in picketing the film's exhibition there, according to a December 24, 1946, *Boston Globe* article. A January 18, 1947, *Chicago Defender* news item noted that, although the film was being shown at the "white theaters" in Washington, D.C., it would not be exhibited by the "six theaters catering to Negroes".

The Walt Disney Archives contains an original handbill distributed by the National Negro Congress during its picket of the film at a Los Angeles theater. The handbill proclaims that the picture contains "dangerous stereotyping [that] creates an impression of Negroes in the minds of their fellow Americans which make them appear to be second class citizens".

The *New York Tribune* reported that, at a press conference, Walt Disney said that any real antagonism towards the film would come from radicals "who just love stirring up trouble whenever they can". Disney defended the film as a "monument to the [Negro] race", pointing out that it was set after the Civil War and so could not be about slavery, and "that the time had not yet come when Negro susceptibilities could be treated with as much delicacy as Hollywood reserves for, say, American Catholics".

*New York Times* film reviewer Bosley Crowther wrote that the movie was a:

> ... travesty on the antebellum South ... no matter how much one argues that it's all childish fiction, anyhow, the master-and-slave relation is so lovingly regarded in your yarn, with the Negroes bowing and scraping and singing spirituals in the night that one might almost imagine that you figure Abe Lincoln made a mistake. Put down that mint julep, Mr. Disney.

Harlem congressman Adam Clayton Powell Jr. called on New York theaters not to show the film, and called *Song of the South* and *Abie's Irish Rose* "insults to American minorities."

*Ebony* magazine, less than a year old and with a circula-

tion of 300,000, ran a full-page attack on the film next to a full-page photo of the smiling face of James Baskett. The article felt that the film was "lily-white propaganda" in Technicolor and would promote "Uncle Tom-ism as the model of how Negroes should behave in white company".

It mentioned that rhythm-and-blues band leader "Tiny" Bradshaw had been offered a part in the film but turned it down, declaring it would "set back my people many years." An August 24, 1944, *Los Angeles Sentinel* article reported that Ben Carter had also turned down a role in the film, as had Mantan Moreland, Monte Hawley, Ernest Whiteman, and Tim Moore.

While the NAACP's initial criticism of the film may have been based on faulty information, it did use the film as a rallying point that resulted in some changes in how films depicting African Americans were later made.

Walt and the Disney Studios were not totally innocent, either. The ambiguity of the time period of the story suggested that all those happy, singing African Americans might indeed be slaves. Walt naïvely treated the film as another Disney fantasy (evident by those strong Mary Blair color stylings, even in the live-action scenes) without realizing that using real people would make audiences think it was authentic. All of these factors and more added to the confusion, and made defending the film much more difficult than it should have been.

In a February 1947 interview, printed in *The Criterion*, Hattie McDaniel (Aunt Tempy) defended the film:

> If I had for one moment considered any part of the picture degrading or harmful to my people I would not have appeared therein.

In the same article, James Baskett commented:

> I believe that certain groups are doing my race more harm in seeking to create dissension than can ever possibly come out of the *Song of the South*.

# Song of the South:
# The Reviews

The reviews for the film were mixed, although in general there was high praise for the animation. However, many reviewers, despite liking James Baskett's Uncle Remus, found the other live-action performances underwhelming.

Local reviews in Georgia, including a notice in the black newspaper the *Atlanta Daily World,* were largely positive, but nationally the film was not well-received.

*Time* magazine called Uncle Remus "a character bound to enrage all educated Negroes, and a number of damn yankees", while still referring to the film as "topnotch Disney." It added that the film "could have used a much heavier helping of cartooning", claiming that except for the two youngsters (Driscoll and Patten), "the live actors are bores".

Others found *Song of the South*, which had been advertised to be "an epochal event in screen history", as "mawkish", "slipshod", and "inconsequential".

*Variety*: "Story of misunderstood Johnny gets away to an ambling start and only picks up when the live Uncle Remus segues into the first cartoon sequence ... the rest of the story, including the confused and insufficiently explained estrangement of the parents, overbalances the three cartoon sequences ... these cartoon sequences are great stuff."

*New York Times*: "The ratio of 'live' to cartoon action is approximately two to one, and that is approximately the ratio of its mediocrity to charm ... The Disney wonder-workers are just a lot of conventional hacks when it comes to telling a story with actors instead of cartoons."

*PM Magazine*: "[Disney] was not trying to put across any message but was making a sincere effort to depict American folklore, to put Uncle Remus stories into pictures."

*Time* magazine: "Artistically, *Song of the South* could have used a much heavier helping of cartooning. Technically, the blending of two movie mediums is pure Disney wizardry. Ideologically, the picture is certain to land its maker in hot water."

In the *Afro-American,* an African-American newspaper, the reviewer declared he was "thoroughly disgusted" by the film.

Herman Hill's review in the black newspaper *Pittsburgh Courier:* "The truly sympathetic handling of the entire production from a racial standpoint is calculated ... to prove of estimable good in the furthering of interracial relations." Hill discussed the negative statements made by *Ebony* and Clarence Muse, and found their comments to be "unadulterated hogwash symptomatic of the unfortunate racial neurosis that seems to be gripping so many of our humorless brethren these days".

# Song of the South: The Conclusion

"It was a film he really wanted to do," recalled Diane Disney Miller. "My dad quoted so much from Uncle Remus' logic and philosophy."

In the same 1946 publicity release quoted at the beginning of this story, Walt Disney wrote:

> Out of the past of every nation has come its folklore: Simple tales handed down from generation to generation and made immortal by such names as Aesop, the brothers Grimm and Hans Christian Anderson. But no folk tales are better loved than Joel Chandler Harris' "Uncle Remus" — stories in which the Southern Negroes brought the warmth of their humble firesides into the hearts of people everywhere. And if, now in *Song of the South* we have succeeded in a measure to help perpetuate a priceless literary treasure — my co-workers and I shall, indeed, be very happy.

For its time, *Song of the South* was innovative not only for its blending of live action and animation (such as the seamless moment where Remus lights Brer Frog's pipe), but for its depiction of black and white children playing together as equals, and a story where the African-American characters are wise and caring, while the white characters are often cruel, insensitive, or dysfunctional.

Ken Anderson said:

> Walt insisted on pioneering the possibilities of combining animation and live action. He wanted to try the most difficult actions and interplay between live and cartoon

characters to enhance the illusion that they truly existed in one world.

Walt wanted his live-action films to have the same quality as his animated classics. If nothing else, *Song of the South* is important as a transitional film between Disney's classic full-length animated features and his later live-action films.

There were subsequent U.S. re-releases of the film.

For the first re-release in 1956, the *Disneyland* weekly television program re-aired the hour-long episode "A Tribute to Joel Chandler Harris" that had first been shown on January 18, 1956. It was a fictionalized retelling of the life of Harris, with David Stollery of the *Mickey Mouse Club* serial *The Adventures of Spin and Marty* as young Joel discovering the classic folktales he would later write, both by observing real animals and by hearing the Uncle Remus tales. The episode ends with the animated Tar Baby sequence from *Song of the South*.

To further support the re-release, Disney Productions held a nationwide contest sponsored by 3M (the makers of Scotch Tape). Contestants had to answer the following question in twenty-five words or less: "I like Scotch Brand Cellophane Tape because ... ." Out of all the entries, twenty-five lucky families would win a trip to the newly-opened Disneyland. The promotional material featured the lovable trio of Brer Rabbit, Brer Fox, and Brer Bear. Those characters would be used prominently in future marketing efforts as well.

There was another release in 1972, two years after the Disney Company claimed in the February 25, 1970, issue of *Variety* that the Studio had put the film "permanently on the shelf as offensive to Negroes and present concepts of race". During its 1972 re-issue, the picture became the highest grossing Disney re-release up to that time.

The film was re-released two more times, first in 1980 and then in 1986. The 1986 re-issue included a "re-premiere" held in Atlanta on November 15 to celebrate the film's 40th anniversary. By gubernatorial proclamation, the day of the premiere was declared Song of the South Day in Georgia. Proceeds from the premiere, which was attended by actress Ruth Warrick, benefited the preservation of Wren's Nest.

Shortly after work started on *Mary Poppins* (1964), Walt

asked his son-in-law Ron Miller to get a copy of *Song of the South*. A screening with all the senior staff present was arranged for that afternoon at two o'clock. After they watched the live actors and cartoon characters on the screen, Walt said, "I just wanted to see something", and got up and left. The next day, Walt called and asked to see the film again. Then Walt said: "You know, I think this picture (*Mary Poppins*) could use a little animation."

*Song of the South* cost approximately $2,125,000 to make and grossed over $60,000,000 worldwide by the time of its last re-release in 1986. However, that first-year release only netted the Disney Studios an initial profit of $226,000.

The continuing controversy surrounding *Song of the South* discouraged other U.S. theatrical releases by the Disney Company after 1986. It has never been available for commercial sale in the United States, although the film has been released in various commercial formats in Japan and in the United Kingdom, where it was even shown for several years on the television station BBC2, with no public outcry or rioting in the streets.

In fact, the film has been released commercially in several European and South American countries, including France, Italy, Germany, Netherlands, Argentina, and Brazil.

At the 2006 Disney Shareholders' Meeting in Anaheim, California, a shareholder asked company President and CEO Robert A. Iger the traditional question of why the Studio hadn't re-released *Song of the South*. Iger replied that he'd seen it "fairly recently" and had concluded that its "depictions ... would be bothersome to a lot of people. ... Even considering the context [in which] it was made, I had some concerns about it."

The year 2006 was the 60th anniversary of the release of the film. The fear, of course, is that the appreciation of the film and the works of Harris can be misinterpreted as acceptance of old-fashioned stereotyping. Others point out that understanding and openly discussing the mistakes of the past may be the best way to insure a positive future. As the character of Uncle Remus says in the movie: "You can't run away from trouble. There ain't no place that far."

One of the major complaints has been that *Song of the*

*South* is a more insidious film than *Gone with the Wind*, since it appeals to young children and is set in a fantasy world of the Old South, a brightly colored, tuneful, romanticized version of the South of the Reconstruction Era, but without the terrors and heartaches that categorized that time period, such as the rise of the Ku Klux Klan. Black journalist Hollis Henry described the film as Song of a Never-Was South.

However, just as Disney cleaned up the works of other fairy tales from Grimm to Perrault to Andersen, so too have the folk tales of Harris been white-washed somewhat by the Disney version. The film overlooks the more rebellious and anarchist overtones of the original tales, where slaves are represented by the meeker creatures Brer Rabbit, Brer Possum, and Brer Tarrypin, while the ruling whites are represented by predators Brer Fox, Brer Bear, and Brer Wolf. Even Uncle Remus himself is much feistier in the Harris stories than in the Disney film.

On May 8, 2007, the Los Angeles Urban Policy Roundtable, which includes representatives from the Los Angeles Civil Rights Association, the NAACP National Board, and the Youth Advocacy Coalition, sent out a press release denouncing Disney's contemplation to ever re-release *Song of the South*.

Roy E. Disney, son of Roy O. Disney, stated:

> [*Song of the South*] is a wonderful film that deserves to be back out in the public. All it needs is context. Some of that animation is stunning, even by today's standards.

At the March 2010 Disney Shareholders' Meeting, once again faced with the question of re-releasing the film, Disney CEO Robert Iger stated that *Song of the South* was problematic and there was no benefit to the Disney Company to ever re-release it. He called the film "antiquated" and "fairly offensive".

The original negatives for the *Song of the South* are stored in a climate-controlled vault at the Library of Congress' audio-visual preservation facility in Culpeper, Virginia. In 2011, Disney began a program to preserve their entire library of volatile nitrate film negatives by making 4K digital scans of the films as well as making new black-and-white successive exposure negatives designed to preserve the films for another

hundred years. *Song of the South* was one of the films preserved, even though there were no plans for a re-release.

Dave Bossert, Disney's Creative Director and Artistic Supervisor of the Restoration and Preservation Team, stated:

> I can say there's been a lot of internal discussion about [*Song of the South*]. And at some point we're going to do something about it. I don't know when, but we will. We know we want people to see *Song of the South* because we realize it's a big piece of company history, and we want to do it the right way.

Bossert oversaw the restoration of such classic Disney films as *Fantasia, Bambi, Dumbo, Cinderella, Sleeping Beauty,* and *Lady and the Tramp.*

*Song of the South* now has its own Facebook page. There is also an on-line petition with tens of thousands of signatures asking for the re-release of the film.

From the Disney press book for theater exhibition in 1986:

> *Song of the South* is one of the best known and most widely applauded animated/live-action feature film achievements of all time. Its timeless appeal spans all audiences, from children to senior citizens, with enthusiastic responses coming from both individuals as well as entire communities. It is a rare entertainment treat, offering the enrichment of educational and cultural values in art and music that are heartily endorsed by the widest segment of the movie going public.

It is important to remember that *Song of the South* was never intended to be an accurate historical documentary of a troubled time in American history. It was meant to be light, fantasy entertainment, similar to other films produced during the 1940s. *Song of the South* was not a malicious attempt to reinforce the foolish stereotype of the inferiority of the black race, but rather an attempt to show that children of all races and different social statuses could play together as friends, learn important moral lessons from stories, and survive times of trouble by finding a place to laugh. It was strongly implied that, for anyone of any race or social status or age, the true "laughing place" was at home with friends and family.

The film was never intended to be a political statement, either. Just as Walt had adapted fairy tales from a variety of

European countries, he thought it was time to share some of the uniquely American folklore stories as well. Unfortunately, he found himself in exactly the same sticky situation as Brer Rabbit when he confronted the infamous Tar Baby, and the harder he struggled, the worse it got.

For those people living in the United States today, the Disney Company has created a situation where the only way to see and study this historic film is to support piracy of Disney intellectual property by buying or downloading an illegal copy, or to obtain a foreign release and convert it into a watchable format.

Many people feel there must be a better solution, but until the film can be viewed objectively without decades of emotional baggage, *Song of the South* will remain securely locked away deep in the Disney Vault, with only its imperfections remembered and none of its virtues.

# Part Two

# More Secrets of the Song of the South

*I'm just a worn-out ol' man what don't do nothin' but tell stories. But they ain't never done no harm to nobody. And if they don't do no good, how come they last so long? ... And just 'cause these here tales is 'bout critters like Brer Rabbit an' Brer Fox, that don't mean they ain't the same like can happen to folks! So them who can't learn from a tale about critters, just ain't got the ears tuned for listenin'.*

— Uncle Remus in Disney's *Song of the South*

No matter how detailed or lengthy an article is about a particular film, there is always more to the story.

Unfortunately, sometimes the additional information does not fit comfortably into the body of the article itself, because it would cause the story to go off on interesting tangents and distract readers from the main thesis.

This part of the book includes some of that supplemental information. Here is everything else you may have wanted to know about *Song of the South*.

# Film Credits

WALT DISNEY PRESENTS *SONG OF THE SOUTH*
WITH UNCLE REMUS AND HIS TALES OF BRER RABBIT
Photographed in Technicolor

## General Credits

| | |
|---|---|
| Production Number | 2029 |
| Running Time | 1 hour, 34 minutes, 23 seconds |
| Photography Director | Harve Foster (live action) |
| Cartoon Director | Wilfred Jackson (animation) |
| Screenplay (live action) | Dalton Reymond, Morton Grant, Maurice Rapf |
| Cartoon Story | William Peed (Bill Peet), Ralph Wright, George Stallings |
| Original Story | Dalton Reymond based on the *Tales of Uncle Remus* by Joel Chandler Harris |

## Cast Credits

| | |
|---|---|
| Uncle Remus | James Baskett |
| Johnny | Bobby Driscoll |
| Ginny | Luana Patten |
| Sally | Ruth Warwick |
| John | Eric Rolf |
| Grandmother (Miss Doshy) | Lucille Watson |
| Toby | Glenn Leedy |
| Aunt Tempy | Hattie McDaniel |
| Mrs. Favers | Mary Field |
| Jake Favers | George Nokes |
| Joe Favers | Gene Holland |
| Maid | Anita Brown |
| Brer Rabbit voice | Johnny Lee |
| Brer Fox voice | James Baskett |
| Brer Bear voice | Nick Stewart |

# Crew Credits

| | |
|---|---|
| Photographed by | Gregg Toland |
| Set Director | Perry Ferguson |
| Film Editor | William M. Morgan |
| Costume Designer | Mary Wills |
| Special Processes | Ub Iwerks |
| Sound Director | C.O. Slyfield |
| Sound Recorders | Fred Lau, Harold Steck |
| Art Treatment | Elmer Plummer |
| Technicolor Color Director | Natalie Kalmus |
| Associate | Mitchell Kovaleski |
| Music Director | Charles Walcott |
| Photoplay Score (live action) | Daniele Amfitheatrof |
| Cartoon Score | Paul J. Smith |
| Vocal Director | Ken Darby |
| Orchestration | Edward Plumb |
| Songs by | Ray Gilbert, Sam Coslow, Allie Wrubel, Arthur Johnston, Johnny Lange, Hy Heath, Eliot Daniel, Robert MacGimsey, Foster Carling |
| Song Titles | "Zip-A-Dee-Doo-Dah", "Song of the South", "Uncle Remus Said", "Ev'rybody Has a Laughing Place", "How Do You Do?", "Sooner or Later", "Who Wants to Live Like That?", "Let the Rain Pour Down", "All I Want" |
| Cartoon Art Direction | Kenneth Anderson, Charles Philippi, Harold Doughty, Hugh Hennesy, Philip Barber |
| Background & Color Stylists | Claude Coats, Mary Blair |
| Background Artists | Ralph Hulett, Brice Mack, Ray Huffine, Edgar Starr, Al Dempster |
| Animators | Don Lusk, Harvey Toombs, Tom Massey, Ken O'Brien, Murray McClellan, Al Coe, Jack Campbell, Hal Ambro, Hal King, Cliff Nordberg, Rudy Larriva |
| Effects Animators | Josh Meador, George Rowley, Blaine Gibson, Brad Case |
| Associate Producer | Perce Pearce |

# Story Summary

*Song of the South* begins with a young boy (Johnny) and his parents (Sally and John) going to visit his grandmother's (Miss Doshy) plantation in rural Georgia. There are vague references to some articles written by Johnny's father that may have created controversy back in Atlanta.

According to the program book for the original premiere:

> [T]he father, an aggressive Atlanta newspaper editor, is caught between domestic responsibility and political challenge. The boy and the mother are left at the plantation while the editor fights for his political life.

None of this is clearly shown in the finished film.

When the family gets to the plantation, Johnny's father leaves immediately to return to Atlanta to resolve his business there. Completely distraught, Johnny runs away to join him, but comes across Uncle Remus telling stories about Brer Rabbit.

Uncle Remus says that the boy's vow never to come back to the plantation reminds him of Brer Rabbit's own vow to leave his briar patch. This leads into the "Zip-A-Dee-Doo-Dah" song and the first animated sequence showing Brer Rabbit running away and being caught in Brer Fox's snare.

Brer Rabbit tricks Brer Bear into taking his place in the snare by saying the bear will make a dollar a minute as a scarecrow. Brer Rabbit escapes. Johnny changes his mind about running away after hearing the story. Remus takes the boy home, and since the family is unaware that Johnny had tried to run away, Remus is scolded for keeping the child out so late listening to stories.

The next morning, Johnny's mother appears and tells the boy to put on a suit because company is coming. The boy protests that he and Toby, a young black boy, are supposed to go frog hunting. The next scene finds Johnny in the suit, with its white britches and lace collar making him look like a prissy Little Lord Fauntleroy.

The two boys pass a broken-down shack, where poor white boys Jake and Joe Favers, who are brothers and about a year or two older than Johnny, are playing with a litter of puppies. Their sister, Ginny (about the age of Johnny and

Toby), is different from her brothers in her clean appearance and nice manners. The boys make fun of Johnny's suit, calling him a "little girl".

He runs off in tears, and Ginny follows. He gives her his lace collar that she had mentioned liking, and she gives him one of the puppies, a runt named Teensy that her brothers plan to drown. Knowing his mother wouldn't want him to have the puppy, Johnny convinces Remus to keep the dog for him.

The Favers brothers spot Uncle Remus with Johnny's puppy, and they demand that he give it back. Remus refuses. This confrontation prompts Remus to tell Johnny another animated tale about how Brer Fox caught Brer Rabbit with a Tar Baby, and then got tricked into throwing Brer Rabbit into the Briar Patch. Being born and bred in a prickly Briar Patch, the rabbit easily escapes.

When Johnny and Toby meet the Favers brothers on the road, Johnny uses the lesson from Remus' story to trick them into telling their own mother that Ginny gave Johnny the puppy. She beats the brothers and chases them out of the house.

While Remus is sampling Aunt Tempy's cooking in the kitchen, the Favers brothers show up and tell Johnny's mother about the dog. Miss Sally tells Remus to give back the dog and not to tell Johnny any more stories, since she feels they are causing problems for her son.

His mother tries to make it up to Johnny by throwing him a big birthday party, but when Johnny goes to pick up Ginny, her brothers knock her into the mud and get into a fight with Johnny. Remus breaks up the fight, and tells the final animated story of how Brer Fox was about to roast Brer Rabbit, who tricked both Brer Fox and Brer Bear into going to his "laughing place", where he escapes them again.

When Miss Sally finds out that Remus is continuing to tell Johnny stories, she tells him that he must keep away from Johnny entirely. Sad and dejected, Remus packs up his belongings and starts to leave the plantation. Johnny finds out and runs after him by taking a shortcut through a bull-pen, where he is gored by a bull.

While Johnny is lying nearly unconscious in bed, Remus

shows up and tells him that the real laughing place is home, surrounded by those you love and who love you. Johnny wakes up to discover that his father has returned and has promised to stay. The final scene shows Johnny, Ginny, and Toby, led by the little puppy, skipping through the woods singing "Zip-A-Dee-Doo-Dah" and enjoying the day with animated animals and a momentarily befuddled Uncle Remus.

# Short Biography of Joel Chandler Harris

On July 20, 1879, the *Atlanta Constitution* newspaper published a story written by their thirty-year-old copy editor, Joel Chandler Harris, entitled "Story of Mr. Rabbit and Mr. Fox as told by Uncle Remus". This first story was followed by many more popular installments in the series.

Within months, magazines across the country were reprinting these tales, and after more than a thousand written requests for a collection, the first Uncle Remus book was published in November, 1880, entitled *Uncle Remus: His Songs and Sayings*. The Remus books were primarily just simple collections of Harris' popular newspaper columns preserved in a more permanent format.

Originally, the editor of the *Atlanta Constitution* had asked Harris to carry on a column that featured the stories of a black character called Uncle Si. Harris didn't like the name or the way the column was handled, so he invented Uncle Remus, a composite of almost a dozen storytellers he had listened to as a young boy at the Southern plantation Turnwold. These storytellers included "Uncle" George Terrell, "Uncle" Bob Capers, Old Harbert, and Aunt Crissy, all of whom had told many tales of Brer Rabbit and his fellow critters. The stories had their roots in the trickster stories from West Africa as adapted for the black slaves in the United States.

Nine additional books on Uncle Remus and his stories followed, and in 1892, Harris wrote a fictionalized biography of his life on a plantation entitled *On the Plantation*.

During his life, Harris was second in popularity only to Mark Twain who, along with writers like Rudyard Kipling, wrote him to express their admiration and interest in the stories.

Harris authored a total of thirty books, and was lauded at the time for his use of dialect. Harris felt that the rhythm and sound of the dialect added to the telling of the stories and made them more accurate to the original source, even though it sometimes made them difficult to read.

"Humor is a great thing to live by, and other things being equal, it is a profitable thing to die by," Harris once said.

Even some of the black critics upset with Harris' treatment of slavery narratives are grateful that he captured these stories in print, as they were originally told, and not only preserved them for posterity but also brought them national exposure. Harris also supported education and voting rights for blacks, advocated racial justice, and condemned mob violence in a series of newspaper editorials he wrote during the peak of his fame.

An extremely shy man who stuttered, Harris died at age sixty in 1908, but Uncle Remus, the wise and kindly philosopher he created, lives on.

# Song of the South Dummies

The huge success of the Uncle Remus stories allowed Joel Chandler Harris and his family a comfortable life in Atlanta. Harris had transformed a modest farmhouse into an elegant, magnolia-flanked Southern mansion, christened the Wren's Nest after a family of songbirds was found nesting in the mailbox. Harris died in his bedroom there in 1908. In 1913, his widow dedicated the house as a museum to her late husband's legacy. The museum still operates today. And in 1946, the Disney dummies moved in.

As part of the promotion for the premiere of *Song of the South*, the Disney Studios donated two life-sized stuffed dummies, one resembling Uncle Remus and the other young Johnny, to be displayed in the parlor of the Wren's Nest. After many years on display, they were stored in the attic, where they were slowly nibbled by moths.

In fall 2007, the dummies were brought down and put in lawn chairs on the outdoor side porch where Harris himself used to relax. The odd figures, their hair matted with cobwebs, their faces frozen in a blank expression, and their clothes showing the signs of age, sit slumping with their arms hanging

limp at their sides. Reportedly, they have startled more than a few museum visitors.

The executive director of the Wren's Nest museum said:

> They're part of Wren's Nest's history — and I thought it would be a cool thing to show people.

Besides these stuffed figures on the porch and a few yellowing newspaper clippings displayed in the parlor about the premiere, there is no other reference to *Song of the South*, and docents who give a tour try to avoid the topic. Many visitors mistakenly believe that the story of *Song of the South* was written by Harris, whereas it was just the animated tales that were based loosely on his writings.

# The Brer Characters

Most history scholars feel that the Brer Rabbit stories can be traced back to African folk tales featuring a trickster character, often a hare. As slaves were brought to America, they adapted some of these traditional tales to their new situation.

Brer Rabbit came to be a substitute for the enslaved Africans by representing a small, seemingly weak creature who, through quickness and cleverness, was always able to overcome his many foes, who were physically much larger and more powerful yet dull-witted and easily tricked.

Rabbit and Hare myths featuring talking animals were also common in stories told by several Native American tribes, including the Creek and the Cherokee. These stories were similar to the ones featuring Brer Rabbit, and may even have predated the African adaptations. Surviving tales of Brer Rabbit and his friends seem to be a mixture of these Native American stories with the African stories, as well as the later adaptations to reflect plantation life on a new continent.

Brer Rabbit appears in about three-quarters of the original Remus stories. He is smaller than the other characters, and is purposely drawn smaller to attract the sympathy and affection of his audience, despite his lack of socially redeeming qualities.

Physically, he is composed of big feet and eyes and rounded shapes, even on his long pointed ears, that give him

an appealing, youthful appearance. Brer Rabbit's huge ego and cockiness get him into trouble, but fortunately, he is clever enough to get himself out of that trouble, so far.

The Disney version of Brer Rabbit made him a much more lovable trickster, unlike in the original stories, which often focused on his amoral characteristics and lack of restraint that made him as much a malevolent villain as a spunky hero.

Brer Fox actually is smarter than Brer Rabbit. In the film, he catches the rabbit twice, but it is his cruelty that is his undoing. The Disney animators even put the fox in sickly green clothing to hide the warm rust brown of his fur. His speech and his movements are very rapid, adding suspicion that the character is trying to hide something. Brer Fox outfoxes himself by trying to be too clever and cruel.

Brer Bear is slow but powerful. His eyes are smaller than the other two characters, while his size is imposingly large. He can focus on only one thing but is easily distracted. As Disney discovered with the character of Goofy, a slow-witted character does not think less but has to concentrate more before making the wrong decision.

In 1976, the Disneyland Character Training department produced a video "to acquaint you with the personality of the character" for Disney Cast Members who performed in costume as Brer Fox and Brer Bear at Disneyland and Walt Disney World.

One big warning in all the videos was for Cast Members to be careful of quick turns so that the tail did not unexpectedly hit a guest or merchandise. Originally, the characters of Brer Fox and Brer Bear most often wandered the New Orleans Square area of Disneyland.

Here is an excerpt from the narration that accompanied video demonstrations of how to "animate" in the costumes:

> The stories all follow the same pattern. Crafty, high strung, quick thinking Brer Fox devises a perfect plan to catch the rabbit but Brer Bear, his well-meaning but slow-witted partner bungles the job and Brer Rabbit gets away. Brer Fox goes a million miles a minute and is forever darting from place to place. Brer Bear on the other hand goes half-a-mile a minute, sniffing the flowers in his own carefree way. As long as the two are together, Brer Rabbit seems to be safe. Naturally, when one of his plans fails, Brer Fox blames his

partner. Although Brer Bear may be simple, his temper is short and the hysterical argument usually ends with Brer Bear bopping the fox on the head and knocking him silly. For all their foolishness, everybody loves these two inseparable comedians.

The characters were also described in the sixteen-page Disney program book created for the original 1946 Atlanta premiere:

Brer Rabbit, the naïve happy-go-lucky hero of the Tales — the protagonist of the human race actually — who stumbles into one kind of trouble after another, always managing through belated thought, courage and a bit of footwork to squeak through. Brer Fox, sly, scheming leader of the forces of evil who will stop at little or nothing — preferably nothing — to gain his sinister designs and whose one burning ambition is to "ketch that biggity rabbit." Brer Bear, the great bumbling side of Brer Fox, whose strength is as the strength of twenty but whose porridge-like brain is unequal to the task of becoming a true villain.

While others had also tried to capture the Brer Rabbit stories in print, it was Harris' work that popularized the characters and their tales to a large mainstream audience, including President Theodore Roosevelt, a huge fan.

# Song of the South Actors That Never Were

While some acting roles in the film are not credited, other actors were officially announced for the movie but never appeared in the final version. Paul Robeson and Rex Ingram had been approached about portraying Uncle Remus but did not accept. An August 24, 1944, *Los Angeles Sentinel* newspaper article reported that Ben Carter had turned down a role in the film, as had Mantan Moreland, Monte Hawley, Ernest Whiteman, and Tim Moore.

An October 4, 1944, *Los Angeles Times* news item stated that actor John Loder would be starring in the film, along with Janet Gaynor and Eddie "Rochester" Anderson (famed for his work with comedian Jack Benny).

On November 8, 1944, the *Hollywood Reporter* noted that "John Loder has been signed by Walt Disney to play Uncle

Remus in *The Three Caballeros*". The character of Uncle Remus does not appear in *The Three Caballeros*. It doesn't seem likely that Loder, a white British leading man best-known for his debonair roles, was seriously considered for the role of Remus. He may have been considered for the role of the father, with Gaynor as the mother and Anderson as a comical Remus.

A November 25, 1944, *Pittsburgh Courier* news item reported that Eddie "Rochester" Anderson would be unable to accept the part offered to him in the film due to "personal appearance commitments."

According to the January 6, 1946, issue of the *Daily Worker*, both Clarence Muse and rhythm-and-blues band leader "Tiny" Bradshaw turned down roles in the film because they felt the picture would be "detrimental to the cultural advancement of the Negro people". Bradshaw declared it would "set back my people many years".

According to the *Los Angeles Sentinel*, Helen Crozier was originally signed for the role of Chloe. The February 1945 edition of the *Sentinel* added the following actors to the cast: Phil Jones (as the Coachman), Walter Knox (as the Gardener), Daisy Bufford, Anna Marby, Theo Washington, and Virgil Sanchies. None of these actors appear in the final film.

The *Hollywood Citizen-News* claimed that Marylin Gwaltney and the B. C. Singers would be in the cast.

A March 1, 1945, *Los Angeles Times* news item reported that Mary Young had been cast in the role of "Aunt Margaret, a meanie, who is the *bête noir* of little Johnny", but no such character appears in the finished film.

A more recent source notes that the cast included Ernestine Jones, who supplied the voice of a butterfly, although this hasn't been confirmed.

# Disney's Uncle Remus Comic Strip

*Uncle Remus and His Tales of Brer Rabbit*, the Disney Sunday comic strip distributed by King Features Syndicate, began on October 14, 1945, and ended on December 31, 1972. King Features also distributed the other Disney comic strips to newspapers, including both the daily and Sunday versions of *Mickey Mouse* and *Donald Duck*.

For over twenty-seven years, every Sunday, it was possible to read in newspapers the full-color Disney interpretation of the famous Joel Chandler Harris characters. The strip started appearing in newspapers over a year before the film was released to build anticipation for the movie.

*Uncle Remus* was written by Bill Walsh, a multi-talented Disney staff member who joined the company in 1943 as a scripter for the *Mickey Mouse* comic strip after a career that included writing gags for the popular Edgar Bergen and Charlie McCarthy radio show. Walsh would later become a Disney Legend, thanks to his many credits as a writer and a producer that included the first Disney television shows as well as *Mary Poppins* (1964) and *The Love Bug* (1974).

The strip was drawn by Paul Murry, who had been an animator on *Song of the South* and a former assistant to the legendary artist Fred Moore. In addition, Murry had supplied animation for other features, including *Dumbo* and *Saludos Amigos*. Dick Moores and Bill Wright inked the strip over Murry's pencils.

At first, the material was a reasonably faithful adaptation of the animated sequences in the movie. Then, original adventures of Brer Rabbit, Brer Fox, Brer Bear, and their friends began to appear. Uncle Remus was only seen as a silhouette on the title panel, although he provided necessary narration through captions to help tell the story and reveal the moral that appeared in a box in the final panel.

Paul Murry left the Disney Studios during spring 1946, with his last *Uncle Remus* Sunday page appearing on July 14. Ironically, he traded doing comic strip work for doing comic book work, and his first new assignment was *Dell Four Color* #129, where he penciled three stories featuring Uncle Remus and friends. All of those stories were written by Chase Craig. Other Uncle Remus stories drawn by Murry followed in 1947, including some in *Walt Disney's Comics and Stories*, and also a Cheerios Premium comic.

Dick Moores took over as the artist when Murry left in 1946. In October 1946, George Stallings, who had worked on the story for the *Song of the South* feature film, took over the writing and introduced such characters as Molly Cottontail, who would become Brer Rabbit's girlfriend.

Like Murry, Moores also left the strip a decade later, in 1956, when he was hired by Frank King to assist on the *Gasoline Alley* comic strip dailies. In 1959, King retired and Moores assumed both writing and drawing duties for the daily strip. Moores continued doing the daily and the Sunday *Gasoline Alley* until his death in 1986.

The Sunday-only *Uncle Remus* strip ran a loose story continuity until February 1949, when it became a self-contained, gag-a-week strip. Others who worked on the strip over the years included Riley Thomson (1951-59), Bill Wright (1959-62), Chuck Fuson (1962), and finally artist John Ushler (with scripting by Jack Boyd), who worked on the strip for nearly ten years until it was discontinued on December 31, 1972.

The Disney Brer characters appeared in new comic book stories filling complete issues of *Dell Four Color* #129 (1946), #208 (1948), and #693 (1956), and they were also the stars of several small giveaway comics, including:

- *Walt Disney's Brer Rabbit in a Kite Tail* (1955), a Kite Fun Book published by Pacific Gas and Electric Company

- *Brer Rabbit's Sunken Treasure* (1951), Wheaties cereal premium D-4

- *Brer Rabbit Outwits Brer Fox* (1947), Cheerios cereal premium X-3, and *Brer Rabbit's Secret* (1947), Cheerios cereal premium Y-2

- *Brer Rabbit in Ice Cream for the Party* (1955), American Dairy Association

These books featured artwork by Carl Buettner, Jack Bradbury, Dick Moores, Tom McKimson, and Paul Murry.

# The Disney Uncle Remus Comic Strip That Never Was

Disney historian Paul Anderson interviewed Disney artist Mel Shaw and uncovered an unusual story about the Uncle Remus comic strip that never was produced. This version would have been influenced more by Harris' original stories than by Disney's *Song of the South*.

At the time of the Disney Strike in 1941, many Disney staff members found themselves without work as projects were postponed or canceled, and so they began to develop side projects of their own. Mel Shaw recalled one such side project:

> And at that time, I had started to work on *Uncle Remus,* which turned out to be *Song of the South* when they [the Disney Studios] opened up again. And while I was working on *Uncle Remus*, I started doing my sketches in a style similar to [Arthur Burdett] Frost if you remember his illustrations of the Uncle Remus [stories]. And George Stallings was working on the story with me, and we got the idea that you could do a comic strip in that style, with the Uncle Remus tales. Each one could be a separate tale.

Stallings later launched his own comedy sports newspaper strip, *Soapy Waters*, about a country bumpkin named Soapy Waters who made it to the major league as a baseball pitcher. He was a dim but good-hearted fellow, constantly in jeopardy of losing his job. *Soapy Waters* ran from February 7, 1955, through April 20, 1957, and was syndicated by Mirror Enterprises. Dick Moores did inking and lettering.

Shaw continued:

> So, being that the studio was closed down, I went to Roy [Disney] and I said, "Could I have the rights to this thing? You're not going to do anything with it right now," and Roy said, "Yeah, go ahead and do a comic strip on Uncle Remus if you want." And I said he would get 5% and would retain the rights. And he agreed to that.
>
> Anyway, George Stallings and I got the thing up. I drew the Uncle Remus things. We had a series, and we gave them to King Features and King Features in two weeks bought the whole series. Then the Studio ... because of the negotiations kind of thing, for every man we would take that didn't go on it, they had to take two of the strikers.
>
> And Roy got the idea. He said, "Mel, why don't you come back and work on the Uncle Remus thing and work in the cartoon department? Then I don't have to take two strikers back into the other part."
>
> And I said, "Well how about the strip that we just sold?" And he said, "Well, I can't go through with that." He said, "I can't go through with the deal. We don't give a percentage to anybody." And it really burned me. And about that time, Hugh Harman had lost his contract with Rudy [Ising]. Rudy

had gone into the army. So Hugh didn't have a partner. And Hugh didn't have any experience in doing features, so he asked me if I would be interested in being his partner, and he was going to do [an animated feature] *King Arthur*. So I agreed to that, and we started on the *King Arthur* thing [that never got made].

Shaw returned in 1974 to the Disney Studios as a concept artist. Stallings contributed writing to *Song of the South* and also to Disney's *Uncle Remus* newspaper strip.

## The Song of the South Song

The phrase "Song of the South" was not an inspirational invention of the Disney Studios. It was a term that had been used informally for decades before the Disney film. There really was a song called "Song of the South".

The 1924 song, with words and music by Sam Goold, Sid Caine, and Al Seigel, was extremely racist. Its lyrics have all the black stereotypes of that era. For example:

> And the fields as white as snow-flakes,
> where the darkies brown as pancakes,
> Gathered for old mammy's Sunday dinner,
> Seems they never did get thinner,
> from the possum and fried chickens,
> Then they used to raise the dickens,
> When they see old Joe a-comin',
> with his banjo set for strummin',
> Cake-walk, shuffle, buck and wingin',
> Tenderly they'd soon start singin' ...

There has never been any reference, allusion, or documentation that Walt Disney or any of his staff who worked on the film were aware of this song's existence. It is just an interesting example that the phrase pre-dated the Disney film.

## The Power of Words

The Brer Rabbit stories contain several words still in common usage then, but which may be obscure to modern readers.

Upon Brer Rabbit's first encounter on a country road with Brer Bear, Brer Rabbit calls him Brother Bear. In French, "brother" is "frère", and a Louisiana Cajun mixture, or

corruption, of those terms becomes "Brer", used as a title in direct address. All the animal characters in the film are "brotherly" to one another and address each other by that honorific.

In this book, the simplest form of the word is used: brer. However, over the decades, the Disney Company has also used br'er, b'rer, and other spelling variations.

In the Disney movie, there is a briar patch, a cotton patch, and even a possum-and-bull patch where [o]possums and bulls are raised. Terms like "pumpkin patch" and "cabbage patch" to describe an area of ground used for a particular purpose have survived into present day vocabulary usage.

The term "Tar Baby" may on the surface seem innocent enough, except that it became a racial epithet that many associate with the infamous N-word.

Into the 1920s and 1930s, the dark skin and dumb passivity of the Tar Baby was an image borrowed by racists as a pejorative term for black children and as an outright slur for black adults.

Today, even the colloquial use of the term to describe a sticky situation impossible to escape despite all efforts is considered implicitly racist. It is important to remember that the concept and name "Tar Baby" was not an original creation of writer Harris, but was merely repeated from the actual story told by different black storytellers whom Harris was recording.

By 1973, Disney storybooks no longer featured a jet black Tar Baby but a white "glue baby" instead. In the Disney theme park attraction Splash Mountain, the Imagineers tried to avoid the controversy entirely by having Brer Rabbit trapped in honey rather than by a tar or glue figure.

# Song of the South Book

A good deal of merchandise was released as tie-ins to the Disney film, including several children's books.

*Uncle Remus Stories* was the title of a Simon & Schuster Golden Book published in 1947. It featured a beautiful signed cover by Disney Legend Mary Blair and twenty-three Uncle Remus stories retold by Helen Marion Palmer, with illustrations by Disney animators Bill Justice and Al

Dempster based on tales developed for the final film and its possible sequels. Palmer was the first wife of Theodor "Dr. Seuss" Geisel and wrote several Disney books.

In the foreword to the original printing, Walt Disney wrote:

> Three generations of readers, young and old, have learned to love the laughter and the wisdom in the tales of Uncle Remus. The pranks of his Brer Rabbit have become a real part of American folklore, so much so that few of us are even aware of the original source from which they came. ... It is because of the universal appeal of these legends, and their place in the artistic heritage of this country, that the Disney studio has become interested in presenting them on the screen. During the preparation of material for the motion picture *Song of the South* a great quantity of the early Remus tales were studied and adapted by the Disney staff. Unfortunately, only a few of them could be included in the short space of one film. Yet we feel that all of them are entertaining and that all of them should be kept alive.

Those story titles were:

- "De Tar-Baby"
- "Brer Terrapin's Tug-of-War"
- "Brer Bear an De Bag Full of Turkeys"
- "Doctor Rabbit Cures De King"
- "Why De Cricket Fambly Lives in Chimbleys"
- "Brer Rabbit Rides De Fox"
- "Brer Fox an De Stolen Goobers"
- "How Craney-Crow Kept His Head"
- "Brer Fox, Brer Rabbit, an De Well"
- "Brer Rabbit's Money Machine"
- "Brer Rabbit an De Huckleberry Jam"
- "De Wuller-De-Wust"
- "De Moon in De Mill-Pond"
- "Brer Rabbit Goes A-Milkin'"
- "Brer Possum Plays Possum"
- "Brer Rabbit an De Gizzard-Eater"
- "De Whipme-Whopme Puddin'"

- "King Lion at De Water-Hole"
- "Judge Rabbit an Miss Grouse"
- "Brer Rabbit's Laffin' Place"
- "De Great Rabbit-Terrapin Race"
- "Brer Bear Ketches Mr. Bull-Frog"
- "Brer Rabbit Visits De Witch"

If the film had been successful, Walt planned to make several sequels using tales from *Uncle Remus Stories*.

# That's What Uncle Remus Said

The song "Uncle Remus Said" (words and music by Johnny Lange, Hy Heath, and Eliot Daniel) was used in *Song of the South* as a means to relate more Uncle Remus stories in a short amount of time, including how the leopard got his spots, the camel his humps, and the pig his curly tail.

An introduction and three other verses (why a fox is called sly, how the turtle won a race with a hare, and why the ostrich hides its head) were written but never used in the film, though they were used by other singers who performed the song.

The 1946 publicity book for the film states that the song was an homage to an American folk music tradition known as an "endless song", which:

> ... consists of a single, brief melody repeated as often as new lyrics come along. Each verse tells how animals got their characteristic shapes, natures, looks and habits.
>
> [Walt] Disney remembered the song form from his days in the first World War as an ambulance driver, listening to perpetual-tune songs of soldiers of all nationalities. Later he heard many occupational ballads in the same style, and discovered that the South was particularly rich in them.

# Splash Mountain

*Splash Mountain takes guests on a waterborne journey via a buoyant log through the backwoods, swamps, and bayous of the Old South as it was depicted in the Disney movie* Song of the South. *Showcased in fifteen scenes from the motion picture, whimsical music and the mischievous antics of 103*

*Audio-Animatronics figures provide a rich audio-visual
treat for guests as they experience thrilling lifts and drops in
a fast water ride.*
— From a Disneyland Press Release, 1989

*America Sings* was a carousel theater show in Disneyland's
Tomorrowland designed by Imagineer Marc Davis for the
American Bicentennial. It featured nearly one hundred Audio-
Animatronics animal characters taking guests on a journey
through America's musical heritage. It closed in April 1988.

Imagineer Tony Baxter was stuck in traffic on the Santa
Ana Freeway in southern California, thinking about the
America Sings attraction that was soon to close, and how
Dick Nunis (then Chairman of the Disney Theme Parks)
wanted a water flume ride for the park. In addition, the Bear
Country area of Disneyland needed an attraction to draw
more people to its remote location at the far end of the
Rivers of America.

Inspiration hit, and Baxter determined that just by adding
Brer Rabbit, Brer Fox, and Brer Bear to the existing America
Sings Audio-Animatronics figures, the Disney Company could
have a cost-effective water ride based on *Song of the South*.

It would be a smooth transition, since Marc Davis had
worked on the original film, and the animal characters he
had designed for the attraction were done in a similar style.

On a Saturday visit to Walt Disney Imagineering, then
CEO Michael Eisner brought along his teenage son Breck to
hear Imagineer Marty Sklar make a pitch for new attractions
for the Disney theme parks. Eisner's son loved the Splash
Mountain model so much that his father okayed the project
but insisted there be no reference to Uncle Remus, which
meant that the animated Brer Frog, the smoking and fishing
companion of Uncle Remus in the film, became the narrator.

Splash Mountain officially opened on July 17, 1989. The
attraction designer was John D. Stone, who worked with Bruce
Gordon (show producer who wrote the new lyrics for the songs
in the attraction) and Tony Baxter (executive producer).

In 1988, Stone explained the Splash Mountain storyline:

> Our moral, similar to that of *The Wizard of Oz*, is that if
> you're looking for adventure, the best place to find it is in
> your own back yard. The story in a nutshell involves Brer

Rabbit's Laughing Place. Brer Rabbit gets caught by Brer Fox and tossed in the Briar Patch — along with us — and finds out in the grand finale that the Briar Patch is where he was born and bred. We really selected the best elements of the film to tell the story in our attraction.

Tony, Bruce Gordon and myself literally spent three days in Tony's office preparing about thirty storyboards and outlining the entire project. The ride was originally called Zip A Dee River Run, and then it was called The Song of the South Log Flume Ride. It was Eisner who said, "It's a mountain and there is a big splash at the end. It's Splash Mountain."

The watery drop into the Briar Patch at Disneyland is roughly over fifty feet. Top speed is forty miles per hour. A separate model was made for each of the fifteen scenes in Splash Mountain. Nine of those scenes feature Audio-Animatronics characters: the Old Mill, the Bog, the Swimming Hole, the Rabbit Hutch, the Hollows, the Laughing Place, the Burrows, Brer Fox's Lair, and the Showboat Finale. The Zip-A-Dee Lady Showboat was then the largest animated prop ever constructed (50 feet wide, 30 feet high at Disneyland, and 36 feet wide, 22 feet high at Walt Disney World).

Nick Stewart was over seventy years old when Disney asked him to voice Brer Bear in the attraction, just as he had done in the film. The voice (and singing) of Brer Rabbit and some other animals on Splash Mountain was supplied by Jess Harnell.

Splash Mountain was so popular that another one was built at the Magic Kingdom in Walt Disney World that officially opened on October 2, 1992.

# Saturday Night Live Parody

To poke fun at the controversy surrounding Disney's *Song of the South*, the long-running, popular NBC sketch comedy show *Saturday Night Live* aired an original cartoon on its April 15, 2006, episode.

*Saturday TV Funhouse* is the title of a recurring, short, animated segment created by longtime SNL writer Robert Smigel that satirizes public figures and corporations. Disney had sometimes been a target of this satire.

The April episode was designed to resemble a typical

Disney commercial that invited two children to take a journey into the Disney Vault, where Disney's animated features are stored when they are removed from general release to the public.

Once inside the Vault, the children discover other things that Disney wants kept secret. One of them picks up a video:

> *Boy:* "I've never heard of this one ... *Song of the South*?"
>
> *Mickey Mouse:* "Ohh, nobody wants to see that one anymore!"
>
> *Girl:* "How bad could it be?"
>
> *Mickey Mouse:* "It's the very original version that he [Disney] only played at parties."

An actual clip from the film of Uncle Remus walking through an animated background is shown, but with a newly dubbed soundtrack of lyrics to the famous song:

> *Uncle Remus:* "Zip-A-Dee-Doo-Dah, Zip-A-Dee-Ay ... Negroes are inferior in every way; whites are much cleaner, that's what I say; Zip-A-Dee-Doo-Dah, Zip-A-Dee-Ay."

The episode satirized the belief that the film is hidden deep in the Vault because of its racism, and it was made in response to the March 10, 2006, Disney Shareholder Meeting held a month earlier. At the meeting, Disney Company President and CEO Bob Iger stated that the film was not released on its 60th anniversary that year because he had concluded that its:

> ... depictions ... would be bothersome to a lot of people. ... Even considering the context [in which] it was made, I had some concerns about it.

# Part Three

## The Other Forbidden Stories: Sex, Walt, and Flubbed Films

*These so-called critics that we have. Sometimes they're*
*odd creatures. I can't figure out what they want. And I,*
*for one thing, just never cared, you see? As I told you once*
*before, I said, "To hell with them," you know? ... The*
*critics never understood us.*
— Walt Disney, 1956 interview with writer Pete Martin

The Disney Company has always been held to higher standards than its competition. That's not surprising. The amazing Walt Disney succeeded in evolving a small mom-and-pop independent studio into a worldwide entertainment empire built on almost impossibly high standards of quality.

At a National Fantasy Fan Club convention in 2004, Walt's nephew Roy E. Disney said:

> [Disney] stands for quality. It stands for family. It stands for getting your money's worth. It stands for a lot of innovation and a lot of new and creative ideas that make things fun every time you visit a Park or go to a film.

There is a Japanese proverb that translates as "the nail that sticks up gets hammered down." Basically, it means that if something stands out above the others, it will be a target for greater attention and criticism.

While Walt Disney always insisted he was making entertainment for the entire family, critics often pigeonholed his output as being primarily for children, resulting in even tighter scrutiny on the work he produced.

The iconic Mickey Mouse was so instantly popular that within two years of his debut, the mischievous character had become a target of severe censorship. The February 16, 1931, edition of *Time* magazine ran an essay about what it described as Walt's "regulated rodent":

> Motion Picture Producers & Distributors of America last week announced that, because of complaints of many censor boards, the famed udder of the cow in the Mickey Mouse cartoons was now banned. Cows in Mickey Mouse or other cartoon pictures in the future will have small or invisible udders quite unlike the gargantuan organ whose antics of late have shocked some and convulsed other of Mickey Mouse's patrons.
>
> In a recent picture the udder, besides flying violently to left and right or stretching far out behind when the cow

was in motion, heaved with its panting when the cow stood still; it also stretched, when seized, in an exaggerated way.

Already censors have dealt sternly with Mickey Mouse. He and his associates do not drink, smoke or caper suggestively. Once, a Mickey Mouse cartoon was barred in Ohio because the cow read Elinor Glyn's *Three Weeks*. German censors ruled out another picture because "The wearing of German military helmets by an army of cats which oppose an army of mice is offensive to national dignity."

Elinor Glyn's scandalous book *Three Weeks*, while not sexually explicit, did recount a romantic fantasy of a short-lived but intense extra-marital affair between an incognito European queen who seduces a younger British aristocrat. It created tremendous controversy when first published in 1907. It was still an international bestseller over two decades later, when in the cartoon short *The Shindig* (1930), an enthralled and naked Clarabelle Cow decides to read the book in her bed before she goes to the big barn dance. Clarabelle puts on a polka dot skirt to cover her huge udder for the party.

The July 21, 1930, issue of *Time* magazine had more coverage on the German ban of Mickey's cartoon *The Barnyard Battle* (1929) that would later lead to Adolf Hitler banning all Mickey Mouse cartoons from German cinemas.

The Disney Company has always been aggressive to preserve its hard-won image of wholesomeness, even if it meant retroactive censorship by editing its own cartoon library.

By the 1980s, classic Disney cartoons were being severely edited or actually removed from distribution if they were considered potentially inappropriate by modern standards, such as featuring exaggerated ethnic caricatures; brief, standard "blackface" gags; or World War II propaganda references.

Those cartoons included "Hell's Bells", "Trader Mickey", "Cannibal Capers", "Mickey In Arabia", "Mickey's Man Friday", "Mickey's Mellerdrama", "Spare the Rod" (sometimes run with the last three-and-one-half minutes of the tiny cannibals missing), "Education For Death", "Reason And Emotion", "Der Fuerher's Face" (winner of an Academy Award for best cartoon short), "Commando Duck", and others.

As the years progressed and the world changed, more and

more things in Disney cartoons were considered unsuitable by the Disney Company.

Originally released in 1948 as part of a compilation feature entitled *Melody Time*, the short "Pecos Bill" recounted the tall tale of the extraordinary cowboy. In 2000, for the DVD release of the film, the entire scene with Bill, who rolled a cigarette and lit it with a lightning bolt (the action mimicking the lyrics of the song), was cut, and all other shots of the offending cigarette hanging from his lips were digitally removed.

In 2000, for the release of the compilation feature *Make Mine Music* (1946), an entire cartoon was removed. "The Martins and the Coys" was a musical short that told in typical exaggerated cartoon drawings the famous country feud between two families (based on the Hatfields and the McCoys). It was quietly deleted without fanfare by the Disney Company because of its excessive graphic gunplay deemed not suitable for children.

As it did with those cartoon shorts, the Disney Company wants to erase the stories you're about to read in this book from its rich history to avoid potential contamination of the current Disney Brand. The stories have been loosely grouped into three categories: stories with sexual aspects; secrets about Walt; and finally, troubled Disney films.

At worst, some of the stories may spark discussion about "questionable judgment", but they need to be viewed in the context of the time period when they took place.

These stories would not be considered unusual or shocking if they were connected with any company other than Disney. However, since the Disney Company is held to different standards, these stories are censored from official Disney publications.

That's probably one of the reasons you purchased this book.

# Whatever Happened to Little Black Sunflower?

*The story of how Disney eliminated a little black character from the Disney animated classic film* Fantasia.

In 1990, the Disney animated classic feature film *Fantasia* (1940) was selected for preservation in the United States National Film Registry by the Library of Congress as being "culturally, historically, or aesthetically significant". The National Film Registry is operated by the United States National Film Preservation Board, which must abide by the rules of the National Film Preservation Act of 1988 (Public Law 100-446).

One of these rules "prohibits any person from knowingly distributing or exhibiting to the public a film that has been materially altered ... and is included in the Registry, unless such films are labeled disclosing specified information".

In the 1930s, when *Fantasia* was being made, the language of American animation was primarily extreme caricature and exaggeration for humorous effect. To accomplish this goal, the major animation studios often used the ethnic stereotypes that were common in other entertainment media, from radio and film to comic strips and the legitimate stage.

Scant comfort that the Disney Studios was the most minor offender in this regard because its cartoons were generally more popular than competitors' cartoons, and so were seen — and seen more often — by a wider audience.

Times change, and things that were once typical, like smoking cigarettes or making fun of women drivers, have now become unacceptable. The Disney Company has

attempted to remove these politically incorrect elements from its films, with varying degrees of subtlety and success.

However, since 1969, the Disney Company has released *Fantasia* in various formats without acknowledging a significant alteration: the removal of a little black centaurette named Sunflower. Before the internet, Disney Studios representatives even suggested that the character never existed, and that audiences were "misremembering" seeing her in the first place.

Sunflower appeared in *The Pastoral Symphony* segment of *Fantasia*. This segment takes place in the serene shadow of Mount Olympus, and presents a story accompanied by Ludwig Van Beethoven's *Sixth Symphony*.

The official Disney production draft of the film, dated September 11, 1940, lists Ham Luske and Ford Beebe as its directors (although it is believed that Jim Handley also did some directing on this segment), with Erwin Verity as assistant director for the centaurette segments. Story development for the sequence was credited to Otto Englander, Webb Smith, Erdman Penner, Joseph Sabo, Bill Peet, and George Stallings.

In the Disney version, famous Grecian creatures like pegasi (the plural of pegasus), satyrs, centaurs, and cupids leap from the dusty pages of mythology books to flirt with the opposite sex, indulge in freshly made wine, and dance and play in the "candy box colored" Elysian Fields, until prankish Zeus puts an end to the party.

The Disney artists were challenged with creating these mythological creatures and having them move in a realistic fashion. For centuries, male centaurs — half man, half horse — typically had been illustrated as muscular stallions with chiseled Mediterranean faces and torsos.

To properly tell the tale, the Disney artists also needed to create never-before-portrayed, delicate female versions that they dubbed "centaurettes", the first time that term was ever used. Disney Legend and supervising animator Fred Moore, famed for his drawings of appealing women, was assigned the task of creating concept sketches that brought femininity to characters who might have appeared grotesque in less skillful hands, since they were, after all, half horse.

These young, alluring, breast-baring creatures resembled the typical high-school teenagers of the 1930s, both in terms of attitude and physical appearance.

Who was the little black centaurette known as Sunflower?

She is called Sunflower because, in the scene where she is braiding flowers into a centaurette's tail, she wears a huge sunflower on the side of her head. Sunflower is a subservient character, like the cupids, whose primary purpose is to care for the other centaurettes. In her design, she is not part human and part stately mare, but rather part human and part donkey, and significantly smaller and younger than the other centaurettes.

Sunflower does not frolic with the herd during the courtship rituals. Instead, she happily spends her time with the little satyrs, who are also in a subordinate role (as preparers of wine). Unlike the other centaurettes, Sunflower never pairs up with a partner, since there is no appropriate match among the centaurs, who are all big, attractive, and older, and who yearn for a similar match among the centaurettes.

Sunflower is a stereotypical caricature of an African-American female child of the time, as evidenced by her distinctive hairstyle in which parts of her hair are separated by bands of cloth into multiple stubby, spike-like bunches of equivalent size. For many, this hairstyle evokes that of the young girl Topsy, a character in the controversial novel *Uncle Tom's Cabin,* and it was often used as a stereotypical visual in live-action and animated films to define a black female child.

It was never Walt Disney's intent to defame African Americans or any other ethnic group. (In fact, during the 1950s, when Walt ran the Studio, he brought in the multi-talented, African American Floyd Norman as an animator and later made him a storyman, something that didn't happen at other animation studios.) At the time, these stereotypes were not considered racist, but merely a part of the tradition of ethnic humor and cartoon caricature that had been common for decades.

That didn't make the use of these physical exaggerations harmless and correct, but at the time, it was an acceptable and widely used practice by which to quickly identify someone, especially for the purposes of humor.

Animation historian John Culhane, who wrote a book about *Fantasia*, said:

> Walt's artistic purpose was to take Beethoven's piece, put a visualization to it, and have people feel happy when that harmony was completed. If someone feels demeaned or insulted, that's going against what Disney wanted when he did it.

In 1969, with the rise of the Civil Rights movement in the United States, the *Fantasia* segments with Sunflower were cut, including the music that accompanied those segments, which created short blips in the soundtrack.

For *Fantasia's* 60th Anniversary DVD release in 2000, Disney's manager of film restoration, Scott MacQueen, supervised a restoration of the original 125-minute roadshow version of the film so that Disney could officially announce it as the original and uncut version.

How could Disney make that claim with Sunflower missing?

This feat of trickery was accomplished by clever panning and digital zooming on certain frames to avoid showing Sunflower. For example, in the scene where Sunflower polishes the hooves of a preening centaurette, the camera was re-focused on the vain centaurette and not on Sunflower.

So, almost every frame of the original version existed in the release, but not everything from those original frames was seen. At the time, John Carnochan, who was responsible for the editing, stated, "It's sort of appalling to me that these stereotypes were ever put in."

Carnochan reframed four shots and replaced others that were beyond redemption by repeating some frames, trying to make "the unavoidable music edits as unobtrusive as possible". However, these enlarged images are obviously not as sharp and clear as the surrounding scenes.

Sunflower is a pantomime character, like all the other characters in *The Pastoral Symphony*, but has a highly expressive face that clearly reveals her feelings. She spends mere seconds on the screen. The elimination of these sequences does not significantly affect the tone or the narrative of the story. They are little "character bits" that, like condiments, add to the overall flavor, but are not necessary for the enjoyment of the meal.

Which scenes were readjusted?

First, at the beginning, as the centaurettes languidly primp with the help of the flying cupids, one has her hair combed while another has her tail braided. The very next shot introduces Sunflower on the left side of the screen holding the hoof of a pretty white-haired beauty.

Sunflower blows on the hoof and polishes it with a white cattail plant (often found growing near bodies of water) in an action reminiscent of the African-American shoeshine boys of that era. At the same time, the aloof centaurette buffs her fingernails with a similar cattail.

Officially, this is listed as Scene No. 19. The description of the action on the production draft is "Medium Close Up — Negro Centaurette is manicuring her hoofs. She is polishing her nails." The animators were Bill Justice and Milt Neil.

Justice is perhaps best-known for his animation on the characters of Chip 'n' Dale, but he had a rich history with the Disney Company, from animating on feature films to programming Audio-Animatronics at the theme parks to designing the first true Disney costume characters for Disneyland. That brief description is just the tip of the iceberg of his many accomplishments.

Neil joined Disney around 1935 and left around 1945. He worked not only on *Fantasia* but also on *Snow White and the Seven Dwarfs, Pinocchio, The Reluctant Dragon, Dumbo, Bambi,* and *Saludos Amigos.* After leaving Disney, Neil moved to the East Coast and had his own commercial animation and advertising business, where he designed the characters on the Pea Soup Andersen's billboards.

Second, after the centaurettes find appropriate head gear, with help from the cupids, the scene with the centaurette using doves in her hair cuts to Sunflower diligently putting a dozen or more pinkish-purple flowers into the yellow tail of a centaurette.

Sunflower is disconcerted when the centaurette cannot hold still and swishes her finely combed tail as she rushes to catch a glimpse of the approaching centaurs. All the carefully placed flowers fly into the air, and Sunflower places her hands on her hips and looks with disapproval as they float to the ground.

Officially, this is Scene No. 37. The description of the action on the draft is "Sunflower (Black Centaurette) pins flowers in the tail of 'Judy' — Judy swishes her tail scattering the flowers. Sunflower annoyed." The animators for this sequence were Milt Neil and Joshua Meador.

Meador worked at Disney from 1936 until 1965. He was especially known for his work in special effects, including the water effects in *Cinderella* and *Bambi*, and the fire and bubbling mud scenes in *The Rite of Spring* segment of *Fantasia*. He was loaned out to animate "the monster from the Id" in the classic sci-fi film *Forbidden Planet* (1956). His real passion, however, was painting, and he was known for his striking landscapes.

Wait a minute! The centaurette in that scene had a name? She was "Judy"? That name doesn't exist on any of the model sheets! To help the animators distinguish between the centaurettes, the official draft of the scenes names each of those characters. The centaurettes gazing out through the vines are identified (in order) as Sandra, Hilda, Melinda, Judy, and Cabina. Even though Melinda is listed, she does not seem to appear in the scene as finally animated.

Melinda is the centaurette with the pale blue body and yellow hair in pigtails — the only centaurette who doesn't "hook up" until the cupids help her do so with the buff centaur Brudus, whose name indicates that he "broods" over his lack of a girlfriend.

(By the way, the supervising animator on the centaurettes was the legendary Fred Moore, and one of Moore's daughters was named Melinda.)

Undeterred, Sunflower follows the centaurette Judy to the grove, where the other centaurettes are peering through the vines. Once again, on the left side of the scene, Sunflower attempts to add decorative flowers to Judy's tail. The scene calls to mind similar movie scenes, such as the African-American female servants in *Gone with the Wind* assisting headstrong young Southern belles to prepare for a dance or a picnic in order to attract the attention of young men.

Officially, this is still considered part of Scene No. 37. Description of the action is "Medium shot — Three Centaurettes looking through foliage on screen right. Judy is

still being decorated by Sunflower." The animators were Bill Justice and Paul B. Kossoff.

Kossoff was perhaps best-known for some of his effects animation at Disney in the early 1940s. It was Kossoff who did the silhouetted animation of the Casey Jr. circus train in the opening of *Dumbo*. Besides *Fantasia,* he also did some animation for *Bambi.*

Third, after the centaurettes parade down the stair-like grassy levels to display their attributes for the eager young centaurs, the scene cuts to a pink-haired centaurette with a garland of flowers around her waist walking back and forth. A little black centaurette prances proudly along behind her, holding the other end of the garland high in the air as if it were the train of an elaborately long dress.

This black centaurette is not Sunflower. In the official draft, it states that "Atika (colored centaurette) holds Hilda's train". The term "colored" was once a synonym for "black".

Except for a different hairstyle, Atika looks exactly like little Sunflower, and so many viewers assumed it was the same character. Instead of the offensively labeled "pickaninny hairstyle" of Sunflower, Atika's hair is in two pigtails. Just like Sunflower, Atika has been removed optically from the scene.

Finally, Sunflower unrolls the red carpet up the steps to the makeshift barrel throne of Bacchus. The playful satyrs and Jacchus, the donkey unicorn, follow behind her, and desperately try to guide the unsteady and boisterous Bacchus up to his seat.

Sunflower stands behind the seat to steady it and tries unsuccessfully to help as Bacchus loses his balance and tumbles forward, causing an upset Sunflower to run around in circles with fearful despair, her hands on the sides of her head. Once again, it is Neil and Kossoff animating the character.

On the currently available Blu-ray version, the red carpet magically rolls itself up to the barrel throne and all evidence of Sunflower has been erased from the scene with Disney cine-magic.

Sunflower then disappears from the rest of the story. There is no shot of her running around in the fields enjoying the party or hiding from the mighty storm or cautiously peering out once things have calmed down.

Sunflower is one-of-a-kind in this blissful world — except for Atika, who appeared only briefly in one short scene. However, two other ethnic characters remain in the film.

When Bacchus first appears, he is accompanied on either side by two stately Nubian zebra centaurettes, one with a large blue feather fan and the other with a blue jug of wine on her shoulder. Their brown torsos, ethnic facial features, and decorative gold rings in their piled high hair define them instantly as different from the rest of the centaurettes.

They only appear for a few seconds during this entrance, and then disappear for the rest of the film, never partaking in the festivities. Unlike Sunflower and Atika, they are obviously adults, and despite their subservient functions, they have a stately dignity and intelligence.

The episode of the weekly Disney television series *Magic and Music* (first shown in March 1958) showed *The Pastoral Symphony* segment intact, including scenes with Sunflower. A repeat broadcast in 1963 was edited to remove Sunflower, and that is the version that has been re-run ever since on television.

This editing was done while Walt was still alive and in charge of approving everything that happened at the Studio, and so he had no objections. Retroactive editing of this type was not unusual. Previously, Walt had gone to additional expense to re-animate a scene in the award-winning short *Three Little Pigs* (1933) to remove an offensive, stereo-typically Jewish peddler and replacing him with a Fuller Brush salesman.

Walt was aware of the Sunflower character, and suggested in an early 1938 story meeting about the segment to have Sunflower eating and be taken by surprise as the shadow of a huge flying Pegasus passes overhead, causing her to run away. He felt it might generate some much-needed audience laughter at that point in the story. The gag never made it to the final draft.

Although the Disney Company has been aggressive in removing any video of Sunflower found on fan sites or else-where online, a persistent Disney fan can find several locations where these scenes can be viewed complete and uncensored.

Sunflower was a product of her time. and there was no

intent on Disney's part to demean anyone. She was charming and amusing if inconsequential. However, without the historical context, Sunflower easily could be misinterpreted as a negative commentary on black people and their supposedly inferior role, even in the fantasy world of animation.

# Disney's Story of Menstruation

*The story of how Disney made an animated
sex education film that became a legend.*

For years, a Disney urban myth was that the Disney
Company had produced an animated cartoon of Minnie
Mouse instructing young women about that "special time"
when they first experience menstruation. Some people
claimed to have seen the film and remembered colorful and
often inappropriate images.

Like some other Disney urban myths, this one did have a
basis in reality. However, neither Minnie Mouse nor any other
familiar Disney animated characters were involved.

During World War II, the Disney Studios produced many
health-oriented films for the U.S. Coordinator of Inter-
American Affairs (CIAA), including *The Unseen Enemy* about the
problems of using untreated waste water, and *The Winged
Scourge*, with the Seven Dwarfs battling the Malaria Mosquito.

By 1945, the CIAA was doing eight thousand showings
each month of such Disney-produced films as *Hookworm*,
*Cleanliness Brings Health*, and *How Disease Travels,* and drawing
an audience of almost four million people.

At the time, Carl Nater was the production coordinator of
military educational films at the Disney Studios, which
produced dozens and dozens of these films, covering
everything from how to operate an anti-tank gun to health
issues like nutrition and sanitation.

This experience led the Disney Studios to produce com-
mercial films after the war for a variety of companies to help

generate badly needed income. These titles included *The ABC of Hand Tools* (General Motors 1946), *Bathing Time for Baby* (Johnson & Johnson 1946), *The Dawn of Better Living* (Westinghouse Electric 1946), *How to Catch a Cold* (Kleenex 1951), and of course, *The Story of Menstruation* (International Cello-Cotton Company 1946, the forerunner of Kimberly-Clark, maker of Kotex products).

Reportedly, some of those productions were shown in movie theaters as entertainment before the feature presentations, thanks to the inclusion of Disney animation.

Walt realized that his studio needed to diversify in order to survive, so in the mid- to late-1940s, he began to expand into live-action films as well as animated informational films utilizing the skills that the Studio had learned working for the military during the war.

It was Walt's intention that the informational commercial films he created for outside companies strike a balance between education and entertainment.

"We'll make educational films but they will be sugar-coated. We can't bore the public with these things. We can't be boring. We've got to be entertaining," Walt told Ben Sharpsteen, a film director and producer at the Disney Studios who was interviewed about the subject in 1968 by writer Richard Hubler.

The term "edutainment" was coined by the Disney Company in 1948 to combine the words "education" and "entertainment" to express Walt's philosophy. Walt's experience with the military training films was that humor and animation helped audiences learn and retain information.

Sex education films were first shown in schools in the 1940s and 1950s to teach children in a clinical manner about sex and relationship issues like dating. From today's perspective, these short movies often seem quaint and humorous, but they served a necessary function, since they were often the only somewhat reliable source of information on these subjects for America's youth.

The films were a substitute for parents embarrassingly uncomfortable and sometimes lacking in the knowledge for honest conversations with their children about these subjects. Even today, studies have shown how rarely this

type of information is communicated directly from parents to their children.

Often a school nurse or a coach would awkwardly try to answer tentative and confused questions from young audiences after the movie ended and the clicking of the film through the projector and the flicker of its bulb had finally ceased.

Unlike the films shown to young soldiers to frighten and discourage them from sexual encounters in foreign countries that might result in venereal diseases, the films made for American schools were an attempt to offer reassurance that it was all perfectly normal as long as hormones never overcame good judgment.

The actual sexual act was vaguely referenced, if at all; instead, the films concentrated solely on the physical changes happening in young people's bodies in a boring health education approach complete with simplified diagrams. The message was that entering adulthood brought physical growth that might seem odd or unpleasant, but one day it would all make sense.

Not all parents and schools agreed that this type of instruction should be taught. In spring 1948, an early sex education film attempting to explain puberty and reproduction entitled *Human Growth* was banned from schools in various parts of the United States. Health educators, however, argued that it was better for children to get this sort of information in an accurate fashion from a carefully scripted, medically approved film than let them pick up misinformation (such as "kissing causes pregnancy") from their friends and acquaintances.

Unfortunately, there was still plenty of misleading information in some of the approved films, but for the most part, the basics were correct.

Soon, different versions of the same film were made for boys and for girls to deal with gender-specific pubescent changes. Girls and their mothers might be brought into an auditorium or a gym to view "their" film while the boys played sports outside. Boys would then get their showing of a film geared just for them, usually in a gym setting so that it all seemed a more manly experience.

"Traditionally," said Rick Prelinger, an archivist who has collected sex education films over the years, "the boys' films speak of pleasure and the girls' films speak of puberty as a set of conditions to be endured."

Disney's *The Story of Menstruation* was an opportunity for the Studio to prove that it could deliver commercial advertising in an educational manner for other companies. If the film proved to be a success, then a new, previously untapped source of revenue could be generated.

Animation, rather than live action, was chosen as the medium because it could be more impersonal and objective as well as make the presentation of the information timeless.

Work began on *The Story of Menstruation* in 1945, with the Disney Studios producing seventy-six storyboards that were shown to high school test audiences. Teachers objected to the image of a smiling embryo, and students didn't care for a scoreboard that compared the menstrual cycle to the change in seasons. The idea of using Disney characters was quickly discarded because, according to research done by the client, "no girl will identify herself with Disney cartoon characters". The image of a box of Kotex at the beginning of the film created a feeling of apprehension, so it was moved to the end credits.

The final script was approved in June 1945. On July 25, 1945, actress Gloria Blondell, younger sister of well-known actress Joan Blondell, was brought in to record the narration.

The probable reason that the nearly thirty-year-old Gloria Blondell was chosen to do the role, besides her velvety voice, was that she had been brought in a few months earlier to supply the voice of Daisy Duck for two Donald Duck cartoon shorts, *Donald's Crime* (June 1945) and *Cured Duck* (October 1945). She was the "normal", non-ducky-sounding voice of Daisy for six of the character's nine speaking appearances in the classic 1940s shorts.

Blondell's most famous role may have been Honeybee Gillis in the popular 1950s television sitcom *The Life of Riley*. She was married briefly to film producer Albert Broccoli, best-known for the James Bond films, but she divorced him in 1945, the same year as this commercial short was being produced.

*The Story of Menstruation* was originally delivered to the

International Cello-Cotton Company on October 18, 1946. The film runs approximately ten minutes. It has been estimated that the film has been seen by over one hundred million American women over the years. Neither sexuality nor reproduction is mentioned in the script, and an emphasis on sanitation makes the physical event seem more like a hygienic crisis than a maturational milestone.

Schoolgirls in the 1950s were often shown "educational" films like *Figure Forum* and *Facts About Your Figure* (made by the Warner Brassiere Company), which helped create "needs" for such things as foundation support, cosmetics, and a variety of "sanitary" products in girls as young as eleven years old.

*The Story of Menstruation* avoids recommending specific sanitary products so that it does not seem like a commercial for the company. Only a brief glimpse of a box of Kotex at the end of the film is shown. However, the accompanying free booklet cheerfully featured illustrations of the fine products available from the caring folks at International Cello-Cotton Company that would help prevent social embarrassment.

Oddly, the booklet discouraged the use of tampons because that market was dominated by rival company Procter and Gamble with their Tampax brand. The booklet suggested that any young girl thinking about using tampons should first contact a doctor for his opinion.

Gynecologist Mason Hohl was hired as a consultant to ensure that the film was scientifically accurate (although the blood flow is depicted as white rather than red to avoid a potentially disgusting image). It was hoped that Hohl's participation and credentials would validate the information and encourage the film to be shown.

But in a memo, producers worried that:

> ... adverse criticism from the medical profession could wreck the entire undertaking. The subject was most delicate, but careful planning produced a good P.R. film.

Reportedly, Hohl's involvement led to a stronger emphasis on the biological aspects of the subject matter.

*The Story of Menstruation* opens with soft, soothing music and with white flowers floating into an open window to reveal a yawning baby in its bassinet, with toys scattered on the floor.

The blue title cards proclaim: "Presenting the Story of Menstruation. A Walt Disney Production Through the Courtesy of Kotex Products."

An older, somewhat sophisticated but still motherly, unseen narrator (the voice of Gloria Blondell) intones in an almost confidential whisper:

> Why is nature always called Mother Nature? Perhaps it is because like any mother she quietly manages so much of our living without us ever realizing a woman is at work. ... Mother Nature controls many of our routine bodily processes through automatic control centers called glands. *The Story of Menstruation* begins with one particular gland: the pituitary gland. ... As the girl grows up from blocks to dolls to books that means her body is obeying the orders issued by the pituitary gland.

This narration is accompanied by some limited animation of young girls of different ages designed in a style similar to the famous "Fred Moore" girls of previous Disney cartoons.

Animator Moore was renowned for his ability to draw appealing young girls for several Disney cartoons from this time period, including the bobby soxers from the "All the Cats Join In" segment of *Make Mine Music* (1946). During the film, these traditional designs are replaced with another style reminiscent of advertising cartoons from the 1950s. The girls have large heads and smaller, simplified bodies with little detail, and are a bit more angular in design. This style was quicker to animate.

Disney's experience producing clear, factual military training films is apparent in *The Story of Menstruation*. There are no backgrounds, animation cycles are re-used, and most of the film concentrates on limited animation diagrams of the ovaries and fallopian tubes rather than character animation. (In fact, one scene has girls of different ages standing stock-still in a circle, while a cute little black Scottie dog in the center turns to each one.)

The entire film is quiet, subtle, formal, and clinical in an attempt to create a feeling of reassurance.

"Menstruation is just one routine step in a normal and natural cycle that is going on continuously in the body," soothes the narrator. She goes on to remind the audience that there is an accompanying free book available, just in

case the information supplied by the film was so emotionally overwhelming that a viewer wasn't able to grasp it all.

The booklet, *Very Personally Yours*, was usually distributed several days before the screening. It was filled with promotional material for Kotex brand feminine products, and included Disney artwork and information from the film.

The cover of the 1947 edition of the booklet features a somewhat sophisticated female hand holding an engraved card that reads "Very Personally Yours", with no hint of its contents. It is approximately five inches by seven inches, small enough to slip into a purse, with twenty pages of text. In the side margins are drawings from the film, but interestingly, there is no Disney copyright anywhere in the book.

The final pages are aimed at promoting Kotex products for feminine hygiene. Since the Disney film was run for several decades after its creation, the booklet and in particular the product ads were updated periodically over the years. The booklet also included some frequently asked questions with answers that presumed the use of Kotex products by its readers.

A separate resource manual for educators included a chart of menstrual physiology and a teaching guide that recommended a casual discussion of the topic as early as the fourth grade, with a more detailed follow-up by the seventh grade.

Disney decided that, about three-quarters through the film, it would be okay to include a moment or two of exaggerated physical humor, so there is a brief scene of a girl being bounced violently while trying to ride a horse, just like in the Goofy cartoon *How to Ride a Horse* (1941). A much more blatant piece of slapstick occurs when a girl is cleaning a big green stuffed chair and picks it up, then looks shocked and lets it drop, sending it crashing through the floor while the narrator warns the audience that normal exercise is fine, but "it is going to extremes that's wrong and to be avoided".

The film ends with the same yawning baby in the bassinet, which not only saved Disney money by re-using earlier animation but suggested that the baby at the beginning of the film had grown up to become a young girl who had taken heed of the information in the film, later married, and then had become a young mother with a baby of her own.

The narrator concludes:

> And that's the story. There's nothing strange nor mysterious about menstruation. All life is built on cycles and the menstrual cycle is one normal and natural part of nature's eternal plan of passing on the gift of life.

Then there is a final title card stating: "Presented with the compliments of Kimberly-Clark, makers of Kotex products".

The point of the film seems to be that menstruation is an introduction to adulthood but not participation in it; that a cheerful, quiet attitude is the most important thing in overcoming any physical discomfort; and that how all this relates to sex is just none of anyone's business.

"Try not to throw yourself off schedule by getting overtired, emotionally upset, or by catching cold!" There is also motherly advice to avoid constipation and depression, and to always look pretty. "It's smart to keep looking smart!"

The film received an enthusiastic response when it was premiered for a group of high school teachers, who praised it for accomplishing in ten minutes what might have taken an hour of prepared classroom lecture. Undoubtedly, the teachers were also relieved that it greatly reduced the amount of verbal explanation they would have to provide to the young girls who had just watched the film.

Encyclopedia Britannica Films adapted an educational film strip from the original Disney film that was accompanied by a script for a teacher to narrate the frames, which gave flexibility in presenting the material when a film projector was unavailable.

In an interview with Disney historian Don Peri, Disney Legend Les Clark recalled:

> Walt thought he might like to get into doing commercial-type, institutional-type things. So, by golly, the studio gets the Firestone Company's *Building a Tire*. Then we worked on another for Autolite Spark Plugs (*The Right Spark Plug in the Right Place*). ... But then Walt said, "Wait a minute, let's do it our way. Why should we build a storyboard that looks like it'll work and then you take it back and they want something different?" We have to change it. They're spending the money. Walt said, "Let's get out of it."

Walt told his investment bankers:

I think that doing that [making these commercial pictures] is a waste of the talent that I had here and I can put it to better purposes by building these features that in the long run pay off better.

*The Story of Menstruation* was so effective that it continued to be screened in schools for nearly three decades.

In the February 1961 issue of *The Instructor* magazine (published for teachers), there is a huge advertisement for the film: "The best loved educational film in all the world!" The ad showed an unrolled strip of film with images from the movie. The text exulted:

Internationally acclaimed! *The Story of Menstruation* is the only fully animated film on the subject of menstrual hygiene. Appealing, absorbing — scientifically accurate! Plan a completely balanced program with the film and auxiliary teaching aids listed in the coupon below. All material FREE from the makers of Kotex sanitary napkins.

The "auxiliary teaching aids" included the booklet *You're a Young Lady Now* (for girls 9 through 11), a physiology chart, and a teaching guide.

This may be the first film for the general public to use the word "vagina" (both in the narration and in an on-screen diagram). The film received the Good Housekeeping Seal of Approval, which undoubtedly increased the opportunities for it to be shown. It was also reviewed favorably by both the American Medical Association and *Parents Magazine*.

Walt's daughter Diane was interviewed by writer Pete Martin in 1956 and said: "Everyone I know should see [*The Story of Menstruation*] before they go into high school." Diane was twelve years old when the film was first released. In the same interview, Walt dismissed the project as just "a commercial thing. We did it for commercial reasons."

Later years brought harsher criticism. In *The Body Project: An Intimate History of American Girls* (Vintage Books, 1997), Joan Jacobs Brumberg wrote:

In the Disney world, the menstrual flow is not blood red but snow white. The vaginal drawings look more like a cross section of a kitchen sink than the outside and inside of a woman's body. There are no hymen, no clitoris, no labia; all focus is on the little nest and its potentially lush lining. Although Disney and Kimberly-Clark advise exercise during

the period, the exercising cartoon girls (who look like Disney's Cinderella) are drawn without feet; bicycles magically propel themselves down the street without any muscular or mental direction from the cyclist. The film ends happily ever after, with a shot of a lip-sticked bride followed immediately by a shot of a lip-sticked mother and baby.

*The Story of Menstruation* was a pioneering achievement in health education films, marketed as "scientific, objective, unemotional", and with nothing that might cause snickers of laughter from its audience. Its higher production values made it stand out from other public service films, and it became a milestone in product promotion. The Library of Congress decreed that the film had "potential historical significance" and ordered two prints for its collection.

The film is now in the public domain. The Disney Studios never copyrighted it.

# Disney Attacks
# Venereal Disease

*The story of how Disney prepared*
*America's school children to battle venereal disease.*

With or without a condom? The Disney Company gave viewers that choice by producing for schools and churches both a sixteen-minute version of their educational health film about venereal disease and a fourteen-minute version without the sequence about how condom use could help prevent infection.

The Disney Company produced many animated films that had wide distribution and were shown to huge audiences for decades, but which otherwise have received little attention or documentation. These educational films, such as *VD Attack Plan* (1973), are often surrounded by myth and misinformation when they are discussed at all.

In a multi-panel, full-color comic book story in the April 4, 1944, edition of *LOOK* magazine, Mickey Mouse fights gonorrhea as part of his exploration of "The Sulfa Drugs". As one panel points out, "Before sulfa, fewer than three out of five gonorrhea patients were 'cured' in two months. Now ... ninety-five percent of patients recover much sooner." This unique comic story even features Mickey wrongly taking some homemade sulfa drugs himself just to be safe.

Unfortunately, many of the training films made by the Disney Studios during the war, for example, *A Few Quick Facts No. 7 — Venereal Disease*, produced in 1944 for the U.S. Army Signal Corps, no longer exist. For reasons of military

security, Disney was not allowed to keep copies of films made for any branch of the military, nor could it keep any material used in the making of those films, including model sheets, drawings, and storyboards. Judging from the other films released at that time, *A Few Quick Facts — No. 7* probably had limited animation, slapstick visual humor, and was effective in communicating information quickly.

During World War II, the Disney Studios did a lot of health-oriented films for the U.S. Coordinator of Inter-American Affairs (CIAA), covering such topics as the danger of malaria from mosquito bite; the problems of hookworm; and how disease travels, especially in unclean environments.

In August 1942, *Fortune* magazine reported that more than three-fourths of the output from the Disney Studios was educational and propaganda films for the U.S. Government. The magazine stated: "It already seems possible that this modest, farm-bred young man who never finished high school will be remembered best as one of the great teachers of all time."

When the war ended, the Studios' experience in producing these films led naturally to its production of educational films for a variety of companies on many different topics.

With the creation of an official educational film division in the late 1960s, Walt Disney Productions produced such original films as *VD Attack Plan*, released in 1973 roughly six years after Walt had died and just over a year after his brother Roy O. Disney had passed away.

The approach that the Disney Studios took to its military training films seems to have helped inspire a similar approach to the story in *VD Attack Plan*, which re-creates the stereo-typical moment in war movies when an impassioned military leader stirs up his troops before the big battle. In this case, the military leader is a blob-like germ, his troops are syphilis and gonorrhea, and their mission is to attack the human body. "Maim 'em for life!" yells the Sergeant.

The narration at the beginning of the film sets the tone:

> This is a war story. It could be anywhere in the world. It could involve anyone. It could only take place within the human body.

Using simple graphics and amusing characters, the film

shows the symptoms and effects of syphilis and gonorrhea, including a photomontage of actual sores, and the importance of prevention and professional treatment while avoiding quack cures.

What really separates this film from others of the era is that some amazingly risky information for the time was shared, for example, the fact that venereal disease could be spread by same sex contact, the need for the use of condoms (although it is a pretty ancient-looking version of a condom in the film), and the fact that it was okay for women to use birth control pills ("A lot of the females who don't want to get pregnant take birth control pills; well, it's fine."). The film points out that those pills won't prevent the spread of STDs, which the Sergeant demonstrates by gleefully chomping on a birth control pill as if it were a round piece of Sweet Tart candy.

One of the few things that dates the film is that AIDS and herpes were not then known as major threats, and so it does not address those dangers.

The Sergeant is an amorphous, brownish blob with yellow eyes and green eyelids, and two small black nostrils for a nose. Black, straight hair spikes out from the top of its head on which he wears a small red cap with a red arrow on top pointing upward, which others have suggested resembles the German Kaiser helmet from World War I. The blob constantly shimmies like gelatin and often expands to fill the entire frame of film with its few, sharply pointed snaggleteeth. The character appears brutish and unkempt.

For some of the talk, the Sergeant is near a simple music stand podium, while at other times he is by a screen with stylized outlines of faceless human beings, although it is still easy to tell the taller male from the shorter female wearing a short dress. The film does not show any nudity.

The troops addressed by the Sergeant wear black berets labeled either with a "G" for gonorrhea or an "S" for syphilis. The gonorrhea germs are dark green and appear on the left side of the screen; the syphilis germs are dark red and appear on the right side of the screen.

The troops, though offering a wonderful opportunity for Disney to save money by just duplicating the same shape, are

actually quite individualized, with slightly different eyes and mouths, and even some differences in body shape. At the end, when they jump in the air for joy, the troops in silhouette resemble jumping beans. Listening closely, the audience might be able to tell that the troops' vocal reactions are a sound clip borrowed from Maleficent's evil goons in the Disney animated feature *Sleeping Beauty* (1959). The film tells its story from the point-of-view of these animated germs.

A/V Geek's Skip Elsheimer, who has over twenty thousand educational films in his collection, wrote:

> One of the biggest challenges for a venereal disease film is to present situations or characters that viewers (whether adults or teens) will identify with. A problem with having a film with actors is that film can quickly become outdated and an audience will often shrug off a message delivered by actors with corny dialogue and antiquated fashion. ... By focusing on animated germs, Disney made a film that is virtually timeless. And not only was this a refreshing change from the traditional venereal disease melodrama — where a hapless teen notices a sore or gets a call from the clinic and spends the next twenty guilt-ridden minutes being lectured on venereal diseases and the toll it takes on the untreated — but it gave the writers an opportunity to use humor to convey the message.

Like most of the Disney educational and training films, *VD Attack Plan* is not only entertaining and informative, but shows sensitivity to its topic, such as when the Sergeant introduces his covert team of Shame, Ignorance, and Fear.

The director of the film was Disney Legend Les Clark, who was employed by Disney from February 23, 1927 (when he did a little incidental animation on *Steamboat Willie*) to September 30, 1975. He died from cancer in 1979, and was made a Disney Legend ten years later in 1989. Born in 1907, he was in his mid-sixties when he directed *VD Attack Plan*.

After serving as sequence director for *Sleeping Beauty* (1959), Clark was asked by Walt to direct television specials and educational films. Clark directed such educational films as the Jiminy Cricket *You Are A Human Animal/I'm No Fool* series (for the *Mickey Mouse Club*), *Donald in Mathmagic Land*, *Freeway Phobia*, and *Man, Monsters and Mysteries* (released in 1973 around the same time as *VD Attack Plan*).

The script is the work of William "Bill" Bosche.

Bosche knew from the age of thirteen that he wanted to be a Disney animator. During World War II, Bosche was assigned as an animator to the Army Air Corps First Motion Picture Unit, where there were many Disney animators in uniform like Frank Thomas working on instructional and training films.

In 1951, Bosche worked as a layout, background, and story sketch artist on training and informational films for the Air Force and Atomic Energy Commission, even traveling to witness atomic bomb tests.

In February 1953, Bosche started at the Disney Studios as a layout assistant on *Lady and the Tramp*. A year later, he transferred to the Story Department to be one of the main writers on Ward Kimball's *Man in Space* trilogy. He also did many special projects for the studio, including scripts for Disneyland attractions.

However, Bosche claimed he got his greatest satisfaction working on educational films like *Freeway Phobia* (with Goofy), *Donald's Fire Survival Plan, Steel and America, The Restless Sea, Eyes in Outer Space*, and of course, *VD Attack Plan*.

He retired from the Disney Studios in 1983.

The only animator officially credited on the film was Charlie Downs, who had a rich career in animation, working for several years at DePatie-Freleng Enterprises on the *Pink Panther* series before coming to the Disney Studios to animate on such projects as *Scrooge McDuck and Money* (1967). Downs would leave the Disney Studios shortly after *VD Attack Plan* to work with Ralph Bakshi on the animated feature *Coonskin (1975)*, and then later for a variety of other animation companies, including Hanna-Barbera. Downs' assistant at Disney was Bob Youngquist, so Youngquist's work is likely also in this film.

The art styling for the film was by Ken O'Connor. In 1935, O'Connor joined the Walt Disney Studios, where he worked as either art director or layout man on thirteen features and nearly one hundred shorts. According to the Disney Legends website:

> Among the most memorable images Ken created for the screen are the magical coach in *Cinderella*, the marching cards in *Alice in Wonderland,* and the dancing hippos in *Fantasia.* ... During World War II, O'Connor worked on

training and educational films that Disney produced for the U.S. government, including *Food Will Win the War*.

O'Connor also worked on the Disney educational films *Freeway Phobia* and *Donald's Fire Survival Plan*.

He retired in 1978.

The music for *VD Attack Plan* was by George Bruns, who used oboes, bongos, and strings to create a creepy militaristic tone. Bruns would retire in 1975, two years after the release of *VD Attack Plan*, but his musical mark on Disney history was well-set by his work on *Yo Ho A Pirate's Life For Me* (lyrics by Xavier Atencio) and *The Ballad of Davy Crockett* (co-written with Tom Blackburn), as well as on many musical contributions to both Disney animated and live-action features.

While some websites describe a general giving a pep talk to his troops, officially the main character in *VD Attack Plan* is called "Contagion Corps Sergeant", voiced by actor Keenan Wynn, who also did the narration.

Wynn, son of the famous comedian Ed Wynn who appeared in Disney films *Babes in Toyland* and *Mary Poppins*, found renewed career attention in the 1960s and 1970s by portraying the blustering villain Alonzo Hawk in Disney films like *The Absent-Minded Professor* (1961), *Son of Flubber* (1963), and *Herbie Rides Again* (1974).

During World War II, Carl Nater was the production coordinator of military educational films at Disney.

Nater remained in charge of the 16mm film division (later Walt Disney Educational Media) for more than two decades, beginning in 1945. Schools could rent Disney features to show in the classroom or at fundraisers. Nater assured cinema managers that Disney would not let schools or PTAs rent Disney 16mm films on Saturdays, since that would put them in conflict with local theaters.

In addition, shortened versions of Disney films were packaged for release to schools. Nater was very aware that the majority of his clients were schools and churches.

Reportedly, Nater tried unsuccessfully to suppress the release of Ward Kimball's television episode *Mars and Beyond* (1957) to schools because he felt a portion of it "promoted evolution". Interestingly, the division had earlier released *The Rite of Spring* dinosaur segment from *Fantasia* on 16mm

with a narration entitled *A World Is Born* (1955) that had also spurred criticisms about promoting evolution.

Around 1968, the Disney 16mm film rental division became the Walt Disney Educational Media Company (WDEMCO), with Nater as its president operating out of an office in Glendale, California. The company was making close to one million dollars a year renting and selling films and filmstrips to schools, but they were looking to expand production.

WDEMCO was an independent subsidiary of Walt Disney Productions, which hired Charles Grizzle as a department head. His first accomplishment was the creation of a *Bambi* filmstrip with a soundtrack. He aggressively tried to increase the catalog of educational films.

By 1973, WDEMCO was grossing more than ten million dollars annually thanks to its expanded catalog, but management pushed to explore even more product ideas such as Personal Hygiene, Worldwide Communications, Ecology, The Conquest of Mexico, The Machinery of Justice, American Legendary Characters, Animals of the Primeval World, and Native American History.

As Charles Grizzle recalled in 1999:

> Then our conservative education director, Donna George, who earned her doctorate while working at Disney, dragged us all into new territory by proposing that Disney produce an animated short subject on venereal disease. This growing problem plagued high schools, and health education teachers nationwide were desperately seeking audio-visual materials that would make an impact. Donna felt Disney could do that. Of course, she was right.

In the early 1970s, during the Free Love era, cases of gonorrhea infections tripled to over one million per year. In 1972, *Newsweek* magazine did a cover story on venereal disease. Also released that same year was a documentary by Richard Leacock (*VD*), a film by Sid Davis (*Summer of '63*), and an Emmy award-winning PBS one-hour special (*VD Blues*) hosted by talk show host Dick Cavett. So, it was not unusual that Disney Educational Media saw an opportunity that year to produce a health educational film about venereal disease for schools.

The project did not receive much support at the Disney

Studios, especially from the older veterans who wondered openly if Disney should be dealing with sexual topics. Even Ron Miller, Donn Tatum, and Card Walker, who together then ran the Disney Company, expressed concerns about how the public would respond to Disney being involved with such a topic.

Their concerns included that possible negative public reaction to the project might reduce audience attendance at regular theatrical Disney film screenings, and that the press could use the film as fodder for unwelcome sensationalistic coverage.

Donna George countered: "We're not dealing with sex. We're dealing with health, a very serious health issue."

Still, despite that reassurance, Walker ordered Disney employees working on the project not to talk to anyone other than teachers about the new film. Walker also made two phone calls to Grizzle to affirm that he wanted silence on the subject, but by that time the Associated Press had learned of the film and wanted more information. When it was not forthcoming, wire services and radio news broadcasters relied on half-truths and rumors about the Disney Studios' new "Donald Duck sex film".

Grizzle explained:

> We were attempting to address a pandemic crisis threatening the lives of teenagers, yet here came the happy boys of the media making funny. They cut short the conversations [with me] when I tried to set them straight. It's called *VD Attack Plan*. Produced in both 35mm and 16mm format for screening anywhere. We feel it's a good weapon in the war against shame, fear, and ignorance. Those are the three main characters.

When the film was released, it was received enthusiastically by educators who continued to use it for years, but still the Disney Studios remained publicly silent about its role in creating the film, despite this admission on the front page of the WDEMCO promotional brochure in 1973:

> Yes, it's true. Walt Disney Productions has made a significant contribution to the war against VD. VD ATTACK PLAN — A fully animated Walt Disney 16mm motion picture.

Why was there also a fourteen-minute version released to

public high schools and churches that omitted the reference to condom usage as a form of prevention? Back then, the primary message to high school students about sexual matters was abstinence, even if the lack of full knowledge meant those young people were placed in a dangerous health situation.

*VD Attack Plan* did not have the extended lifespan of *The Story of Menstruation*, because the shift of public attention to incurable sexually transmitted diseases like AIDS and herpes pushed treatable venereal diseases out of the spotlight.

Due to the delicacy of the subject matter and the possible negative connections to the Disney Brand, the Disney Company stopped producing sexually themed health education films, and concentrated instead on films about safety and nutrition. Those films are still available to schools and other groups today.

# Disneyland Memorial Orgy Poster Story

*The story of how comic book artist Wally Wood drew such vivid sexual images of Disney characters that they have never been able to be completely suppressed.*

The wholesome image of the Disney Brand has been a tempting target for satirists and a variety of creative artists for decades. What are the acceptable limits for parody, social commentary, or artistic inspiration and reinterpretation without infringing on the original intellectual property? Magazines, television shows, and stand-up comedians have all made fun of the world of Disney, even while Walt was alive.

*MAD* magazine began parodying Disney, and specifically the iconic Disney characters, in issue #19 (January 1955) with the story "Mickey Rodent!" in which the title character takes a frightening revenge on Darnold Duck. Artist Bill Elder aped the house artistic style of Disney, and even added the "Walt Dizzy" signature at the bottom of many of the pages.

However, for the Disney Company, the protection of the right to parody is negated when it comes to sexual images of its famous brand characters.

The infamous *Tijuana Bibles*, also referred to as "eight pagers", were privately printed and, for their time, much sought after comic book publications. These pornographic pamphlets gained popularity because they featured thinly disguised caricatures of famous actors or cartoon characters engaged in exaggerated sexual escapades.

Even the Disney characters couldn't escape such dubious

fame. An early, anonymous example from 1937, *Mickey Mouse in Of Mice and Women by Salt Pisney*, featured the sexual antics of Mickey, Minnie, Goofy, Clarabelle Cow, and a very obliging human girl. *Donald Duck Has a Universal Desire* depicted a sexually frustrated Donald enjoying the pleasures of a curly-haired duck transvestite.

These randomly distributed, badly written and drawn, low print-run publications were not seen as a threat worth addressing by the Disney Company, but they gave birth to a more enduring artistic sexual parody of the world of Disney.

From a distance, or at a quick first glance, the infamous "Disneyland Memorial Orgy" poster appears to be a typical cartoon of a host of Disney animated characters frolicking in a forest with a castle in the background. However, closer examination reveals that the beloved characters are involved in very un-Disneylike activities, ranging from extreme sex to drug use. *Time* magazine's Richard Corliss described the poster:

> In Wally Wood's lushly scabrous "Disneyland Memorial Orgy", a 1967 parody that ran in *The Realist* magazine, Walt's creatures behaved exactly as barnyard and woodland denizens might. Beneath dollar-sign searchlights radiating from the Magic Kingdom's castle, Goofy had his way with Minnie, Dumbo the flying elephant dumped on Donald Duck, the Seven Dwarfs besmirched Snow White en masse, and Tinker Bell performed a striptease for Peter Pan and Jiminy Cricket. Mickey slouched off to one side, shooting heroin.

Paul Krassner, who created the underground satirical newspaper *The Realist* in 1958, had worked in the same office building that housed publisher Bill Gaines' *MAD* magazine, and had sold a couple of submissions to Gaines. Contributors to *The Realist* (which published its last issue in spring 2001) included Lenny Bruce, Jules Feiffer, Norman Mailer, and Richard Pryor. Krassner remembered:

> After Walt Disney died (in 1966), I somehow expected Mickey Mouse, Donald Duck and the rest of the gang to attend his funeral, with Goofy delivering the eulogy and the Seven Dwarves serving as pallbearers. Disney's death occurred a few months after *Time* magazine's famous "Is God Dead?" cover, and I realized that Disney had served as god to that whole stable of imaginary beings who were now mourning in a state of suspended animation. Disney had been their creator, and

had repressed their baser instincts, but now with his departure, they could finally shed their cumulative inhibitions and participate together in an unspeakable Roman binge, to signify the crumbling of an empire.

I contacted Wally Wood, who had illustrated my first article for *MAD* ("If Comic Strip Characters Answered Those Little Ads in the Back of Comic Books") and he (anonymously) unleashed their collective libido, demystifying an entire genre in the process. I told Wally my idea, without being specific. In a few months, he presented me with the artwork, unsigned. I paid him $100. The "Disneyland Memorial Orgy" was a *Realist* center spread (May 1967 issue in black and white) that became our most infamous poster. The "Disneyland Memorial Orgy" center spread became so popular that I decided to publish it as a poster in 1967.

Wally Wood was a legendary comic book artist whose work continues to be collected and studied today, especially his early efforts for EC comic books. He was the perfect choice to do the artwork for two reasons.

First, since the mid-1950s, Wood had worked at *MAD* magazine drawing parodies of Disney characters for some of the articles. For instance, in the December 1956 issue of *MAD* (#30), Wood drew a wonderful six-page satire of the *Disneyland* weekly television show entitled "Walt Dizzy Resents Dizzyland". Many of the Disney animated characters that would later appear on the notorious poster, including Mickey Mouse, Donald Duck, Dumbo, and the Seven Dwarfs, first appear in this piece.

Second, Wood had been earning extra income by supplying softcore cartoons for men's magazines like *Gent, The Dude*, and *Nugget*, and was no stranger to that type of subject matter. In the 1970s, Wood pursued this market even further, with contributions to Al Goldstein's *Screw* magazine as well as adult parodies inspired by Disney fairy tales entitled "Malice in Wonderland" and "Slipping Beauty".

An inside source at Disney supposedly told editor Paul Krassner that the company chose not to sue to avoid drawing attention to what ultimately could be a losing battle. Since Krassner jobbed out his printing and had no capital investment nor any assets that Disney could garner, it was

hardly worth the time and expense. It also did not make sense at the time (just months after the death of Walt) to create further public embarrassment and get nothing in return.

In those days, this was not an unusual tactic for the Disney legal department when they felt that the infringement would be seen only by a small segment of its audience, and then quickly forgotten and thrown away as new issues of the periodical were published. For example, the September 1970 issue of *National Lampoon* magazine featured a cover of a classic 1930s-style Minnie Mouse flashing her bare top and revealing her small breasts covered with flower pasties. The editors purposely published the cover in the hope that it would stir the ire of Disney and bring some publicity to their fledgling new magazine. Disney chose to ignore it, and indeed the cover was quickly forgotten.

In May 2005, Krassner told the *L.A. Weekly*:

> In Baltimore, a news agency distributed that issue [of *The Realist*] with "Disneyland Memorial Orgy" removed; I was able to secure the missing pages, and offered them free to any reader who had bought a partial magazine. In Oakland, an anonymous group published a flyer reprinting a few sections of the centerspread and distributed it in churches and around town.

Krassner claimed that the original art for the "Disneyland Memorial Orgy" was stolen from the printer.

There were several pirated editions of the poster available during the 1970s. One of these editions was done in a vertical format (rather than the original horizontal format) and made crude alterations and additions to Wood's art. Even today, images from the original Wood artwork have been illegally used for everything from T-shirts to tattoos.

Disney was not so reluctant to assert its rights when entrepreneur Sam Ridge pirated the drawing and sold it as a black light poster. The commercial nature of the bootleg, and the fact that it would reach a much larger audience than the poorly distributed *The Realist*, prompted Disney to file a lawsuit, which was settled out-of-court and forced Ridge out of business.

Corporate lawyers say that lawsuits against visual artists are rare, and usually are filed only when the artists try to sell copies of the images (on T-shirts, for example) or when the company believes that the work tarnishes its brand.

Lawyers today also argue that they must sue or else suffer severe legal consequences. A facet of intellectual property law called acquiescence compels intellectual property owners to fight every infringement they find or else give up the right to defend their trademark or copyright when it really matters, such as when a competing company appropriates a logo or image.

As a result, when the Disney Company files an injunction against a children's elementary school or a hospital for using Disney characters on a wall mural without written permission, the company is perceived as a mercenary, heartless bully. Yet not to sue would allow the characters to become fair game for anyone to use, since Disney had not aggressively protected its property.

Underground comix [sic] artist Joel Beck drew a poster in 1966 issued by the Print Mint called "Odalisque". An odalisque is a female slave or concubine in a harem. In this case, the nude female was Daisy Duck. Disney sued unsuccessfully because the court determined that since this Daisy had a pair of teats it was sufficiently different from the Disney duck, and would not be confused by the general public as a Disney character.

The artwork for the "Disneyland Memorial Orgy" poster was part of a 2002 traveling exhibit, "Illegal Art: Freedom of Expression in the Corporate Age", which was intended to provoke discussion about the relationship between intellectual property law and the First Amendment.

As late as 1981, shortly before his death, Wood never admitted to doing the drawing, but did tell an interviewer:

> I'd rather not say anything about that! It was the most pirated drawing in history! Everyone was printing copies of that. I understand some people got busted for selling it. I always thought Disney stuff was pretty sexy... Snow White, etc.

In 2007, Krassner told the *Atlantic Free Press* how things had drastically changed since the first publication of the "Disneyland Memorial Orgy" poster:

> In 2005, I published a copyrighted, digitally colored edition of the original poster. As artistic irreverence toward the Disney characters has continued to grow, attorneys for Walt Disney Productions have become busy filing lawsuits

to stop the sale of such items, because their corporate client has worked "for many years to acquire the image of innocent delightfulness known and loved by people all over the world, particularly, but not only, by children," but now these characters are being shown in a "degrading, lewd, drug addictive, offensive and defaced" manner, some of them "in poses suggestive of a love-in". The lawyers state that "[S]ome of the cartoons portrayed by these people are pornographic" and complain about "copyright infringement and unfair competition".

What would Walt Disney have thought about the poster? Bob Thomas, who knew Walt and interviewed him several times, wrote in his book *Walt Disney: An American Original*:

> Telling a dirty joke to Walt could evoke a stony silence. Not that he was prudish. Like any farm boy, he had learned about sex at an early age. To him, sex was not a ludicrous subject, nor did it hold any great mystery. Above all, he believed that sex was a private matter, and that is the way he preferred to leave it.

In his essay "The Wonderful World of Walt Disney" for the book *You Must Remember This* (Putnam 1975), Disney Legend Ward Kimball remembered:

> There were a lot of cartoonists and artists who didn't work at the studio who'd draw porno versions of the Disney characters. I've seen drawings of Dumbo flying through the air dropping elephant turds on everybody with Mickey Mouse in the foreground with a week's stubble of beard giving himself a fix or jerking off.
>
> Perhaps the reason for this sort of thing is that everything seemed so perfect and dreamlike in Disney's world. That led to the urge to make these drawings. So far as I know, Walt never saw any of those drawings. You could never tell Walt a dirty joke. The word got around quickly to new employees not to try and ingratiate yourself with Walt by telling him an off-color story. He thought dirty jokes were terrible, and he was embarrassed by them.

As diligently as the Disney Company has tried to suppress the Wally Wood image, it continues to be posted on the Internet, reprinted, and re-used, not just because of its cartoony craftsmanship, but because it fulfills a need for some people to tweak the ever wholesome image of Disney.

# Jessica Rabbit:
# Drawn to Be Bad

*The story of how Disney created a female
animated bombshell that it couldn't control.*

"I'm not bad. I'm just drawn that way," affirmed Jessica
Rabbit in her alluringly hoarse whisper of a voice in the
Touchstone film *Who Framed Roger Rabbit* (1988). CEO
Michael Eisner considered the film too risqué, which is just
one reason it was released under the Touchstone rather than
the Disney label.

Disney female characters from Tinker Bell to various
princesses have always embodied a healthy but innocent
sexiness, but Jessica Rabbit was the first to be blatantly
sexual in nature.

The stunningly beautiful and passionate Jessica was the
human toon wife of cartoon comedy star Roger Rabbit.
Redheaded Jessica does indeed appear as a sultry, glamorous
night club singer at the Ink and Paint Club, but underneath
all the cel paint, she is a fiercely loyal wife who loves Roger
because he makes her laugh.

In Gary Wolf's original 1981 novel, *Who Censored Roger
Rabbit?*, Jessica is a much more devious and jaded character
not above using her sexual endowments to get what she
wants. She had "a body straight out of one of the magazines
adolescent boys pore over in locked bathrooms", wrote Wolf.

Later in the book, detective Eddie Valiant pays $200 for a rare
Tijuana Bible entitled *Lewd, Crude, and In the Mood*, which
portrayed in graphic detail the antics of a randy, female nurse.

The nurse was played by a younger, slimmer, blonder, but definitely recognizable Jessica Rabbit. When confronted with a copy of the book, Jessica claims she was only eighteen at the time, and Sid Sleaze drugged her and took the pictures.

Wolf said:

> Jessica Rabbit came about because in my home town in Illinois, the boys outnumbered the girls thirty to one — so good luck getting a date if you're president of the chess club. I spent a lot of time fantasizing about my ideal woman, and Jessica is that fantasy. She's every boy's dream. I based her on Red Hot Riding Hood from the Tex Avery cartoon *Wild and Woolfy* (1945). Jessica Rabbit is my idea of the perfect woman.

The harsher character description from the book influenced director Darrell Van Citters and designer Mike Giaimo when they tackled the first attempt at an animated version of the character for the Disney Company back in the early 1980s. In their sample animation, they made Jessica more of a traditional film-noir femme fatale who looked like a young Lauren Bacall, very slender and with high cheekbones.

During the writing of the Robert Zemeckis version of the story that was finally filmed, screenwriters Jeffrey Price and Peter Seaman wrote a draft of the script in which Jessica Rabbit was the villain who framed Roger for a crime.

It is the more endowed, more innocent version of Jessica seen in the Zemeckis film that owes a debt to director Tex Avery and artist Preston Blair and their earlier creation of a sexy female human toon character now known as Red Hot Riding Hood for a series of MGM cartoons.

Animation director Richard Williams recalled:

> We started with a Jessica that was much more illustrative, but one day one of the writers came to me and said I should make it more cartoony. So I did. ... I used a combination of Veronica Lake, Rita Hayworth and Sophia Loren. It's so funny that she's become this pin-up. Of course, she's absurd. Her waist is so tiny that she'd fall over if she was real.

The famous peek-a-boo hair style of Lake, the distinctive red hair of Hayworth, and the voluptuous physique of Loren, combined with their screen personas as the world's most desirable women, were the physical foundations for Jessica. Jessica's waist was made incredibly tiny not just for cartoon exaggera-

tion, but to convince audiences that the character was not simply rotoscoped (traced from live action) but drawn.

Bob Hoskins, who played Eddie Valiant, explained:

> When we were filming [*Who Framed Roger Rabbit*], nobody really knew what the final Jessica Rabbit looked like. Zemeckis said, "Think of the sexiest woman you can imagine, Bob. Think of sex!" I thought up this really sexy bird, thinking, "Ooooh, wonderful." They did the work on Jessica up in Camden Town, and I used to live round there, so they'd call and say, "Come and see what we're doing." When I saw it, she was just so sexy that I felt so boring. The bird I'd created was like some person's old granny compared to this.

Supervisor animator Russell Hall remarked:

> She had to be a testimony to what a man could do with a pencil and a fertile imagination. In a sense, she shares the two realities of the cartoon world and the real world. She would have to appeal to the rabbit and Bob Hoskins.

Animator Andreas Deja also worked on the film, and recalled:

> Russell — who did Jessica — he's a terrific draftsman and very solid, so it was decided Russell should just focus on Jessica and not do anything else.

While the Disney Company did not then have a "walk around" Jessica Rabbit character at its theme parks or participating in special events, as it did with Roger Rabbit, Disney did market the character through the traditional venues of merchandise, including some unique options in Orlando, Florida.

When Disney-MGM Studios opened in May 1989, theme park guests who disembarked from the Backlot Tram Tour found themselves in a merchandise venue called The Loony Bin, themed to *Who Framed Roger Rabbit*. Guests had two opportunities to pose with Jessica. There was a glittery life-sized plywood cutout of the character for amateur photographers. In addition, the photo shop allowed guests to don Eddie Valiant's overcoat and hat, and then be superimposed into an actual cartoon drawing with Jessica.

The shop sold a lot of merchandise related to the film, but real fans of Jessica went to the newly built Pleasure Island in what later became Downtown Disney. From roughly 1990-

1992, there was a small merchandise shop at Pleasure Island called Jessica's, filled with Jessica Rabbit nightgowns, jewelry, shower curtains, beach and bath towels, pins, a limited edition watch, ceramics, perfume bottles, magnets, and much more. The interior of the shop was stocked with images of Jessica, and there was a large stage door with Jessica's name and star on it.

On the outside of the building was a giant, nearly thirty-foot-high, two-sided neon sign of Jessica in her sequined dress, with her left leg slowly swinging back and forth. The concept art for the sign was done by artist Mark Marderosian, who was responsible for the design of a great deal of the Jessica merchandise sold in the store. When the shop closed, the sign was relocated to a building near one of the entrances to Pleasure Island, where it remained until 2006.

Jessica merchandise was a challenge because contractually Steven Spielberg and his Amblin Entertainment company were entitled to a share of the revenue from its sale. So, a new licensing operation had to be set up with all items copyrighted Touchstone/Amblin Entertainment, and the accounting done separately from other character merchandise.

At the time, the Disney Company was unfamiliar with how to deal with such a flamboyantly sexual character. Jessica was a troubling anomaly not able to be shoehorned into the familiar Disney Brand.

When the Laserdisc version of *Who Framed Roger Rabbit* was released in 1994, media controversy arose over a scene in which (supposedly) Jessica Rabbit flashes the private area between her legs to the camera.

In that scene, Jessica and Eddie are thrown from Benny the Cab while leaving Toontown. Jessica spins out of the car, which causes her red dress to start hiking up her body and her legs to spread apart for a moment. On a few frames of Jessica's second spin, her underwear supposedly disappears, revealing Jessica's nether regions. During those three frames, Jessica's pubic area is darker than the surrounding flesh-colored areas of her legs and certainly not a dark red like the color of her underwear.

Within minutes of this revelation made public on several

media outlets, including CNN, many retailers found their entire inventory of the Laserdisc sold out. A Disney executive responded to the trade newspaper *Variety* in 1994 that:

> [P]eople need to get a life than to notice stuff like that. We were never aware of it. ... At the same time, people also need to develop a sense of humor with these things.

Animator and Disney historian Mark Kausler studied the frames, and in his expert opinion, it is just a paint error: in the rush to complete production, the small area for underwear was left unpainted in those frames, making the dark background briefly visible through the unpainted, transparent part of the cel.

For later DVD releases, color correction was done for those frames. By 2002, the scene was re-animated, so that a piece of Jessica's skirt strategically covers the questionable area.

Technology had begun to change how films were released. Things that were unnoticeable at the usual twenty-four frames per second became very visible when viewed frame-by-frame. With laser offering 425 lines of resolution compared to 240 lines for VHS tapes, images became much more distinct.

A plan to include a topless Jessica for a few brief frames was cancelled even before the film was released to video so as to avoid close scrutiny by sharp-eyed viewers.

In a 1995 interview, Gary Wolf recalled:

> The animators wanted to do an homage to Fleischer's Betty Boop. He [Max Fleischer] had her topless in every movie, for six frames, invisible to the human eye. So they did the same with [Jessica] in *Roger Rabbit*. When we decided to release the film on video, the producer went on Johnny Carson and spilled the beans. So we were forced to take it out.

The Disney Company was frustrated by its inability to completely control Jessica's sensual image to the general public.

The cover of the November 1988 issue of *Playboy* featured an airbrushed photo of September Playmate Laura Richmond portraying Jessica Rabbit. The cover appeared at a time when Disney was having difficulty handling the success of its sexy star, and was toning down her cleavage and slit skirt for her appearances in storybooks, coloring books, and related items.

The *Playboy* cover was apparently a spontaneous inspiration that occurred within a twenty-four-hour period. Photographer Stephen Wayda and art director Tom Staebler photographed model Richmond with Jessica-style hair, gown, and pose, and then subjected the work to a dye transfer process, which resulted in an animated look. Airbrushing was necessary to pull in the waist to the cartoon proportions of the animated Jessica.

*Playboy* figured that Disney would have a sense of humor about the whole thing, but Tom Deegan, then Director of Corporate Communications for Disney, went on record saying:

> We don't have any reaction [to the *Playboy* cover]. We don't think anything about it at all. Anyway, that's not really Jessica on the cover. It's *Playboy's* interpretation of her.

Disney was less cavalier when the French edition of the July 1989 issue of *Penthouse* magazine was released. Reportedly, at that time, Disney had not yet secured the international copyright for Jessica Rabbit. This was an oversight quickly corrected when the company saw the color cover of the *Penthouse* issue, featuring a cel-like drawing of a topless Jessica with long purple gloves, a purple garter belt, and purple bikini panties.

The interior ten-page spread mixed artwork from the Disney animated feature with new color artwork of a topless Jessica posing seductively. The article was an interview with Zita Hayworth, a fictional actress who supposedly portrayed Jessica.

No mention was made that the real voice of Jessica was supplied by the breathy delivery of actress Kathleen Turner, with Steven Spielberg's soon-to-be divorced wife, Amy Irving, doing the singing voice. Both actresses were uncredited (by their own choice) in the final film. Turner stated:

> Bob Zemeckis and I worked together on *Romancing the Stone* and he was developing *Who Framed Roger Rabbit*. He wanted Jessica to be the epitome of femme fatale and many people now when they think of a femme fatale, think of my voice. It was perfect for me at the time because I was pregnant. I could just waddle into the studio and off I'd go. We had a lot of fun in terms of Jessica's breathing. I said, "She's got such big boobs, so why don't we add in lots of sighs, and then you guys can make them bounce?"

Jessica's performance model was actress Betsy Brantley. Brantley was in her early thirties when she went through the movements for the character, such as walking down the stage in the Ink and Paint Club. The painted image of Jessica was superimposed over Brantley's movement. Around the same time, Brantley played the role of the mother of the boy who is listening to his grandfather tell him a story in *The Princess Bride* (1987).

Victoria's Secret supermodel Heidi Klum helped *GQ* magazine celebrate its 45th birthday in the September 2002 issue by posing in a photo layout of her done up as such great sex symbols as Marilyn Monroe and Raquel Welch. According to an interview at the time, her favorite photo was her as Jessica Rabbit.

There is just something about Jessica Rabbit that stirs the hormones of amateur artists to re-imagine her in the most seductive situations and costumes. The July 31, 1989, issue of *Screw* featured the three-page comic strip "The Tramp of Toonturf", with a character who looked suspiciously like Jessica doing an awful lot of off-color naughtiness in only twenty-four panels.

The real Disney Jessica later appeared briefly in three theatrical cartoon shorts: *Tummy Trouble* (1989), *Roller Coaster Rabbit* (1990), and *Trail Mix-Up* (1993). A fourth cartoon short, *Hare in My Soup*, was planned but never made. For decades, there have been unsuccessful attempts to make a prequel or sequel to the original feature film.

Jessica Rabbit has truly become the stuff that dreams are made of, and many women enjoy trying to imitate her look of sexiness and intelligence, even going to the extreme of plastic surgery. Gary Wolf agrees:

> I've seen surveys which rank Jessica Rabbit as one of the hottest movie actresses of all time. Quite an accomplishment for a Toon. I've seen Heidi Klum, Katy Perry, Megan Fox, and Rachael Ray all dressed as Jessica. So Jessica is still with us in spirit and in form. Hopefully, she'll be with us for a whole lot longer.

Or as Jessica would say: "You don't know how hard it is being a woman looking the way I do."

# Mickey Mouse
# Attempts Suicide

*The story of why Walt Disney thought it would be a good idea for a heartbroken Mickey Mouse to commit suicide.*

In the early decades of the 20th century, the Great Crash on Wall Street brought economic ruin to thousands of people, resulting in over 23,000 suicides just in 1929. The suicide rate remained higher than normal throughout the remainder of the Great Depression years.

While the subject of suicide was a scary reality for many Americans, it was even more frightening that in 1930 Mickey Mouse contemplated it as a solution to his personal depression. Even more amazing, it was Walt himself who suggested the idea.

Walt Disney was fond of silent movie comedies, and had great admiration for popular silent screen comedian Charlie Chaplin. As a kid, Walt won contests in movie theater competitions by imitating Chaplin, and those memories helped inspire the creation of Mickey Mouse. Walt told an interviewer:

> We felt that the public, and especially the children, like animals that are cute and little. I think we are rather indebted to Charlie Chaplin for the idea. We wanted something appealing, and we thought of a tiny bit of a mouse that would have something of the wistfulness of Chaplin — a little fellow trying to do the best he could.

In the mid-1920s, Chaplin announced that he would produce a film called *The Suicide Club* based on the stories of

Robert Louis Stevenson about an organization that assisted people with ending their lives. Chaplin intended to portray the stories with a darkly humorous, slapstick approach. The film was never made, but Walt — like the rest of Chaplin's fans — had heard the announcement.

There are significant differences between Chaplin and Mickey Mouse. Chaplin's portrayed his Little Tramp character as a scrappy, down-on-his-luck immigrant trying to fit in with the mainstream of American society, and often doing things that, while amusing, lacked integrity or legality. That was never Mickey Mouse's character.

While certainly feisty and even destitute in his early cartoons, Mickey Mouse was meant to convey the impression of a clean-cut, Midwestern, All-American farm boy. By 1930, while Mickey occasionally might have danced on the line of appropriateness, he lacked the mean-spiritedness sometimes shown in Chaplin's character. Mickey was more similar to another of Walt's silent movie comedian favorites, Harold Lloyd.

Most people remember only the famous film image of the bespectacled and well-dressed Lloyd hanging dangerously from a clock over a busy Los Angeles street. However, Lloyd was one of the most popular and amusing silent screen comedians of his day, and starred in many films. He was a typical small-town, normal-looking young man who found himself involved in the most outrageous situations that often required athletic prowess for him to finally get the girl or win the day. Just like Mickey.

In 1920, Walt saw a Harold Lloyd comedy entitled *Haunted Spooks*. There are two distinct storylines in this film, but its first half presents Lloyd's character as being so despondent that he tries to kill himself.

Since the film is a comedy, the results are unexpected. Lloyd picks up a gun to shoot himself and it turns out to be a water pistol. He stands in front of a trolley to be run over and it veers away on another track a mere three feet in front of him. He ties a rock around his neck and leaps from a bridge in Echo Park into a pond of water that is only a little over ankle-deep.

A sad side note is that, while taking promotional stills for

this film, Lloyd did a gag publicity shot of himself holding a bomb as if it were a cigarette lighter. The prop accidentally went off, badly burning him (permanent blindness almost resulted) and the thumb and forefinger of his right hand were blown off. He was fitted with a prosthetic glove to finish the film, and he is indeed wearing that same glove when he hangs dangerously off the clock in his later film triumph, *Safety Last!* (1927).

So what does all of this have to do with Mickey Mouse attempting suicide?

Walt was famous for never forgetting a gag, especially one that was successful with the audience, and he would incorporate those gags in his films. Actor Dean Jones remembered complaining in the 1960s to Walt that a gag in his latest Disney film seemed corny, and Walt replied, "They laughed at it in 1923 and they will laugh at it today." At the premiere, hearing the audience laughing loudly, Jones had to admit that Walt was right. Jones said even he laughed at the gag on screen.

In 1930, the Mickey Mouse daily comic strip appeared. Originally written by Walt Disney and drawn by Ub Iwerks, it was immediately successful for King Features Syndicate. However, several weeks into the strip, Ub Iwerks left, and the illustration chores were turned over to Disney artist Win Smith, who had been inking Iwerks' penciled artwork.

The comic strip was a gag-a-day format, but King Features wanted more of a story continuity strip because story continuities were extremely popular and built a loyal newspaper readership who eagerly wanted to know what happened to the character on the next day.

Walt didn't have time to handle his expanding studio and all the other things claiming his attention, including merchandise opportunities, and certainly not the chore of writing a daily strip. Walt tried to convince Win Smith into taking over the writing as well as the illustrating. Smith balked at the suggestion and quit.

Newly hired Disney artist Floyd Gottfredson, who had always wanted a career as a newspaper cartoonist, took over the strip, with his first episode appearing on May 5, 1930. Walt continued to write the continuity for another two weeks

before having Gottfredson take over completely and finish the story of Mickey Mouse in Death Valley looking for treasure.

The next continuity story, "Mr. Slicker and the Egg Robbers" (September 22, 1930, through December 29, 1930), was written by Gottfredson, with some interesting input from Walt himself.

Although Walt was busy with his studio responsibilities and was happy with Gottfredson's work (except for his occasional complaints that Gottfredson should simplify the backgrounds and trim the dialog), Walt called the artist into his office to discuss a storyline he would like to see in the latest continuity. Floyd Gottfredson discussed this meeting in a November 1975 interview with Disney archivist Dave Smith:

> He would make suggestions every once in a while, for some short continuities and so on, and I would do them. One that I'll never forget, and which I still don't understand was when he said, "Why don't you do a continuity of Mickey trying to commit suicide?" So I said, "Walt! You're kidding!" He replied, "No, I'm not kidding. I think you could get a lot of funny stuff out of that." I said, "Gee whiz, Walt. I don't know. What do you think the Syndicate will think of it? What do you think the editors will think? And the readers?" He said, "I think it will be funny. Go ahead and do it." So I did, oh, maybe ten days of Mickey trying to commit suicide — jumping off bridges, trying to hang himself ... I don't remember all the details. But strangely enough, the Syndicate didn't object. We didn't hear anything from the editors, and Walt said, "See? It was funny. I told you it would be." So there were a few things like that.

The suicide episodes appear roughly from October 8 through October 24, 1930. In the story, Mr. Slicker looks remarkably like Mickey's rival, Mortimer Mouse, and with the same attitude of arrogance and sneakiness. He takes a fancy to Minnie Mouse, who sees only his effusive (but fake) gentlemanly manners and hears only his fine words. Mickey finds himself continually upstaged by Mr. Slicker, and shoved farther and farther into the background.

One evening, Minnie has invited Mr. Slicker over to her house and shows him the family photo album. ("Here is my grandpa, Marshall Mouse — and that's my grandmother Matilda Mouse — this group down here is Uncle Milton Mouse

and his family!") Mr. Slicker's long, rat-like nose is very close to Minnie as he leans in to look at the photos. When Mickey, who has been worrying that Minnie will fall for Slicker's big city ways and dump him, stops by to see Minnie, he thinks the silhouette on the window shade is Slicker and Minnie kissing!

Of course, Minnie would never betray Mickey. It was just an illusion of distance and lighting, but in his frustration, Mickey immediately assumes the worst.

A despondent Mickey returns home and moans: "Oh, what's the use? She doesn't care for me anymore — what is there to live for? Without Minnie, I might as well end it all!" Mickey reaches for the rifle on his wall and takes it down.

The next day, the reader sees that Mickey has rigged the rifle on two chairs with a rope so that when he pulls on the rope, he will be shot in the back of the head. Fortunately, the cuckoo clock goes off, and Mickey realizes he is cuckoo for trying to end it all that way.

The next day, Mickey jumps off a high bridge but lands instead on the deck of a small boat that had been tugging underneath. The ship's captain decides to throw Mickey overboard, but the plucky mouse pleads: "Please don't! I can't swim! I might drown!"

The next day, Mickey turns on the gas in his house and lies down on his bed to drift into endless sleep. "Goodbye, Minnie! Goodbye, cruel world!" However, while his eyes are closed, a squirrel scampers in to use the escaping gas to fill his balloon. The balloon over inflates and explodes, waking Mickey, who thinks he has been shot.

The next day, Mickey puts a huge anvil around his neck and goes to the river bank, where he asks a nearby fish, "How's the water today?" The fish responds, "Br-r-r! Cold as the dickens!" Mickey decides to try again the next day and throws the anvil in the river.

Finally, Mickey tosses a noose over a tree branch to hang himself, but before he can do so, he is surrounded by happy playful squirrels, and says: "I guess you think I'm crazy — Well, I must've been to think of hanging myself! When I look into your smiling faces, I feel ashamed! It isn't such a bad old world after all! It took a squirrel to prove what a nut I was!" So Mickey uses the hanging rope to make a swing.

There were only seven daily strips recounting this story before it moved on to the main story of all the chicken eggs disappearing from Minnie's father's farm. Readers began to wonder if Mr. Slicker might have something to do with that tragedy.

In the era before television and videotape recorders, Walt felt that audiences wouldn't remember a ten-year-old film by Harold Lloyd with gags about committing suicide. Since Mickey and Lloyd had the same comedic personality, Walt thought that Mickey would be a good character with which to re-create that humor.

The early Mickey Mouse comic strips were a product of their time, and certainly don't reflect the political correctness of today's famous corporate icon. One panel in an early Mickey Mouse newspaper strip shows Mickey discovering a room full of cheese and proclaiming in a script written by Walt, "Oh boy, what cheese! If only I had a bottle of beer ... "

However, this is not the end of the story. The first-ever Disney book available for sale in the United Kingdom was the *Mickey Mouse Annual* published by London's Dean & Sons Limited around Christmas of 1930. It featured new, original artwork (not reprints of the syndicated newspaper strip). The primary artist was U.K. cartoonist Wilfred Haughton, later renowned for his cover illustrations of Britain's *Mickey Mouse Weekly*. Haughton produced a series of one-page gag sequences done in comic strip form for the annuals.

Apparently inspired by Gottfredson's strip, Haughton did a one-pager, "A Close Shave", in the third *Mickey Mouse Annual* (1932). In the first panel, Mickey is shocked to see in the distance, at a neighborhood park, Minnie sitting on a park bench next to a male mouse in a top hat with his arm around her waist. Mickey immediately assumes the worst and thinks Minnie has found a new boyfriend.

In the next panel, Mickey is storming out of a nearby shop with a revolver in his right hand and a lengthy coil of rope in his left. "I shan't hang about any longer!" he grumbles.

In the third panel, he is in a rowboat near the shore of a lake. He ties a noose around his neck and ties the other end to a low, overhanging branch of a tree. He says: "Now, I'll just kick the boat away — and — but — ."

In the fourth panel, he is securely tied to the tree, although his knees are shaking. In his right hand, he holds a revolver pointed directly at his snout as he precariously stands on the bow of the small boat. " — [I]n case it hurts I'll make sure and blow out my brains at the same moment!"

In the fifth panel, he fires the gun with a loud BANG!, and a huge cloud of smoke obscures the image as he pushes the boat away with his feet. However, because of the action of pushing the boat away, Mickey slips and the gun misses his face and severs the rope hanging from the tree.

In the sixth panel, Mickey falls into the shallow lake.

In the final panel, he crawls back onto the shore and says, "It is a jolly good job I can swim, or I should have drowned!"

No matter how tough things got for Mickey Mouse in the coming years, either in the comic strip or in the theatrical shorts, he never again contemplated suicide. Neither did any other Disney character. Yet, for one short moment at the height of the Great Depression, Mickey Mouse decided like so many others that committing suicide was the only solution to his problem.

# Walt's Owl Nightmare

*The story of how Walt Disney was
troubled by strange, recurring nightmares.*

The affable, smiling Walt Disney so familiar to audiences who saw him on television each week was just one aspect of a complex man. The stress of running his studio to the highest standards gave Walt a nervous breakdown in 1931. Much later, in 1956, Walt told writer Pete Martin:

> In 1931, I had a hell of a breakdown. I went all to pieces. The worry and things. I kept expecting more from the artists and when they let me down and things I got worried. Just pound, pound, pound. I cracked up. I just got very irritable. I got to the point that I couldn't talk on the telephone. I'd begin to cry at the least little thing. It used to be hard to sleep. It was an emotional thing you know.

Walt went on an extended vacation with his wife, took up various forms of exercise including golf and horseback riding, and tried several different hobbies from model trains to collecting and building miniatures in an effort to relieve his constant creative and financial pressure.

However, late at night, after a long, hard day of decision-making, Walt still did not always find comfort in his sleep, but suffered nightmares from his childhood. Two recurring nightmares were most prominent.

As Bob Thomas wrote in the biography *Walt Disney: An American Original*:

> Often in the middle of the night, Lilly [Walt's wife] awoke to see Walt standing at his dresser, studying a script or making sketches, or talking to himself about a project.

For six years as a young boy, Walt delivered daily news-papers, missing only four weeks during all of that time because of illness. His father, who managed the paper routes, was a stern taskmaster, and felt great anxiety to make the routes a success after previous business failures. In a 1966 interview, Walt recalled, "He insisted that it [the newspaper] be delivered fresh and clean, without wrinkles. He was meticulous about it."

His father would also become upset if a customer phoned to complain that they could not see their paper on the porch, not realizing that the young Walt had sometimes placed it behind the storm door so it wouldn't be damaged by bad weather. Walt would be sent back to that house immediately with a replacement copy, even if it meant being late for school.

In his 1956 taped interviews with Pete Martin (which later appeared as a series of articles in the *Saturday Evening Post*, and then as *The Story of Walt Disney* (1957), a book credited to Walt's daughter Diane Disney Miller, Walt revealed:

> You know, that period I went through as a newsboy ... I mean I've never forgotten. You know to this day I have nightmares that I've missed customers on my route. Yes sir, I wake up in a kind of a sweat and think, "Gosh, I've got to hurry and get back. My dad will be waiting up at that corner." I dream that. It's the darndest thing. Still have those nightmares.

But it was a foolish mistake that Walt made as a child that truly haunted him for the rest of his life.

There are plenty of owls in Disney films. In the films made during Walt's lifetime, the cliché of a wise old owl pops up in several cartoons. Whether as a judge in the Silly Symphony *Who Killed Cock Robin?* (1935) or as a sagacious professor in films like *So Dear to My Heart* (1948), *Toot, Whistle, Plunk and Boom* (1953), and *Adventures in Music: Melody* (1953), there is often an owl filling that role in the animal kingdom.

Sometimes, the owl is a smart friend like Archimedes in *The Sword in the Stone* (1963), or (with a humorous twist on an owl's supposedly expert knowledge) the pseudo-intellectual owl in the Winnie the Pooh featurettes, or the misanthropic Friend Owl in *Bambi* (1942), whose physical appearance was based on animator Mel Shaw's caricature of writer Alexander Wolcott, who had given a lecture at the Studio.

There aren't owls in every Disney film about animals, and those that do appear are minor characters. There has been speculation that the inclusion of so many owls in Disney films was not just because they were a common part of the animal kingdom, but because Walt was somehow troubled by the seemingly all-knowing bird.

In 1906, Walt's father purchased a small farm on County Pike Road in Marceline, Missouri. It had plenty of grazing land for cows, as well as room for raising crops like corn and wheat. In particular, there was an apple orchard with trees that had to be pruned and harvested by hand, something that even young Walt could help with during his time there.

His father, Elias, attempted to make some extra money by selling the juicy fruit the trees produced, but it did not generate significant income. In the fall, the trees in the orchard hung heavy with crispy red Wolf River Apples, "so big that people came from miles around to see them", Walt recalled.

In the March 6, 1938, issue of *The New York Times*, Douglas W. Churchill wrote an article entitled "Disney's 'Philosophy'". With all the direct quotes from Walt in the piece, it was obvious that Churchill had a nice, personal chat with the creator of Mickey Mouse.

The article opens with:

> An owl drowsing in the cool shade of a tree on a Missouri farm one afternoon 30 years ago influenced the career of a man and helped fashion the fantasy of an era. Blinking in the uncomfortable light, the bird felt hands encircling it. Instinctively it beat its wings and clawed, and just as instinctively a frightened lad of seven hurled the owl to the ground and, in his terror, stamped on it.
>
> That owl is the only thing that Walt Disney ever intentionally killed. The incident has haunted him over the years. Occurring in a formative period, it directed his attention, subconsciously, to the birds and gentle beasts that play such an important part of his craftsmanship, and helped to shape his philosophy.

In 1956, Walt vividly recounted the incident to Pete Martin, even though Walt was only seven years old when it occurred:

> Something happened to me when I was on the farm [in Marceline, Missouri] there that I've never forgot. There was

a big owl in the tree. It was a Sunday. I'll never forget it. It was just dull. Folks were all doing something else. There was nothing for me, you know? I didn't have anybody to play with then. So, the owl was up there.

And he flew away and I followed him and he went over in the orchard and he landed on a low limb in the orchard. Well, I don't know why but I wanted to catch that owl. It was one of these big brown owls. So I snuck up behind the owl and ... I grabbed this owl. Well, he immediately began to claw and fight and I threw him on the ground. In my excitement, I stomped on him and I killed the owl. That thing haunted me for a long time afterward.

I could see that darn owl in my dreams, you know? But I was just so excited. I didn't want him. I didn't want to kill him. But when he began to claw and everything else, I got so excited I threw him on the ground and stomped on him, you know? And I killed him. I didn't want to kill him. I didn't have it in my mind at all. And I don't know yet why I wanted to have that owl. It was just ... I could catch him, you know? He was on a low limb there.

Walt did indeed kill an owl accidentally when, as a young, bored seven-year-old child, he got flustered and surprised, and reacted instinctively to stop something that was moving around wildly and scaring him. He was sincerely and deeply sorry about that moment. The fact that he continued to have nightmares about it shows how intensely it affected him.

Certainly, many things Walt experienced in Marceline, from trains to the circus to so many other first experiences, influenced his approach to things later in his life. The killing of the owl may indeed have influenced Walt's philosophy that animals had just as much right to live their lives as humans do theirs.

Marjorie Davis, Walt's niece, remembered an incident that took place at Walt's home in Los Angeles:

One time, the gardener was complaining because the squirrels were eating all the fruit. He had planted all these beautiful fruit trees down the canyon by the house. [The gardener had planned on poisoning the squirrels but Walt wouldn't allow it. Walt] just said, "Plant some more. Plant enough for everybody. Look, you can go to the market to buy fruit. They can't."

One visitor to the Disney Studios, Mrs. Ted Cauger,

recalled that while they were walking outside, Walt gently picked up a worm from a tree and, holding it up, lectured:

This is one of God's creatures ... and we don't harm them.

In "At Home with Walt Disney", an article by Elmer T. Peterson for the January 1940 issue of *Better Homes and Gardens* magazine, one quote stands out:

I couldn't kill any animal — least of all a mouse.

# The Mickey Rooney Myth

*The story debunking the myth that Mickey Mouse's
name was inspired by actor Mickey Rooney.*

Everyone loves a good story, whether it is true or not.

In her later years, when she appeared on various talk
shows, actress Judy Garland told many hilarious and
outrageous anecdotes about working on the set of *The Wizard
of Oz*, especially tales of drunk and perverted munchkins.
Fortunately, Ozian researchers have debunked some of the
more extreme recollections without undercutting their
respect for Garland's performance and talent.

Garland was often paired with another talented performer,
Mickey Rooney, who also liked to tell a good story for the press.
Rooney has had a rich and colorful life filled with so many
triumphs and so many interactions with so many interesting
people that it seems odd he would find it necessary to fabricate
an event just for the sake of another good story.

But that is exactly what he does in his story about the
naming of Mickey Mouse.

Most Disney fans know that Walt originally intended to call
his creation Mortimer Mouse, but at the urging of his wife,
Lillian, he changed the name to the more friendly sounding
Mickey. No one has ever challenged that story, and there is
much independent documentation, including private inter-
views with Lillian and Walt's brother Roy, that confirm it.

On Friday, May 21, 2004 (ironically seventy-six years to
the day that the Mickey Mouse trademark was filed by Walt
Disney in 1928), the Pacific Pioneer Broadcasters had a

luncheon in Southern California to honor screen legend Mickey Rooney, who was then eighty-three years old.

At the presentation, Rooney was talkative and funny, and did honor to his reputation as a cinematic legend. He told many of his favorite anecdotes, including — unfortunately — one that I believe first appeared in his 1991 autobiography, *Life Is Too Short*.

On a lunch break while filming the Mickey McGuire comedies, five-year-old Rooney walked by an open office at Warner Bros. Studios, poked in his head, and introduced himself:

> "Who are you?" I asked the guy working there.
>
> "My name is Walt Disney," he said. "Come over and sit on my lap."
>
> So I went over and sat on his lap, and there was a mouse he had drawn.
>
> "My gosh, that's a good-looking mouse, Mr. Disney."
>
> "It sure is, Mickey," he said, and he stopped and looked into space for a minute. "Mickey, Mickey," he said. "Tell me something, how would you like me to name this mouse after you?"
>
> And I said, "I sure would like that, but right now I got to go and get a tuna sandwich." And I jumped down.
>
> "It's a true story," added Rooney, as he regaled the crowd.

No, it's not a true story! Rooney only began telling this fabrication decades after Walt Disney passed away and Walt was unable to debunk it, just like so many other Disney urban myths.

Several websites repeat Rooney's story as fact, and several sites embellish it by claiming that one of the reasons Walt named his famous mouse Mickey was that he briefly dated Mickey Rooney's mother. That's not true, either.

Sometimes Rooney claimed he was walking down the street on the back lot, and Walt called out to him from his office window to come in and look at his new character. Sometimes Rooney murmurs the word Mickey under his breath repeatedly and Walt gets a "thoughtful look". Sometimes it is not even a tuna sandwich but a cheese sandwich.

There are several variations, but in all of them, Rooney claims he was the inspiration for the name of Mickey Mouse.

Of course, over the years, some of the most outrageous stories have been proven to have an element of truth, but the facts here undercut even that possibility.

Mickey Mouse was created in 1928. Mickey Rooney didn't even become Mickey Rooney until he officially changed his name in 1932. He was born Joe Yule Jr. on September 23, 1920, and that was his name in 1928.

Rooney got his big break in films at the age of six, when he was cast as the lead in a series of several dozen comedy two-reelers beginning in 1927 and named for Mickey McGuire, a character from a popular comic strip known as the *Toonerville Folks* by Fontaine Fox.

The live-action *Mickey McGuire* series was designed to compete with Hal Roach's successful *Our Gang* comedies. The Warner Bros. series was popular enough to span from the silents to the talkies, with dozens of *Mickey McGuire* comedies made between 1927-1933.

The character of Mickey "Himself" McGuire, a tough little gang kid with ragged clothes and an oversized derby hat, was a popular figure in the comic strip, and spawned some equally popular toys as well.

In *Mickey's Thrill Hunters,* the gang starts their own window-washing business. In *Mickey's Race,* Mickey enters the Toonerville Derby Day races with a mule. In *Mickey's Luck,* the gang becomes volunteer Toonerville firemen, and end up freeing all the livestock of the town's pet store.

So there is the possibility that if Joe Yule Jr. had been introduced to Walt Disney in 1928, he would have been introduced as the star of the *Mickey McGuire* comedies, which at that time would have been in production for almost a year.

Giving Rooney the benefit of the doubt, he would have been seven years old — not five as he claimed — when he met Walt Disney at Walt's Warner Bros. office, and Joe Yule Jr. might have referred to himself as Mickey rather than his real name.

Except Walt never had an office at Warner Bros. nor any connection with Warner Bros. Not only did Disney have his own studio on Hyperion Avenue at that time, but his *Alice Comedies* and *Oswald the Lucky Rabbit* cartoons were distributed by Universal. So it makes no logical sense that Walt would have an office at Warner Bros.

Speaking of Universal, one of the reasons that Walt was desperately creating Mickey Mouse in 1928 is that his pre-

vious creation, Oswald the Lucky Rabbit, was firmly in the hands of Charles Mintz and Universal, and had been taken away from Walt along with just about all of his animators.

With the success of the synchronized sound *Mickey Mouse* cartoons, Universal decided to give Oswald a voice as well. The director of the series, Walter Lantz, hired young Mickey Rooney to provide Oswald's voice in 1929-1930. So did Rooney confuse the two Walters and the two characters?

The story that Walt Disney dated Mickey Rooney's mother is another myth.

When Mickey Rooney was three (1923), his parents divorced and his mother took him to Kansas City, Missouri. But by the time they got there, Walt had already left to seek his fortune in Hollywood. She very briefly came out to Hollywood in 1924 so Mickey could audition for the *Our Gang* comedies. Supposedly, however, Hal Roach thought he was too "slick", and so Mickey and his mother went back to Kansas City almost immediately. They did not return to Hollywood until 1926.

Walt married Lillian Bounds in July 1925. Walt never seemed to have the interest or the finances to casually date and, for the most part, seemed oblivious to any woman who might have been interested in dating him. In addition, he was so firmly focused on his work that he had little time for casual dating, especially during this time period. Once he started his studio in Hollywood in 1923, there is no evidence that he dated anyone until he started seeing Lillian.

The final nail in the coffin for this urban legend is that Walt Disney himself loved telling stories, and if there were any truth at all in this tale connecting the creation of his mouse with a young Mickey Rooney, he would have loved to share it with reporters because it would have garnered publicity.

In fact, it was Walt himself who implied to a reporter that Tinker Bell was inspired by Marilyn Monroe, a falsehood that creator Marc Davis spent the rest of his life refuting.

At the time Tinker Bell was being developed, Marilyn was a struggling actress who had not had a leading role, nor had her infamous *Playboy* centerfold yet appeared. It is apparent from Disney Studios' records that the live-action reference model, Margaret Kerry, was the physical source for Tinker Bell.

But when *Peter Pan* premiered, Walt casually implied that the now popular Miss Monroe was the inspiration for Tinker Bell because it was a good story and would generate publicity for the film.

Myths aside, there are several legitimate connections between Mickey Rooney and Disney.

Among other Disney credits, Mickey Rooney was the voice of the adult Tod in the animated feature *The Fox and the Hound* (1981), the character of Lampie in *Pete's Dragon* (1977), and the voice of Sparky the Junkyard Dog in *Lady and the Tramp II: Scamp's Adventure* (2001). In addition, an animated Mickey Rooney caricature teased Donald Duck in the animated short *The Autograph Hound* (1939).

Tim Rooney and Mickey Rooney Jr., the sons of Mickey Rooney, were cast as part of the original Mouseketeers for the 1955 season. They were released from their contract shortly after filming began due to what has been described as an "unruly and mischievous foray into the Disney paint department".

While it might be interesting to speculate whether the popularity of the Mickey McGuire character in films, comic strip, and merchandising planted the Mickey name in the consciousness of Walt and Lillian as a more audience-friendly name than Mortimer, it is clear that no chance meeting between Mickey Rooney and Walt Disney gave the world another Mickey.

# J. Edgar Hoover Watches Walt

*The story of how Walt Disney got on the
"bad boy" list of the director of the FBI.*

The Federal Bureau of Investigation file on Walt Disney is over two-hundred-and-fifty pages long, and is just one of three sections devoted to the Disney Studios. Most of the documents in the file are internal memos and telegrams that were sent to and from FBI Director J. Edgar Hoover and his agents or staff.

In July 1936, as Walt traveled to Kansas City for the National Conference of the Order of DeMolay, the local office of the FBI took his fingerprints and forwarded them to the main headquarters in Washington, D.C. Hoover wrote to Walt to tell him that his fingerprints were now on file in the Civil Identification Unit. Hoover's standard practice was to keep fingerprint identification of public figures for a variety of reasons, including to verify the victim's identity in the case of accidental death.

That was the beginning of Walt's FBI file. It continued to be maintained and expanded until Walt's death thirty years later in 1966. The file also included photostats of newspaper and magazine articles, photographs, and advertisements.

There was even a confidential memo from 1945 concerning the formation of the Inter-Racial Film and Radio Guild that included stage and screen actor Clarence Muse's comments in December 1945 that he:

> ... had been called by the Disney Studios and put on salary to

render an expert opinion on [the film then called *Uncle Remus*]. Muse stated that he had rendered this opinion and the studio had objected to it. Muse stated he desired that the Negro characters be depicted as dignified characters, whereas studio officials insisted on portraying the Negro in an inferior capacity. In concluding, Muse made a strong appeal to the Negro press and right thinking Negroes to take action against this type of policy on the part of studio officials.

Walt's trouble with the FBI began in 1956, when he decided to produce a segment for his popular children's afternoon television program, the *Mickey Mouse Club*, showing America's youth the fine work of Hoover's FBI. It took over a year for that segment to be produced with the necessary FBI approval of the script and rough-cut footage.

Walt and Hoover were both men who hated to yield any type of control and be told what to do. As the air date for the program approached, Walt delayed sending the final cut of the segments to the Bureau, which led to concern and threats in FBI memos sent to the Disney Studios. Finally, on the morning that the show was to be aired, the FBI got to review the final cut and saw that all their suggestions had been followed, resulting in their official approval of the show.

An internal FBI memo dated January 23, 1958 (one day before the actual broadcast) stated:

> Obviously, the mishandling on the part of the Disney Studios and failure to live up to their agreement will be taken into consideration when future approaches are made to the Bureau by this outfit.

A cordial relationship had been severely strained, and some at the Agency were angry over Disney's perceived snub. Associate director Clyde Tolson, Hoover's protégé, wrote on the memo: "No further cooperation is to be extended the Disney Studios."

Those ill feelings bubbled to the surface just a few years later.

Released in Spring 1962 to capitalize on the public's interest in the historic Space Race between America and Russia, *Moon Pilot* is a slight live-action Disney comedy loosely based on the lighthearted novel *Starfire* by Robert Buckner.

Walt Disney visited Vandenberg Air Force Base to see the

launching of an Atlas missile during the early preparation for the film, and toured control rooms and other facilities. Much of the information was highly classified, and Walt was not permitted to use some specific details in the final film.

In the story, Astronaut Captain Richmond Talbot accidentally volunteers to become the first man to go into outer space. Given three days to visit his family before blast-off, Talbot encounters a mysterious and attractive young woman known as Lyrae, who seems to know everything about the secret mission.

The Federal Security Agency tries to capture this suspected spy. It turns out that Lyrae is from another planet, and has information about a major defect in the coating of the space capsule that must be corrected before the flight. After a series of comedic misadventures, Talbot and Lyrae fall in love, and the flight is successful.

Why did a seemingly harmless piece of Disney film fluff get under the skin of J. Edgar Hoover and result in twenty-two pages of documents being added to Walt Disney's FBI file? Strangely, it had nothing to do with classified information about the space program.

This is the story behind the story, and no names have been changed to protect the innocent.

The Federal Bureau of Investigation monitored many publications. Hoover had read in Hedda Hopper's "Hollywood" column (*New York Daily News*, February 20, 1961) that actor Edmond O'Brien had been cast as an FBI agent in *Moon Pilot*, a forthcoming Disney live-action film.

On February 24, 1961, Hoover sent a telegram to the Special Agent in Charge (SAC) of the Los Angeles office to state his concern about "the nature of the script and how the FBI agent is portrayed". He probably was also aware that O'Brien physically looked somewhat like himself.

Things heated up even more when copies of *The Saturday Evening Post* featuring the serialized story were sent to Hoover on March 1, 1961. The synopsis, sent in a memo on March 13, indicated that the Air Force officer was "continually outwitting surveilling agents" who are "generally pictured as bumbling, heavy-footed incompetents". The story also states:

The principal FBI agent, who, it develops, is a flying saucer fan, pleads with the Air Force officer in the final scene ... "If you'll tell me where the girl really came from I'll promise not to tell anybody, not even J. Edgar Hoover, on my word of honor."

In a March 16 memo to the Los Angeles SAC, Hoover wrote:

You should arrange to personally confer with Walt Disney concerning his proposed filming of the story *Moon Pilot*. Tactfully point out to him the uncomplimentary manner in which FBI agents are depicted. Advise him that the Bureau will strongly object to any portrayal of the FBI in this film. As you will note from the story, FBI action basically involves guarding of the Air Force officer who is to make the first flight to the moon. Suggest to Mr. Disney that since FBI jurisdiction does not extend to the guarding of individuals that this action can be better represented by another government agency. Handle diplomatically.

In a memo dated March 17, the Los Angeles SAC wrote that he had already met, on March 15, with associate producer (and Walt's son-in-law) Ron Miller at the Disney Studios, and that Miller had:

... inquired concerning any limitations or regulations which exist in connection with the portrayal of FBI agents or reference to the FBI in film productions. Miller commented that the studio wants to submit the script, which will not be ready for several weeks, to the Bureau for its review and reaction. He will contact this office when the script is ready for submission.

The SAC informed Miller of Public Law 670, a Federal statute that prevents the commercial exploitation of the name of the FBI or the use of it in such a way to imply a commercial endorsement by the Bureau. Internal Disney memos suggest that Walt had consulted with the Disney Studios legal department, which informed him that such a challenge could not successfully be used in court to stop production. The friendly reminder by the SAC did indicate the FBI's displeasure.

On March 24, the SAC talked personally with Walt at the Studio to tactfully point out that the FBI felt the portrayal of its agents in the film was not complimentary. In a March 27 memo to recount the meeting for Hoover, the SAC wrote:

Disney said that if Bureau objects, he would change the script to eliminate the FBI and substitute another security agency but he feels that this would be unrealistic since the situation, in his opinion, properly warrants portrayal of the FBI. He stated that there have been changes in the script and that the treatment of the FBI is most complimentary to the Bureau and depicts the FBI as solving the case. He requested that Director Hoover review the script before the final decision. Disney pointed out that the situation involves espionage, which is under FBI jurisdiction, and states it would be an inaccuracy to call in any other agency. Disney stated the script would be available within a week or two. He stated that he would never portray the FBI other than in a favorable light due to his esteem for the Director and the Bureau.

Six weeks passed, and no *Moon Pilot* script was sent to the FBI, nor had one been sent to the Motion Picture Production Code office for approval. However, production on the movie started on May 8, 1961, with filming in San Francisco.

A memo to Hoover on May 10, 1961, noted that filming had begun, and that William (Bill) Anderson, the executive producer, had informed the SAC that the script had been amended to portray the previously described FBI agent as:

> ... a government security officer and no reference is made to this Bureau in the film. ... According to Anderson, actor Edmond O'Brien is portraying the role of the security officer and filming is expected to be completed in about four weeks. ... The Air Force is cooperating with the studio on this film, and some shooting is being undertaken on location at Vandenberg Air Base near Lompoc, California.

In fact, it took roughly three months of filming to complete the movie, and there is no further documentation in Walt's FBI file until a memo dated January 17, 1962, after the film had been released:

> The Air Force has a problem. They cooperated in this movie to the extent of furnishing a Technical Director, making some stock footage available and furnishing air craft for a scene or two. The credits now gratefully acknowledge the cooperation of the Air Force and, from the discussion among Air Force officers present at the showing of this film, it is apparent that they feel the public will identify them as having approved the film. They do not approve and were

discussing means of getting a change made since the film sent to them is the final print. Of course, no comments or suggestions were made to them by our Agent.

Of greater interest to Hoover, the memo stated:

> The investigators identify themselves as "Federal Security". The public would not identify these people with the FBI. The portrayal of Federal Security is entirely slapstick. There are no references which would indicate that the name Federal Security is a cover up for FBI. There are lines reflecting referring of material to the Laboratory but what Laboratory is not specified. Credentials are exhibited only one time and the face of the credentials are never seen. Only the leather cover is observed and it is in bright red.

In a stern letter dated April 24, 1962, after the film had gone into wide release and been reviewed, Agent DeLoach wrote:

> It was my understanding that Mr. Disney had originally intended to portray FBI Agents in this movie and he has done so to all intents and purposes, despite our protests, even though the Agents are not named as such. Needless to say, the Boss (Hoover) was amazed that Disney would produce such a picture which carries implications or criticisms of the FBI. I can only hope that the general public, in viewing this film, will not interpret the investigative efforts depicted as representing the work of the FBI as some movie reviewers have done.

Attached to the letter was a copy of James O'Neill's review of the film from the April 26, 1962, *Washington Daily News*:

> Air Force brass are mutton-heads, and the FBI is as ineffectual as the DAR. ... Walt Disney's targets in *Moon Pilot* are not, actually, anybody in space. The boys he's leveling his humorous rifle at are members of Congress, the Air Force, the FBI and French movie starlets. ... *Moon Pilot* is a lot of fun and the kids ought to adore it. They won't even understand where Disney's pot shots are aimed.

This review is in Walt Disney's FBI file, along with a hand-scribbled note written by Hoover himself: "I am amazed Disney would do this. He's probably been infiltrated."

By 1962, Hoover had become very protective of his own image and that of the Bureau. In his mind, anyone who

would treat his organization with such humor and disrespect must be a Communist sympathizer.

Another Washington DC newspaper, *The Evening Star*, ran a review from Jay Carmody on April 23, 1962:

> Walt Disney is in an impudently comic mood in *Moon Pilot*, an Easter offering to moviegoers in which he takes an irreverent glance at space exploration. By the time, he has finished with the subject in the film, space itself is strewn with such awesome casualties as NASA, the Air Force, the FBI and even the astronaut team which is sowing the seeds of a truly universal traffic problem. These are not actually identified in every case but they could not be more thinly disguised in what is intended as innocent fun. Well, fun. ... It is all very slapstick and impertinent but Tom Tryon as the astronaut, Dany Saval as the girl and Edmond O'Brien as the intelligence genius and Brian Keith as the general make it quite hilarious.

A master storyteller, Walt Disney knew an audience enjoyed the tweaking of authority. In fact, it was the foundation for many of the films of Charlie Chaplin, an inspiration for Walt. But neither Hoover nor the FBI had much of a sense of humor.

It is important to realize that this film was produced during the Cold War and that most (if not all) Americans believed the government knew what it was doing and always did things in the best interests of the public. A very serious space race was going on between the United States and the Soviet Union, with the Soviets seeming to have the upper hand, so the topic of the effectiveness of national security was no laughing matter.

Walt may not have been completely innocent. There is no indication that Walt sent a copy of the final shooting script to the FBI for review. He may have felt that, since the film no longer depicted FBI agents, there was no need to do so.

However, one of the newspaper advertisements had cartoon caricatures of Edmond O'Brien, Brian Keith, and Tom Tryon in space helmets straddling a flying rocket ship in pursuit of a floating cartoon caricature of Dany Saval, who portrayed the female alien, Lyrae. The copy for the advertisement was:

> The F.B.I. thought she was a SPY! ... The General thought she was a KOOK! ... The Astronaut thought she was OUT-OF-

THIS-WORLD! ... and she was OUT-OF-THIS-WORLD! (She's from a planet that has 7 moons ... all made for LOVE!)

The advertisement clearly indicated the bumbling character played by O'Brien was from the FBI, not the Federal Security Agency. It appeared in newspapers around the country.

Oddly, this advertisement never made it into Walt's FBI file, nor did any memo commenting upon it.

It wasn't long after *Moon Pilot* that Disney was again on the FBI radar. On July 11, 1963, a Los Angeles FBI agent sent a memo to Hoover informing him that Walt Disney had bought the film rights to a book called *Undercover Cat*. Walt intended to make a film based on the story, but to release it under the title *That Darn Cat!* (In the book, the name of the cat, D.C., stood for Damn Cat.)

The book was written by the husband-and-wife team of Gordon and Mildred Gordon. Gordon Gordon was a former FBI agent who had challenged the Bureau over the years with his literary portrayals of FBI agents. The duo's novels *FBI Story* (1950) and *Operation Terror* (1961) were the inspiration for popular movies. (*Operation Terror* was released in theaters as *Experiment in Terror*.)

Walt tried to reassure the Los Angeles SAC that "any portrayal of the FBI or its agents in this picture would be done in a dignified and efficient manner", but FBI documents from the time emphasized that the Bureau considered this as:

> ... just another instance where Gordon Gordon is trading on his former affiliation with the FBI to further his own personal motives. Certainly any production or book authored by Gordon is not going to do the Bureau any good.

*That Darn Cat* was released in December 1965 to positive reviews. The good-looking but somewhat bumbling FBI agent Zeke Kelso was played by actor Dean Jones. The film's writers, Mildred Gordon, Gordon Gordon, and Disney Legend Bill Walsh, were nominated by the Writers Guild of America for Best Written American Comedy. It was the last Disney movie in a series of six for the young actress Hayley Mills.

This incident would be the last problem that Walt had with the FBI because, about a year later, Walt passed away. Hoover sent a telegram of sympathy to Walt's wife, Lillian, praising Walt's "dedication to the highest standards of moral values".

# The Myth of Walt's Last Words

*The story debunking the legend of*
*Walt Disney's final words.*

Many believe that, just like Charles Foster Kane in the classic movie *Citizen Kane* (1941), who uttered the cryptic one-word clue Rosebud on his death bed, Walt Disney also left a final enigmatic clue just before he passed away.

The legend of Walt's last words has been around for decades. Several years ago, they again took the spotlight.

In April 2007, on the *Jimmy Kimmel Live!* talk show, actor Kurt Russell, who was promoting his new film *Death Proof,* confirmed that the last words Walt Disney wrote before he died in December 1966 were "Kurt Russell":

> It's true. I don't know what to make of that. I was taken into his office one time after he died and I was shown that.

In 1966, Kurt played a feature role in Disney's *Follow Me, Boys!,* a film that also starred Fred MacMurray as a Boy Scout master who adopts Russell's character, a troubled youth. Supposedly, after this film, and at Walt's urging, Russell was put under a ten-year Disney Studios contract.

Russell went on to star in several Disney live-action films, including *The One and Only, Genuine, Original Family Band, The Barefoot Executive,* and as Dexter Riley in *The Computer Wore Tennis Shoes* and its two sequels: *Now You See Him, Now You Don't* and *The Strongest Man in the World.* He was also loaned out to other productions.

Russell enjoyed his time at the Disney Studios. As he told Howard E. Green and Amy Boothe Green for their excellent and highly recommended book *Remembering Walt: Favorite Memories of Walt Disney* (Disney Editions 1999):

> Sometimes he'd [Walt] come down to the set and ask, "Do you want to see part of a movie that's being put together?" So I'd watch a movie or parts of a movie with him and we'd talk about it, and he'd ask me questions.
>
> What was interesting about Walt, as I look back on it now, is that he was picking the mind of an uninhibited 13-year-old. He would ask, "What do you think of this?" and we'd kick ideas back and forth. I think he was finding out how a young mind worked.
>
> The script lady pulled me aside one day and said, "I think they're going to offer you a contract. Do you know why Walt likes you? Because you're not intimidated by him." I never could figure out why anybody would be intimidated by him.
>
> He didn't blurt things out like a child. He sat and thought. I think he was a realistic dreamer. He was slower and a little more thoughtful and had an awareness about him. You felt like he was taking in the whole room.
>
> When I was over at Universal working on a Western while under contract at Disney, I was shooting a close-up and noticed there was some hubbub going on off camera. Then everybody went quiet. They were looking at me and I thought, "What the hell's this?"
>
> This guy came over to me and said, "I'm sorry to tell you this, Kurt, but Walt Disney died." They were all very sweet. The director asked me if I was okay to work and I said, "Oh, yeah, sure. Go ahead."
>
> His death was a surprise and I was saddened by it. But, I don't look at death as some sort of finality. It's sad you won't be able to spend time you had together. At that moment, I immediately appreciated the time I shared with Walt more than ever.
>
> What Walt represented to me was someone who was constantly aware of what might be fun to do, not necessarily cutting edge or different or what would blow people away, but what might be fun. I remember he would always say, "Wouldn't that be fun?"

Walt liked the clean-cut, enthusiastic young Russell, but he liked a lot of the other young performers who worked for the

studio as well. There was no evidence of a special bond between the two any different from Walt's other interactions.

So why would the last words that Walt wrote be "Kurt Russell"? The obvious answer was Walt might have been considering the actor for a role in an upcoming Disney production and wanted to make sure he wrote down the name to pass along to others at the Studio for follow-up.

The challenge with these types of stories is to find a smoking gun, and not rely on logical assumption but rather some hard fact or quotation as solid proof, because sometimes the logical answer is not always the correct one.

For more than a decade, that smoking gun has stared Disney historians in the face. It wasn't hidden. It was in plain sight of millions of Disney theme park visitors if they had bothered to look closely instead of rushing somewhere else.

Walt Disney had two offices. He had a formal office to officially greet visitors to the Studio that included the bookcase and the piano so familiar to viewers of his weekly television program. Next door, he had his working office, where he would read scripts, catch up on his mail, and hold meetings with Disney Studios personnel. Both offices were closed and locked and undisturbed after Walt's death, with only a maintenance person occasionally going inside to dust and vacuum.

When the Walt Disney Archives was established in June 1970, one of the first tasks assigned to founder and former chief archivist Dave Smith was to accurately inventory everything in Walt's offices. Thanks to Smith's careful documentation, the two offices were re-created in accurate detail from the carpet to the ceiling tiles in 1973 for The Walt Disney Story attraction in Disneyland's Main Street Opera House.

On October 1, 2001, at what was then the Disney-MGM Studios, a new attraction, Walt Disney: One Man's Dream, opened as part of the "100 Years of Magic" celebration. With great care and at great expense, Walt's working office from the Disneyland exhibit was installed "temporarily, just for the celebration". The office remains there more than a decade later.

The contents on the desk are exactly the same as Walt left them on his last day in the office, including the exact same paperclips. There were scripts that Walt was working on, along

with a battered, open briefcase nearby that he would have used to take the scripts home for review.

Also on Walt's desk are copies of the company magazine, *The Disney World*, along with such papers as a note "to discuss with Card Walker and others" the "Progress Report on the Disney World Project" (dated September 8, 1966). Nearby, almost forgotten, is a typewritten list of possible live-action productions entitled "TV Projects In Production: Ready for Production or Possible for Escalation and Story". At the very bottom of the list, Walt used his famous red grease pencil to make the following notes:

```
Ron Miller—
2 Way Down Cellar
2. Kirt [sic] Russell
3. CIA—Mobley
```

What does it mean?

Ron Miller was Walt's son-in-law and a producer on some of the live-action films. Walt had been giving him more responsibility in that area.

A little more than a year later, in January 1968, the weekly Disney television show offered the two-part live-action story *Way Down Cellar*, based on the novel of the same name, just as Walt indicated. In the film, during a friendly football game, three young boys search for their lost ball after a bad pass and discover an entrance to a secret tunnel hidden in the ruins of a burned-out church. One of the boys' roles was played by Butch Patrick, better known as Eddie Munster from the popular television show *The Munsters*.

Kurt Russell's name is misspelled, and just below it is a reference to young actor Roger Mobley, who played the lead role in the *Gallegher* series on Disney's weekly television show.

Right up to the end, Walt was not just working on the Florida Project (which became Walt Disney World) but also other Disney Studios projects, including its upcoming live-action films. He indicated that *Way Down Cellar* should be a two-parter, and that perhaps Russell or Mobley or both would be good for the roles. CIA was apparently a reference to the talent agency that might be representing Mobley at the time.

So why was Russell shown this piece of paper? Former Disney archivist Dave Smith shines light on that situation:

These were obviously projects that he [Walt] thought would be good to do. In the early 1970s, when we still had this office up at the Studio, Kurt Russell was on the lot filming *Now You See Him, Now You Don't*. I went down to the stage one lunch time and I said, "I've got something I'd like you to see up in Walt's office." I took him up to Walt's office and showed him one of the last things that Walt had written was his name. I think he was quite impressed even though Walt misspelled it. He's got Kurt [as] "Kirt".

And that is how urban legends begin: a little bit of truth mixed with a lot of false assumptions.

# Walt Liked Ike

*The story of how Walt Disney became a
conservative Republican and produced
Disney's only animated political television ad.*

In its September 19, 2010, issue, the *Orlando Sentinel* reported that, since the start of 2009, Walt Disney World had doubled its contributions to Florida's Republican Party. Those contributions totaled $525,000 in money (different Disney entities like the Disney Vacation Club, Disney Cruise Line, Disney Gift Card Services, etc., can each make separate contributions so that the grand total exceeds the maximum amount allowed by state law from one company) and $53,000 in tickets, rooms, and meals. Contributions to the Florida Democratic Party totaled $246,000.

Companies do not make campaign contributions merely in the interest of good government. Companies make contributions in the interest of being heard on issues like restricting lawsuits from "slip and fall" accidents, limits on fees trial lawyers can earn in workers' compensation cases, and support for more publicly-funded tourism advertising.

In the mid-1980s, shortly after Michael Eisner took over the reins as CEO of the Disney Company, he attended a large group presentation where, without hesitation, Roy E. Disney, Walt's nephew, cheerfully lauded Mickey Mouse as a "good Republican mouse". Eisner had to hurriedly explain that Mickey Mouse had no political affiliation and loved members of all political parties.

Walt Disney himself was apolitical. For the majority of his

life, he showed little interest in politics. He had built his own kingdom and even his cartoons reflected moments of both liberal and conservative agendas.

When science fiction author Ray Bradbury seriously suggested that Walt run for mayor of Los Angeles, since then Disney would be able to utilize innovations like the monorail to save the city from urban chaos, Walt replied with a smile, "Why should I run for mayor when I am already king?"

When asked the same question by writer Arthur Miller in *Los Angeles Magazine* (November 1964), Walt responded:

> Gosh, not for me. Sam Yorty [then mayor of Los Angeles], for all anyone knows, may be a very good mayor. But how can he prove it? He hasn't got the authority to get things done. Talk about rapid transit — he had all he could do to get the garbage picked up. It's not a mayor we need — it's some power for him, whoever he is.

Disney Legend Joe Grant, who accompanied Walt on several trips to Washington, D.C., told author Neal Gabler that Walt "was very apolitical, believe me. He was an extreme liberal at one time, viewing socialism as about everybody pulling together."

To call Walt Disney politically naïve would be an understatement. As early as 1931, a Nazi newspaper condemned Mickey Mouse as:

> ... the most miserable ideal ever revealed ... the dirty and filth-covered vermin, the greatest bacteria carrier in the animal kingdom, cannot be the ideal type of animal. ... Down with Mickey Mouse!

Adolf Hitler repeatedly denounced Mickey Mouse, and in 1937, tried to ban Mickey completely from cinemas in Germany. In *Overland Monthly* magazine, Walt responded:

> Mr. A. Hitler, the nazi old thing, says that Mickey's silly. Imagine that! Well, Mickey's going to save Mr. A. Hitler from drowning or something some day ... then won't Mr. A. Hitler be ashamed ... .

At most, Walt might have worried about Hitler's effect on the foreign market distribution of his animated product, but he wasn't politically astute enough to determine how Hitler's political agenda would have any impact on the American way of life. As Walt admitted in a letter dated August 13, 1940:

A long time ago I found out that I knew nothing whatsoever about this game of politics and since then I've preferred to keep silent about the entire matter rather than see my name attached to any statement that was not my own.

In his 1956 interview with author Pete Martin, Walt said:

My father was a Socialist. He used to get the [Socialist newspaper] *Appeal to Reason*. It would come to our house every week. I was trying to learn to draw so I copied cartoons in the paper. I got so I could draw cartoons of "Capital" and "Labor" pretty good, the big fat capitalist with the money with his foot on the neck of the laboring man with the little cap on his head.

My dad before he was a [Eugene] Debs man, he was a [William Jennings] Bryan Democrat. He became a Debs man and Socialism in those days is not what we think of it as today. They were advocating certain reforms that were ever more liberal. A Socialist then is what we might call a liberal Republican or liberal Democrat today.

Radical screenwriter Maurice Rapf, who worked for several years at the Disney Studios as a contributor to the screenplays for *Song of the South* and *So Dear To My Heart*, recalled Walt's politics in an interview in the book *Tender Comrades*:

[Walt] was very conservative except in one particular — he was a very strong environmentalist. He once told me why he was a conservative when I asked him. I said, "It doesn't make any sense for you to be as conservative as you are." He told me a story, in the presence of other people, explaining why he had become a conservative.

He said it had to do with the fact that his father was a Socialist. They lived in Kansas City, Missouri, which was run by the Pendergast Democratic machine. There was an election coming up and a bunch of Irish kids, the sons of the ward heelers who worked for the Democratic machine, stopped him on the street and asked him, "How's your father going to vote in this election?" Disney said, "Well, he ain't going to vote for your candidates. He's going to vote for Eugene V. Debs". Or something like that.

Disney said that these kids pulled down his pants and then put hot tar on his balls. He said, "From then on, I was always a dyed-in-the-wool Republican." I think [Walt] was a decent enough guy who was very conservative and it got worse as time went on and as he got richer.

It was most likely the 1912 election, at which time Walt was almost eleven years old, when this incident supposedly happened.

As Walt told Pete Martin:

> Gradually I became a Republican. In the election of 1936, I just couldn't go Republican. [Alf] Landon was running and my brother Roy and I spilt. Roy went Republican and I voted for [Democrat Franklin] Roosevelt. By 1940 and everything that happened in the next four years, I was right back on the other bandwagon. I became a [Republican Wendell] Willkie man. He was a great man. My folks voted for Willkie.

Yet, Walt politely refused a request from the Willkie campaign for an official endorsement.

In 1941, an acrimonious strike at the Disney Studios resulted in a major shift of Walt's political preference. Whether it was his disappointment with how the Democratic Roosevelt Administration handled the strike, basically granting the strikers almost everything they wanted, or whether it was Walt's belief that the strike was the work of Communists and that Republicans were more aggressive in their fight against that ideology, Walt did indeed become a "dyed-in-the-wool" Republican.

Rapf recalled:

> Of course, the strike hurt him a lot, and that made him more reactionary because he felt the strike was Communist inspired. He did believe that.

Walt Disney was a "friendly witness" who testified willingly and passionately at the October 24, 1947, House Un-American Activities Committee (HUAC) meeting in Washington, D.C., to declare his belief that the infamous strike against his studio was the result of Communists who were attempting to smear him.

At that time, Walt strongly believed that anyone who was against him must have been a Communist because Walt was such a staunch All-American and a benevolent employer.

A front-page headline in the October 25, 1947, *New York Times* announced "Disney Denounces Communists". The article also noted that the principal witness of the day's hearings, Walt Disney, failed to fill the hall with spectators as "friendly witness" Ronald Reagan had the previous day.

In 1944, Walt said: "[A]s an independent voter I owe allegiance to no political party." However, for the first time in his life, he did publicly endorse a Presidential nominee, Republican Thomas Dewey, the popular Governor of New York.

Disney donated heavily to the GOP in 1944, allowed a Dewey rally to be held at the Disney Studios, gave a pro-Dewey speech at the Los Angeles Coliseum, and was chosen as one of California's electors should Dewey win. To a Republican fund-raiser, Walt wrote, "I'm sorry I can only give money." Walt's 1944 activity marked the start of his consistent support of Republicans for the rest of his life.

A bank check, No. 847, dated November 12, 1959, and signed by Walt Disney from his personal Bank of America account, was payable to the Republican National Finance Committee in the amount of $1000. The notation on the left side of the check is "Contribution". The back of the check bears the endorsement of the Treasurer of the National Republican Congressional Committee, Robert V. Fleming.

During an interview with me in 1996, Disney Legend Ward Kimball recalled:

> One time, Walt and I got into a big fight over politics Walt wanted the staff to donate money to [Richard] Nixon's campaign [for President] and I vehemently refused. Walt didn't like that, and in fact, towards the end [of his life], things were strained between the two of us.

Richard Nixon was a good friend of Walt's, even showing up at Disneyland in 1959 with his family to inaugurate the new Monorail attraction. Walt had other powerful Republican friends from the world of entertainment, including actor George Murphy, who later became a senator. Walt encouraged Murphy to run in 1964, and chaired a fund-raising dinner for him. Walt also lent his name and photo to a campaign mailing.

Walt also strongly supported Ronald Reagan's successful 1966 campaign for governor of California. Reagan later became president of the United States. Reagan had been one of the three television hosts for the opening of Disneyland in 1955.

Over the years, other animators have shared stories of being bullied by Walt to make campaign contributions to

Republican politicians running for office. One animator remembered that, in 1964, the electric golf cart that Walt used to drive around the back lot of the Disney Studios had a big bumper sticker that read "Vote for Goldwater!"

In a speech, Walt once mentioned that he had some minor traffic tickets for illegal left turns. The police officer warned him to make only right turns in the future. Walt smiled and said that would be an easy request because "I lean that way anyway."

One of Walt's forgotten animated milestones was the creation of a political television advertisement for the Dwight Eisenhower presidential campaign.

Dwight D. "Ike" Eisenhower was a World War II hero. By the end of the war, he had supreme command of all operational Allied forces. Eventually, he was named Supreme Commander of the North Atlantic Treaty Organization (NATO), and was in charge of those forces in Europe after the war.

He retired from the service in May 1952. Democrats and Republicans each wanted him to run as their candidate in the 1952 presidential election. Not a career politician, Eisenhower was a private citizen who had remained nonpartisan, citing an Army regulation that forbade partisan political activity by serving officers.

Republicans coined the phrase "I Like Ike" as early as spring 1951, and New York Governor Thomas Dewey and Senator Henry Cabot Lodge Jr. (both Republicans) helped create the National Citizens for Eisenhower organization.

Jacqueline Cochran was a successful cosmetics executive and one of the most famous female pilots in the world. She was the first woman pilot to break the sound barrier. In February 1952, she helped sponsor a massive rally at Madison Square Garden in New York for Eisenhower supporters. The arena held 16,000 people, but more than 25,000 showed up.

Even New York's police officers couldn't get people to leave. Cochran flew to Paris, where Eisenhower was staying at the time, to show him a three-hour tribute film that documented the rally. It convinced him to run for president. Ike and Cochran remained close friends for the rest of their lives.

What does all this have to do with Walt Disney? During the 1952 campaign, Cochran contacted Roy O. Disney, always a staunch Republican, at the Disney Studios, and persuaded him to produce a black-and-white animated television commercial in support of Eisenhower's candidacy. Eisenhower was the first presidential candidate to use television commercials.

His opponent, Democrat Adlai Stevenson, wouldn't appear on television, because he thought it was demeaning for a man who hoped to be president. There were a handful of Stevenson television ads, including the animated "Platform Double Talk", with a two-headed Republican politician taking both sides of any issue, but Stevenson did not appear in his television commercials. He stated:

> The idea that you can merchandise candidates for high office like breakfast cereal is the ultimate indignity to the democratic process.

However, Madison Avenue advertising executive Rosser Reeves (responsible for the M&Ms' slogan "melts in your mouth, not in your hand") persuaded Eisenhower that short ads played during such popular TV programs as *I Love Lucy* could reach more voters than any other form of advertising.

In a confidential memo about the proposed campaign, Reeves (who worked for Ted Bates & Company, and who looked and acted like he stepped out of an episode of the television series *Mad Men*) wrote:

> His [Eisenhower's] top advisers know that it's going to take plenty of work, lots of money, plus something *new* and something *extra* and *special* ... the humble radio or TV "spot" can deliver more listeners for less money than any other form of advertising.

The result was a series of "staged" commercials where "average citizens" asked Ike questions and he responded. (Reportedly, each of these sections was filmed separately at different times, but a smiling, confident Ike came across as listening to the person and knowing all the answers in a quick sound bite.) These commercials were part of a series called *Eisenhower Answers America* (1952), which consisted of twenty-five 20- and 60-second spots flooding the airwaves twelve days before the election.

But the most frequently run (and supposedly most popular) Eisenhower campaign advertisement was produced quickly by the Disney Studios. The actual spot, and the song created by the Studio, was called "We'll Take Ike (to Washington)". Officially, 225 prints of the one-minute spot and 210 prints of the two-minute spot were shipped nationwide to the largest television stations.

In November 1952, Disney producer Bill Anderson said:

> Since the election, we have been advised by these stations that these cartoon spots were played more than any of the other Eisenhower television films.

The two-and-a-half-minute version features additional material book-ended on to the more familiar one-minute spot. This material begins with a little, confused, animated "everyman", overwhelmed by all the issues of the day, from war to lower pay: "I've listened to everyone. I've tried but who's right? What are the facts?"

The film then cuts to a dapper business-suited, live-action actor, who remarks that the confusion is natural but "beyond all the words, beyond all the claims, there is actually just one thing on which most people base their final decision ... the man".

Then, the version segues into the well-known advertisement. At the end, the live-action actor appears again to state: "Those were the voices of the people. What's your decision? Who will you vote for?" The animated everyman now wears an "I Like Ike" button, and smiles as he says: "Me? I like Ike!"

Silent footage of Eisenhower accepting his nomination at the Republican National Convention follows, with the voice-over: "The National Citizens for Eisenhower-Nixon have presented this message to all thinking voters regardless of party affiliation."

The body of the one-minute commercial is filled with a catchy tune and repeating animation cycles. A strutting Uncle Sam wearing an Ike button on his lapel leads a parade of regular citizens marching to the nation's capital, where a shining sun with the name Ike in the middle rises in the air. Those steadfast American citizens include young parents pushing a baby carriage, a cowboy, a house painter, a baker, a

railroad engineer, a fireman, a draftsman, and even a milkmaid.

The parade also includes a large gray elephant draped with a banner featuring a caricature of Eisenhower's face. The elephant beats his tail on a drum pulled behind him to help rally the spirits of the placard- and banner-carrying supporters. All of these folks are marching to the right, and seen briefly in the background is a shadowy figure (implying it is Eisenhower's opponent Stevenson) riding a Democratic donkey the wrong way to the left.

Singers:

> *Ike for President. Ike for President. Ike for President.*
>
> *You like Ike, I like Ike, everybody likes Ike for President.*
>
> *Bring out the banners, beat the drums, we'll take Ike to Washington.*
>
> *We don't want John or Dean or Harry. Let's do that big job right.*
>
> *Let's get in step with the guy that's hep. Get in step with Ike.*
>
> *You like Ike, I like Ike, everybody likes Ike for president.*
>
> *Bring out the banners, beat the drums, we'll take Ike to Washington.*
>
> *We've got to get where we are going, travel day and night.*
>
> *Let Adlai go the other way. We'll all go with Ike.*
>
> *You like Ike, I like Ike, everybody likes Ike for President.*
>
> *Bring out the banners, beat the drums, we'll take Ike to Washington.*
>
> *We'll take Ike to Washington!*

The "John or Dean or Harry" mentioned in the song and caricatured as donkeys was meant to suggest Stevenson's running mate, John Sparkman; Dean Acheson (Truman's Secretary of State); and Harry Truman.

After the triumphant arrival at the domed capitol, the voiceover announcer (Winston Hibler, narrator and writer of the *True-Life Adventures* series) states: "Now is the time for all good Americans to come to the aid of their country." (By voting for Eisenhower, of course!)

The Disney Studios put together an autographed cel setup for several people directly involved in Eisenhower's campaign, including Arthur Summerfield (whom Ike made his Postmaster General), Paul Hoffman (an influential, if unofficial, adviser), Paul Helms (whose Smoke Tree Ranch home was used as a vacation spot by Ike), and Tex McCrary (who helped stage the

Madison Square Garden rally). In addition, an autographed cel setup was sent to Jacqueline Cochran.

On November 19, 1952, producer Bill Anderson wrote to Cochran:

> I am enclosing an autographed cel setup for yourself, and an autographed cel setup and a copy of the song "We'll Take Ike" for General Eisenhower. The cel setups were prepared from the original art material used in the television spot "We'll Take Ike".
>
> We prepared several of these and rather than send them all to General Eisenhower, we sent one to Mr. Arthur Summerfield, Mr. Paul Hoffman, Mr. Paul Helms, Mr. Tex McCrary, and yourself. We thought all of you would get a kick out of them as a souvenir.
>
> We have sent General Eisenhower's to you as the original idea for a television spot was yours and we think you are the logical one to pass them on to him. Thanks again for rallying us to the Eisenhower Band Wagon and we hope you will enjoy this autographed cel setup as a memento of the campaign.
>
> All of us here take this opportunity to thank you for the part you played in putting the idea of a television spot over. We had a great deal of fun in making the films and it was with pride that we viewed our work on television night after night. For most of us, this was our first active political campaign.
>
> Naturally, we are all very happy that General Eisenhower was elected President with landslide proportions and we like to think that our films contributed in a small way. Producing these films taught us a lesson; we found out just how quickly we could put a one-minute spot together and get prints distributed on a nation-wide basis.

Walt's brother Roy Oliver Disney had written to Cochran a few days earlier on November 14, 1952:

> The boys and girls all enjoyed working on the project and, of course, we are all very happy at the outcome of the election. Kindest regards.

Roy also included a list of the Disney employees who had contributed their time and efforts to the cartoon. That list and other related correspondence is in the Jacqueline Cochran Papers, Eisenhower Campaign Series, Box 2, in the Eisenhower Presidential Library and Museum in Abilene, Kansas.

Walt became an active part of the "People to People" program that Eisenhower started in 1956 to promote international understanding. Walt and Ike occasionally saw each other socially in Palm Springs at the Smoke Tree Ranch. Walt was photographed with the former President at the 1964 Republican National Convention.

In 1963, Walt Disney received the George Washington Award for promoting the American Way of Life from the Freedoms Foundation at Valley Forge. Former President Eisenhower, who read the citation in a ceremony, praised the entertainer as an artist who excelled in "communicating the hope and aspirations of our free society to the far corners of the planet".

The Disney Studios never made another political campaign advertisement.

In 1968, Diane Disney Miller, Walt's daughter, told interviewer Richard Hubler:

> Politically, Dad was also kind of a strange figure because he said, before he died, "You know, I consider myself a true liberal". He did, of course, support especially conservative people, like [Barry] Goldwater and had not much respect for [Lyndon] Johnson, as a President. But he was definitely not an ultra-conservative. For instance, he really felt that Social Security and those things were good ... that you've got to help people.

Whether it was an example of a darkly impish sense of humor or a sincere, passionate commitment to the Republican party, Walt was responsible for a story involving President Lyndon Johnson that for years many believed was an urban myth.

On July 3, 1964, the White House announced that Walt would be a recipient of the Medal of Freedom, one of the highest awards that can be given to an American citizen. However, the award was to be presented by President Lyndon Johnson, who was already preparing for his election campaign and was perhaps using this ceremony as an opportunity to be photographed with a beloved American pop culture figure.

Accompanied by one of his secretaries and her husband, Walt attended the presentation. Disney historian Michael Barrier tracked down the truth of the situation — that at

some point Walt decided he wanted to wear a "Vote Goldwater" button when he received the medal from Johnson.

Walt had a small gold button stud that had the letter "G" and the number "64" (signifying Goldwater in 1964) that would be under his left lapel and clearly visible only if he flipped it. He also asked for a much larger button clearly declaring "Vote for Goldwater", so if anyone complained about his wearing the smaller pin, Walt would flash the larger button and ask, "Would you prefer I wear this one instead?"

People who attended the ceremony recollected that Walt, with his back to the audience, did flip the lapel to show Johnson the small pin. Johnson was already aware of Walt's fervent support for Goldwater from a phone conversation the president had had with one of his advisors eight days before the ceremony. Johnson was not happy but didn't say anything about it, and apparently there were no repercussions. With glee, Walt later told the story to others at the Disney Studios.

Diane Disney Miller wrote to Barrier that:

> Dad did not respect Johnson, but did have great respect for the office he held. I was uneasy about what he said he'd done, but I did not let on. Rather, I probably said, "Good for you!" or something like that.

# Disney's Secret Commercial Studio

*The story of how Disney secretly created television commercials during the 1950s.*

In the 1950s, the American film industry believed that the greatest threat to the United States was not the Russians and the possibility of a nuclear war, but the increasing success of television, which had millions of Americans abandoning their local movie theaters for free entertainment on a tiny black-and-white screen at home.

Movie studios tried to employ every technology in their arsenal, from wider screens and 3-D to advances in color and sound, to fight what seemed to be a losing battle. Actors under studio contracts were banned from appearing on television.

Any movie producer involved with television was considered to be giving aid and comfort to the enemy. So, even though Walt Disney's little independent studio had never been regarded at the same level as the other major film producers, Walt's decision to do a weekly television show for ABC in 1954 was frowned upon by other movie studios fighting for their lives and producing expensive epic films to attract audiences.

At that time, perhaps the only thing worse than producing a television show would have been making television commercials. Walt did both, although he did not publicize his involvement in commercials, claiming it was handled by Hurrell Productions, a subsidiary independent production company.

In the 1950s, almost all television advertisements were

done with live performers extolling the virtues of the products whose makers sponsored the show. Sometimes the stars of the show would do the actual advertisement themselves, for example, Desi Arnaz not only loving Lucy but Philip Morris cigarettes, and George "Superman/Clark Kent" Reeves chowing down on Kellogg's Corn Flakes for a super breakfast.

At that time, animation was expensive and time-consuming to produce, but advertisers soon discovered it was also highly effective, and so many of the best-liked ads were animated.

Former Disney artists, including David Hilberman, Zack Schwartz, Shamus Culhane, Grim Natwick, and Art Babbitt, did animated television commercials starting in the 1940s. Disney animator Preston Blair told animation historian Karl Cohen that he felt "like a race horse tied to a milk wagon. I wasn't exercising my full potential at all."

In the early 1950s, the Disney Studios was struggling financially. It was still recovering from the monetary hardships of the war years. While the animated feature film *Cinderella* had been a success, Walt was desperately in need of money to help maintain the Studio and to finance his latest project, the world's first theme park, soon to become known as Disneyland.

Because of the large studio debt, Walt was also under great pressure from bankers to find additional sources of income beyond the animated films — perhaps even from the new medium of television.

Phyllis Bounds was the niece of Walt Disney's wife, Lillian. Bounds' husband at the time was George Hurrell, famous for his glamor photography of movie stars in the 1940s. George and Phyllis started their own television production studio in 1952, located on the Disney Studios lot, to produce advertising with help from Disney artists who didn't have enough work to do on the theatrical shorts. For the rest of their staff, they used freelance animators. The company freely used all the physical resources of the Disney Studios.

In the 1951 Walt Disney Productions annual report to shareholders, Walt's brother Roy tried to soften the situation by writing that the Disney Studios engaged in:

... small scale production of live-action films for television, particularly spot announcements, through a controlled subsidiary, Hurrell Productions, Inc., which operates on our studio lot at Burbank. This subsidiary is exploring the possibilities of producing serialized dramatic and comedy shows on film for TV.

Reportedly, Lillian was upset at Walt for hiring Phyllis because Lillian's sister Hazel thought Walt had already given Phyllis (whom she considered flighty) too many chances.

George Hurrell left the Burbank studio and returned to New York in 1954, leaving Phyllis as the TV commercial co-coordinator from 1954-1957. Officially, the Disney Studios was not producing the commercials; instead, this independent studio that happened to be on the Disney lot was bringing in the income.

Disney veteran Harry Tytle, who worked at the Studio for more than forty years in many capacities, including producer of the weekly television program, stated in his autobiography:

> Commercial work answered our prayers, as it supplied badly needed capital. Advertising work clearly helped keep the studio intact. But while the studio made money with this type of product (and I mean big money) it was not a field either Walt or Roy were happy to be in. Their reasoning was sound. We didn't own the characters we produced for other companies; there was absolutely no residual value. Worse, we were at the whim of the client; at each stage of production we had to twiddle our thumbs and await approval before we could venture on to the next step.

In a 2008 interview with Didier Ghez, animator Paul Carlson remembered:

> [D]uring 1956-58, I worked for Phyllis Hurrell, Walt's niece. She was in charge of the Disney Commercial Division. Phyllis' assistant was her cousin, Sharon Disney, Walt Disney's daughter. Sharon was about four years my junior and I shared an office with her adjoining Phyllis' office. Those offices were all in the H-wing of the Animation building. This H-wing was being used at the time by Herb Ryman and Claude Coats and other artists who were working on the design of Walt Disney's Disneyland in Anaheim.

In another interview, Carlson elaborated:

> Phyllis was the head of the commercial division that was responsible for all of the commercials for the three television shows that Walt was producing for ABC. *Disneyland* was an hour show that ran weekly. *Zorro* was another half-hour show, and of course *The Mickey Mouse Club*, which was on every weekday. We had those three shows to monitor the commercials that were placed in all three of them.

According to all sources, Sharon loved working with Phyllis, and Walt loved having his daughter on the studio lot.

"Walt would come and stand in the door frame visiting Sharon. He'd bring her in and take her home," said Carlson, who also mentioned that roughly once per month Walt would review in a screening room the commercial work that the unit produced.

From about 1952-1959, the Studio created some memorable characters and produced commercials for a wide variety of clients.

After a year of working on *Sleeping Beauty*, artist Tom Oreb was moved to the new commercial division at Disney. Previously, Oreb had done freelance work on television commercials in 1952 for Ray Patin Productions. His angular, striking designs were perfect for limited animation. Oreb's commercials had received quite a bit of recognition, and it is likely that Walt was aware of those successes.

Disney artist Vic Haboush, who went along as Oreb's layout artist, told animation historian Amid Amidi:

> I was kind of Tommy's surrogate, I did most of the physical work. Tommy would lay the stuff out and I would follow through on it.

Oreb designed Bucky Beaver for Ipana toothpaste; a crafty fox and his adversaries (two Indians named Pow and Wow) for Welch's grape jelly; a series of Mary Blair-influenced boys and girls at play for Trix cereal, before the Trix rabbit was created; a little bee with a huge head and eyes for Johnson's Wax; and many others, including the original Cheerios Kid.

Designs flowed from Oreb. He was also responsible for an energetic gray seal with expressive eyes and whiskers wearing a black tuxedo jacket, a black bowtie, and a dapper

little top hat. On the left lapel of the jacket was a round button that said "Gold Seal", with a ribbon tail hanging beneath it. This appealing little character was created to appear in television commercials for the Canadian Fishing Company's premium national brand of canned salmon, tuna, and seafood products.

Jimmie Dodd, the adult Mouseketeer host on the original *Mickey Mouse Club* television show, not only narrated commercials for Ipana toothpaste, but his sped-up voice was used for the character of Bucky Beaver singing the jingle: "Brusha Brusha Brusha. Use the new Ipana." Dodd, a talented song writer himself, wrote that jingle.

The two large "buck" teeth that were Bucky's trademark were perfect for Ipana protection, along with the many exciting exploits he had to face for dental health.

In "White Knight", Bucky as the white knight must face his archenemy Decay Germ, who as the black knight has captured the fair maiden and threatens her beautiful teeth with decay.

In "Bucky Beaver, Engineer", train engineer Bucky's train is temporarily stopped by a blockage on a train trestle placed there by Decay Germ. A cliffhanging fight ensues, but of course, a tube of Ipana toothpaste "even better than fluoride toothpaste" defeats the villain.

In "Bucky Beaver, Circus Star", the agile Bucky is performing on the tightrope high above the circus crowd, when a wild, caveman-looking Decay Germ escapes. Using a whip and chair (and a tube of Ipana), Bucky bravely herds the bad guy into a cage.

In "Bucky Beaver, Space Guard", Bucky's spaceship is shot down by space ship DK-1 (Decay-1), piloted by Decay Germ. Stranded on a strange planet, Bucky seems helpless, but quickly he turns the tables, thanks to Ipana.

The primary director for all of these commercials was Charles Augustus "Nick" Nichols, who began his Disney career as an animator on the Disney shorts, and was the main director on the Pluto cartoons from 1944 through 1951. He was reportedly a favorite of Walt's. Animator Iwao Takamoto said:

> Walt regarded him [Nichols] as a jack-of-all-trades and a troubleshooter; if he had something that was out-of-the-

ordinary that needed to be done, he'd just call Nick in. Nick's unit worked on many of the television commercials produced by Disney, and since he had a live action Director's Guild card, he also shot some of Walt's introductions to his Sunday evening television show.

Animator Paul Carlson recalled:

> We handed the animation [of the commercials] to artists outside the Studio. They worked on a "1099" arrangement, where they were not on staff and then we paid them as freelance artists. Phil Duncan was one of the guys we used, George Nicholas was another one and Volus Jones was another one and Mike Lah was another animator. All of these animators ... were freelance animators working for our commercial division.

Carlson worked as Nichols' assistant on the commercials. He also worked with other Disney artists like Bob Carlson, Bill Justice, Amby Paliwoda, and Bob Youngquist, who were brought in to do some of the commercial work.

In the 1950s, 7-Up's advertising was being handled by the Leo Burnett Company, but Disney designed 7-Up's Fresh Up Freddie character and produced the commercials.

"Right now, you're probably asking yourself ... ", as Fresh Up Freddie would say, what is the story behind this character?

Fresh-Up Freddie was the mascot created by the Disney Studios for the 7-Up soft drink company. He was a cocky animated rooster who looked like a mixture of Panchito the Mexican rooster and the wacky Aracuan bird, both of whom appeared in *The Three Caballeros* (1944). Freddie demonstrated how to plan successful parties and picnics by having plenty of 7-Up on hand. He spouted catchphrases like "Fresh Up with 7-Up" and "Nothing Does It Like 7-Up".

At first, Freddie didn't have a name, but when he started receiving fan mail and became highly recognizable by audiences, he was supposedly named in honor of 7-Up bottler Fred Lutz Jr., and followed in a long line of cartoon characters with alliterative names.

Merchandise produced by 7-Up included a Fresh Up Freddie plastic doll, a Fresh Up Freddie Ruler, a pinback button, a cigarette lighter, and a Fresh Up Freddie stuffed doll.

Freddie also appeared in four-panel, comic-book-style

story ads on the back covers of Dell comic books, primarily from 1957-1959. These adventures included Freddie as a ghost hunter, a private eye, a lumberjack, a test pilot, a bobsled champ, and more, always quenching his thirst with a handy bottle of 7-Up.

7-Up was one of the two sponsors for the *Zorro* television show. The other was AC Spark Plug (with print ads of the white cartoon horse Sparky dressed up as Zorro). 7-Up had a monthly Zorro newsletter for bottlers that prominently featured Freddie, who sometimes dressed up as Zorro himself.

In a talk with animation historian Michael Mallory, Paul Carlson remembered:

> They [7-Up] spent $2.5 million on their TV commercials. I think they did 26 one-minute commercials at $100,000 apiece. He was an Aracuan bird that we designed for 7-Up. Dave Detiege and I designed that character. Sharon [Walt's daughter] and I pasted up the model sheet.

One commercial has Freddie at a party, dressed in a cone-like hat, playing 7-Up bottles like a cello, a piano, and bells, as he sings the praises of the Uncola.

Another commercial has Freddie as a soda jerk dancing with a live-action teenage boy as smoothly as Gene Kelly danced with Jerry the Mouse in the MGM film *Anchors Aweigh* (1945).

Yet another had Freddie as a sports reporter interviewing a fighter, a female swimmer, and a basketball player, all of whom look like variations of Freddie and love 7-Up as part of their secret for winning in sports.

Another had Freddie dressed up in a tuxedo preparing for a party with a staff that included a confetti cutter, a horn tooter, and a balloon blower (as well as a closet filled with cans of laughter … canned laughter). "7-Up gives every party a lift", with the punch line a house that looks like the one in the recent Pixar-animated feature *Up* (2009) floating high in the night sky, thanks to all of those balloons that have been blown up.

Walt signed a contract in 1951 to produce a series of eight animated commercials for Mohawk Carpets and to create a mascot character. The contract refers to the character as Tommy Hawk, but later was renamed Tommy Mohawk. He was a young Indian boy sporting a Mohawk haircut with a

single feather who carried a tomahawk. The spots themselves were all animated in 1952.

*Daily Variety*, the entertainment industry trade newspaper, printed a short blurb in its September 22, 1952, issue with the headline "Disney Producing Spot Telepix Blurbs". It stated that the Studio completed its first animated television commercials, for Mohawk Carpet Company, in September 1952.

The titles of the commercials from the Disney production files were:

- "Tommy Tests Carpets"
- "Tommy Supervises Weaving"
- "Tommy Plants Carpet Seeds"
- "Tommy Designs Carpets"
- "Tommy Falls for Minnie"
- "Tommy Gives Animals Sleeping Carpets"
- "Birds Use Waterfall for Loom"
- "Tommy Harvests Carpets"

Besides Tommy himself, the commercials featured his demure Indian maiden friend, Minnie (short for Minnehaha), and a mischievous squirrel known as Chatter, who looked very similar to the character of Dale from Chip 'n' Dale, but with a smaller nose and a squirrel tail. He also wore a plain headband and a single feather, and the oversized headband kept dropping comically over his eyes. There is a strong Bill Justice influence in the design of the characters, especially Chatter.

There were also radio commercials featuring Tommy. One 1954 magazine ad had a Disneyesque Tommy sleeping comfortably under a tent-like structure hung on the branch of a tree while pouring rain rolls off the angled sides.

The copy says:

> As the rain keeps Tommy from play, he sleeps undisturbed through the day. For water can't harm the twist of this yarn, Mohawk Evertwist won't ravel or fray!

Tom Oreb designed the original Cheerios Kid, and there were some later commercials where Donald Duck had adventures with the character.

In "The Explorer", Donald goes into a cave and is chased up a tree by a bear, but his nephews get the Cheerios Kid to help with his Go Power.

In "Sharks", Donald is out swimming at the beach when he is confronted by hungry sharks. His nephews on the shore watch as the Cheerios Kid once more comes to the rescue.

In addition to creating new characters, the Disney commercial division also used Disney characters for television ads, but generally just for the sponsors of the three Disney television shows at the time: *Disneyland*, *Zorro*, and the original *Mickey Mouse Club*.

In a series of Jell-O commercials, well-dressed young girls look into a mold of Jell-O, where in its jiggling form they see all sorts of *Alice in Wonderland* adventures.

In one televised spot, recycled animation from the original feature where Alice wanders the woods was used, but with vastly different dialog. "Are you the smile on my Jell-O or the smile on the Cheshire Cat?," asks Alice with the voice of actress Kathryn Beaumont, who played the same role in the animated feature.

The reply comes from the Cheshire Cat, voiced by Sterling Holloway, who also provided that same voice for the character in the animated classic. After extolling the different colored flavors of Jell-O, the cat disappears.

Another commercial with new animation had the characters of the Griffin and the Mock Turtle (neither of whom appeared in the *Alice* feature film) learn from Alice how easy it is to make Jell-O for a party. Alice informs the viewers: "For energy, for color or just playing games, there is nothing quite like Jell-O."

Animator Paul Carlson recalled another series of commercials:

> *Disneyland* [the television show] was sponsored by American Motors and George Romney was president then. He came to the Studio one day. Walt sent George Romney and his wife and two kids down [one of whom was a very young Mitt Romney]. I showed them how to draw Jiminy Cricket.

Innovative artist Tom Oreb redesigned the classic Disney characters with a more streamlined look for the American Motors commercials. Mickey was given a big "adult" suit and

a very angular, triangle-like face. His iconic round ears were transformed into what looked like large, floppy jungle plant leaves.

In one commercial, an angular Donald Duck is in a schoolroom lecturing unintelligibly to his bored nephews, Huey, Dewey, and Louie, about the benefit of deep coil springs on the Hudson Hornet. Another commercial has Donald and his nephews bouncing wildly down a steep mountain road in an old car because they don't have deep coil springs. Fortunately, a live announcer is able to translate for Donald the advantages of American Motors cars.

To escape Brer Fox and Brer Bear, Brer Rabbit locks himself inside an American Motors car with "all-season air conditioning". He remains comfy through the seasons of excessive heat and freezing snow that his adversaries endure. What the clever rabbit eats in his "laughing place" during all of those months is never explained.

Jiminy Cricket on a window sill sings:

> A dream is a wish your heart makes when you see a star. A Nash is a star a car makes. It outshines all others by far.

The voice was provided by Jiminy's original animated feature voice, Cliff Edwards, who also did the voice for the cricket on a variety of projects in the 1950s, ranging from shorts for the *Mickey Mouse Club* to records for the Disneyland label. Jiminy also appeared in another commercial extolling the wonders of AMC's deep coils that was similar to having "sea legs" that would adjust to sharp turns.

Besides his appearance in an American Motors commercial, Jiminy Cricket also shilled for Baker's Instant Chocolate Flavored Mix during the original *Mickey Mouse Club*, claiming that Baker's made the "most delicious chocolate drink" to encourage the young audience not to use Hershey's syrup or Bosco with their milk. Jiminy had his own "Sipping and Singing Society" for which viewers could get their membership card and, for ten cents, a cardboard marionette puppet of Jiminy. In these commercials, Jiminy was not stylized as he was in the AMC commercials, but was more reminiscent of his original feature film design.

One of the most unusual American Motors ("More for America") commercials was Pluto napping by his doghouse

when he is hit by an advertising flyer for the 1955 Nash auto-
mobile. He takes the flyer to Mickey Mouse, who is relaxing in
a hammock. Pluto is distracted by a cat eating out of his bowl,
and chases the feline through the yard and into the garage
while the announcer extols the benefits of how the car can
turn and has a nice big windshield (since Pluto now has his
head stuck in a fishbowl). Mickey is convinced and ready to
walk out and go to the car lot, and takes Pluto along.

Victor Haboush, who did background design on a number
of the commercials, told Amid Amidi that when the Nash
commercial aired with Mickey Mouse:

> There was a little kid that used to write Walt telling him to
> stay away from modern art because it's communistic. So
> when the commercial came on, he got a letter from this kid, a
> little malcontent somewhere, and he wrote, "I'm
> disappointed Walt. I never thought you'd succumb. What
> happened to you?", and Walt went crazy. He stormed down
> there and outlawed us against using any of the Disney
> characters in commercials. I remember at the time everybody
> was incensed that we couldn't use them, and it basically
> spelled the end of the unit. [Companies] were coming for the
> celebrity, to be able to use Disney characters in commercials.

That same oddly-styled Mickey appeared in another AMC
commercial. In that one, Minnie rests comfortably in the
passenger seat while two mouse children in the back seat
enjoy the "all-season air conditioning". Other AMC com-
mercials included Cinderella and Alice. No official listing of
the commercials has ever been released.

Peter Pan Peanut Butter had been around since 1929, and
Derby Foods, which controlled the brand, was one of the
earliest sponsors of the *Disneyland* television show on ABC.

Disney storyman Bill Peet had a run-in with Walt Disney
when Peet didn't make a change Walt wanted in a scene from
*Sleeping Beauty* where the prince and Aurora dance in the
forest. In his autobiography, Peet wrote:

> The next day, I was sent down to the main floor to work on
> Peter Pan Peanut Butter TV commercials, which was without a
> doubt my punishment for what Walt considered my stubborn-
> ness. I toughed it out for about two months on peanut butter
> commercials, then stubbornly decided to return to my room
> on the third floor whether Walt liked it or not.

Animator Paul Carlson remembered:

> Yes, he worked on some Peter Pan commercials. And he had some input on those. I don't remember what he talked to Phyllis [Hurrell, the head of the department] about, but yeah, Peet did make some comments or some suggestions to story.

Tinker Bell was mute in those days, and had to pantomime her delight at the peanut butter that could be put on hot toast because it melted like butter and was so smooth it could even be "spread on crispy potato chips". A lively background chorus would sing :

> Your eyes know and your tummy knows, best of all, your taster knows, Peter Pan Peanut Butter is so grand — the smoothest peanut butter in the land.

In keeping with the theatrical stage tradition, the image of Peter Pan on the jar was a mature woman.

Cliff "Jiminy Cricket" Edwards and Sterling "Winnie the Pooh" Holloway often narrated these commercials. At the time, Holloway had finished doing the voice of the Cheshire Cat in *Alice in Wonderland*. Reportedly, Josh Meador, head of the Disney Studios animation effects department, did some work on the Tinker Bell commercials.

Captain Hook tied up little Tinker Bell to force her to tell him where to find the Peter Pan Peanut Butter. When she refuses, he makes her walk the plank. She is rescued by Peter Pan, who battles Hook and tosses him to the hungry crocodile, who is already consulting a recipe book for "Hook Stew" and "Baked Hook". However, a kindhearted Tink rescues the Captain from the jaws of death with a jar of peanut butter because "it certainly is true, Peter Pan Peanut Butter is the favorite of people, and crocodiles, too!"

Hook later returned with his whole pirate crew to steal Peter Pan's treasure chest filled with peanut butter. The clever Pan substituted Tick-Tock the crocodile for the tasty peanut treat in the chest, and it gave Hook quite an unpleasant surprise.

Tink appeared in a commercial where she uses her hands to make shadows on a nearby blank wall for viewers to guess the images, including the easiest of all, her miming the opening of a jar of Peter Pan Peanut Butter. Sometimes there

were enthusiastic off-camera children's voices, like when Tink played a game with live-action hands.

In one commercial, Tink even plays a game of connecting the dots to reveal a jar of Peter Pan Peanut Butter, and in another plays with a large storybook of words and pictures. One commercial has a peanut butter machine with the distinctive voice of actor Paul Frees making crunchy peanut butter for Tink.

Tink's character design was very similar to the simplified version used for the opening of the *Disneyland* television show. At the end of that weekly show, Tink might do an animated sequence to remind viewers to get some Peter Pan Peanut Butter, or that the American Dairy Association recommends three glasses of whole milk each day. Tink served a similar role to the live-action television stars who were promoting their sponsors in commercials.

In 1956, Oreb and Haboush left the Disney commercial division to work at John Sutherland Productions, which produced industrial cartoons for major corporate clients.

Officially, the Disney Studios closed its television commercial division in the late 1950s. By then, the Disneyland theme park was generating plenty of additional revenue, and just like his involvement with military training films, Walt had become irritated at not having the final word on what he was producing in the commercials. Paul Carlson said:

> One time Walt was very upset because the agency that was sponsoring *The Mickey Mouse Club* used Woody Woodpecker in a cereal commercial on *The Mickey Mouse Club*. And he didn't like it because he didn't have control of the animation. They dropped it right into the show after the whole show was mixed. It wasn't sound mixed with everything else. It was dropped in by an editor later. And the sound was up. So when they broadcast it, it was obvious that the volume went up and it wasn't smooth, and Walt didn't like it. And he usually looked at all the shows.
>
> We did so many different commercials and to tell you the truth I can't remember all of them. There were so darn many of them. Some of these commercials were animation and some of them were live action. Nick had a live action [Director's Guild] card and that's how he got involved. Nick Nichols and I had a great time together producing TV

commercials. He was a great guy. He was very nice to work with. When they closed down the commercial division in '59, I think, Nick went over to Hanna-Barbera, and he produced a lot of shows over there.

Unfortunately, scant documentation exists on Walt Disney's venture into the world of television commercials or the obscure animated masterpieces that were produced. It still puzzles people when they stumble across an old treasure like a black-and-white cel of Dumbo flying high to promote Canada Dry Ginger Ale.

While the Disney Archives has some basic paperwork from the production of some of these cartoons, they do not have physical, viewable copies of all the commercials themselves, nor a complete, accessible listing.

In general, television commercials were not preserved by the production company or by the sponsor once they had fulfilled their limited-time sales objective. Walt thought the commercials would disappear forever, never clouding the history of Disney animation or some of its iconic characters.

These one-minute wonders, often fondly remembered by audiences decades later, are entertaining time capsules of a world that no longer exists, and truly a lost Disney treasure.

# The Sweatbox:
# The Documentary Disney
# Doesn't Want Seen

*The story of how Disney, during the making of a documentary of an animated film, ended up with more than they expected.*

In 1997, the Walt Disney Company asked musical performer and composer Sting to write the music for a new animated feature, *Kingdom of the Sun*. It was to be directed by Roger Allers, who was basking in the success of his work as co-director for Disney's *The Lion King* (1994), where he helped fix some of the story problems and contributed toward making the film a box office miracle.

Sting agreed, on the condition that his wife, filmmaker Trudie Styler, could document the process with their own production company, Xingu Films. The documentary was co-directed by Styler and John-Paul Davidson. Styler had produced Davidson's previous directorial efforts.

At Walt Disney Studios, there was a small, cramped screening room with no air conditioning, which caused animators to sweat while their rough work was being harshly critiqued. The room became known as The Sweatbox for a number of reasons, and it also became the term used for the process of reviewing animation under development.

Since the documentary was to recount the process of making an animated film, it seemed appropriate to use that same term.

The 86-minute documentary *The Sweatbox*, originally set

for release in early 2001, was heavily edited into a short extra feature on *The Emperor's New Groove* DVD and renamed *Making the Music Video*. It included only the section on the Oscar-nominated song "My Funny Friend and Me".

A cut of the entire documentary approved by the Disney Company got a world premiere at the Toronto Film Festival on September 13, 2002, and opened shortly afterward in one theater in Los Angeles (the Loews Beverly Center Cineplex) in an unpublicized, one-week run to make it eligible for an Academy Award nomination.

It was also shown at The Enzian theater in Orlando, Florida, as part of the Florida Film Festival in March 2003.

Sting's wife was given unlimited access to Production No. 1331 (aka *Kingdom of the Sun*). She and her camera sat in on story meetings for the movie, and she also taped actors' auditions as well as Sting recording the score. No one expected that, just two years into the production, the film would shift so drastically in direction and tone.

The mood of the documentary is established fairly early, at the premiere for *The Emperor's New Groove*, where Sting, President of Walt Disney Feature Animation Tom Schumacher, and a number of other people discuss what a painful experience the complete and unexpected revamp of the original animated film created for them.

Following a tense, brutal Sweatbox screening for executives Schumacher and Walt Disney Studios Chief Peter Schneider, the film was halted after three years of development and a year-and-a-half of active production, with about twenty percent of the animation completed. The original story, which was sort of an Incan version of the well-known Mark Twain story *The Prince and the Pauper*, was torn apart in the meeting. Director Allers asked to be removed from the project when he is refused additional time to fix the film. Sting's songs, done in collaboration with lyricist David Hartley, are suddenly out-of-key in a movie being redone as a raucous comedy.

By a stroke of luck, Styler captures the phone call to her husband from producer Randy Fullmer in which Sting learns that the six songs he has struggled over with collaborator David Hartley have been cut from *Kingdom of the Sun*. Sting said:

At first, I was angry and perturbed. Then I wanted some vengeance. We couldn't use the songs in this new film because the characters they were written for didn't exist anymore. It is quite dramatic because everything falls apart. And then it comes back together again. Some of those songs will appear in the making-of movie.

The documentary includes the animators' initial research trips to Peru, rough sketches, long discussions of color palettes and backgrounds, completed animation that was later totally discarded, intense story meetings, Eartha Kitt's voice recording, and glimpses of Sting's songwriting process. The first forty minutes or so document the great detail and effort that went into putting together *Kingdom of the Sun*.

The remainder of the documentary showcases the breakneck rush to complete the film when it becomes *The Emperor's New Groove*. The difference in the quality of the new animation and story is jarring.

One of the delights in the early portion of the documentary is a nearly full musical number going back and forth between Kitt in the sound booth and the animated scene.

Rarely have artists been caught so evocatively in fear of executives, or executives portrayed as so clueless about how to deal with artists, or how not to resolve story problems, or how to misunderstand what audiences want.

The original story for *Kingdom of the Sun* was fairly basic.

Pacha, the peasant llama herder, was not a heavyset, middle-aged, married man, but a carefree, good-hearted, eighteen year old, and a dead ringer for Emperor Manco. (In the final version, the character is renamed Kuzco following Fullmer's horrified discovery of the Japanese slang term "omanco", which translates politely as "vagina".) A young Owen Wilson provided the voice for Pacha.

Sting wrote "Walk the Llama Llama" that Pacha was to sing as he led his trio of llamas down the mountainside and into the marketplace. There was concern that David Hartley's clever lyrics were too sophisticated for an unsophisticated peasant boy, who would never use words and phrases like "panorama" or "the perfect fashion statement".

Manco (voiced by actor David Spade) had grown bored as

ruler of his mountain kingdom, so when he discovers the kindly llama herder is his doppelganger, he decides to get away from his duties of state by switching places. Unfortunately, a sorceress named Yzma, who has her own agenda, turns Manco into a llama who cannot talk, and so Pacha must continue the masquerade after the switch.

The situation becomes more complicated when Manco's intended bride, the handmaiden Nina, discovers the arrogant and haughty emperor is now kind and funny. She finds herself drawn to the seemingly transformed emperor. Pacha also finds himself falling in love with Nina, even though she is promised to the emperor.

Sting's song, "One Day She'll Love Me", was to appear midway through the movie where Pacha and Nina are at a party at the palace, and the two teens fight their growing attraction to one another.

Yzma had once been an incredible beauty in the Incan royal court. However, time and the sun have cruelly robbed her of her good looks. Yzma begins dabbling in the dark arts in an attempt to revive her youthful attractiveness, although she firmly believes it is the sun that has robbed her of her beauty, and is the source of her many wrinkles.

She wants to snuff out all light on Earth by unleashing the demon Supai, a force of darkness, to block out the sun. In a world locked in perpetual darkness, Yzma feels that her great beauty will be restored. She is assisted in her plans by an evil little totem named Hucua, voiced by actor Harvey Fierstein.

Sting created a truly show-stopping number, "Snuff Out the Light", with Eartha Kitt, as the voice of Yzma, cutting loose with some really clever lyrics. Yzma works in a black light dungeon that soon fills with wild streaks of color and a trio of comic mummies. The mummies were named after badly aging rock stars: Mick (Jagger of the band The Rolling Stones), (David) Bowie, and Lemmy (Kilmister of the British metal band Motorhead).

The song has a driving beat and builds and builds in intensity. Some animators have compared it to the song "Pink Elephants on Parade" from *Dumbo* (1941) in combining horror and humor. Once Yzma's storyline was snuffed, there was no reason for the song, so it got snuffed as well.

Master Disney animator Andreas Deja, who was working on the Yzma character and saw her as a classic Disney villainess in the tradition of Maleficent or Cruella De Vil, was said to be furious with the way producers Randy Fullmer and director Mark Dindal had re-invented the character after Allers left the production.

Yzma became just one of Kuzco's advisers whom the emperor thinks has gotten too old to do the job, and so he fires her. Instead of a fearsome sorceress, Yzma becomes an inept mad scientist. Instead of raging at the ravages of time, she merely wants to rule the kingdom. Deja left the production entirely, telling Fullmer that he wanted to work on "a great film", and soon did with *Lilo and Stitch* (2002).

Not only were Sting's songs like "Snuff Out the Light" removed from the film, causing friction with Sting, but another blow-up came when Fullmer asked the still angry Sting to compose two new songs, "Perfect World" and "My Funny Friend and Me", for the revamped storyline.

In the film, Sting doesn't really want to continue with the project, as he's now working on an album and going on tour, but he finally relents. He only threatens to quit once more, and the threat is averted by a major change in the movie's ending. Originally, the emperor was still going to build his huge mansion in the peasant village, but Sting argued that by doing so, the character had learned nothing during his experiences:

> After about five minutes of ranting and raving, I thought "OK, let's get back to work. Let's try to make this thing happen."

He and Hartley wrote the two new pieces, with "My Funny Friend and Me" sung by Sting during the closing credits, and "Perfect World" performed by singer Tom Jones as a lounge act. Sting admitted:

> It's been a very long road but I'm happy we got this far. I didn't think we would at one point.

Why the drastic change in the direction of the film? Some have said it was the high cost of "fixing" the film after disappointing audience-testing. Others felt that certain people at the Disney Studios thought the story lacked broad appeal, and that another rehash of Twain's familiar story wouldn't generate enough interest. Still others claimed that the poor box office for *Pocahontas* (1995) and *The Hunchback*

*of Notre Dame* (1996) — both of which failed to match the critical and financial rewards from *The Lion King* — had scared the Disney Company about undertaking any new prestige productions.

The Disney Company already had large financial agreements in place with its promotional partners, including McDonalds, Coca-Cola, and General Mills, that *Kingdom of the Sun* was going to be the big release for the summer of 2000.

Mark Dindal was brought in to add some hipper, zany humor. Dindal had directed a popular non-Disney animated feature, *Cats Don't Dance* (1997), and it was hoped that his direction would enliven the pacing of the film.

In the documentary, Allers gives a wistful soliloquy about why he's quitting the project he had been working on for years rather than continue with the pared-down story that the writers, including Chris Williams and Mark Dindal, came up with to meet the Studio's demands to ready the film for its announced release. Supporters of Allers' original vision still feel that if he had been given sufficient time, money, and support, the film would have been a masterpiece.

Instead of the more ambitious *Kingdom of the Sun*, the Disney Studios decided to go with a supposedly more commercial film, incorporating some of the same characters and locations, but renaming it *The Emperor's New Groove* (2000), inspired by the title of the famous fairy tale *The Emperor's New Clothes*.

Dindal reworked the original project and was given a short deadline extension, which required the Studio to move up the release date of its computer-animated feature film *Dinosaur* (2000) to the summer slot. Apparently, at one point, it was even suggested that the locale for the revised film should be moved from Peru to Nebraska, and the llamas turned into sheep.

The new storyline retained the setting of Incan Peru and two of the original main characters that the test audiences had liked. The arrogant teenage monarch Kuzco tries to maintain his upbeat "groove"; fires his chief advisor, Yzma, because she is too old; and plans to devastate a quiet, happy mountain community by building an elaborate summer vacation home there. Aided by her stupid, muscle-bound

assistant Kronk, Yzma tries to poison Kuzco and take over ruling the kingdom, but only succeeds in turning him into a llama, who soon finds himself lost and scared in the jungle.

Kuzco teams up with a kindly, older, portly peasant named Pacha, who with his family live happily in the mountain village destined to be the site of the emperor's private resort. The two go through a series of dangerous yet comic misadventures to return Kuzco to his throne and find an antidote to the transformation, while Yzma and Kronk are in hot pursuit to finish the assassination.

The film opened in direct competition with Disney's own live-action feature *102 Dalmatians* (2000). While receiving some good reviews, including one in the *New York Times* that singled out its "zany high jinks and snide, adolescent jokes" as well as its "abundance of clever acrobatic sight gags and giddy nonsense", *The Emperor's New Groove* was — in terms of box office — the Disney Company's worst performing animated feature of the four years prior to its debut.

The film eventually did well enough in the final financial tally, and revenue continued to increase with DVD sales, which spawned a straight-to-video sequel, *Kronk's New Groove* (2005), as well as an animated television series, *The Emperor's New School* (2006).

Producer Randy Fullmer said:

> We wanted to set it in the 1400s before the Spanish came [to South America]. The Spanish brought the wheel, but we had to have a cart on the storyboard. We debated for three hours whether to have a wheel on the cart. At the end of the day, it hit several of us. We are really on the wrong track. We are not trying to make a documentary on the Incas. We are just trying to have fun. We realized we had missed the boat on our film. We had sacrificed the potential humor in the movie creating instead an epic love story with powerful songs. We had taken ourselves and the film too seriously.

When David Spade's emperor character was turned into a llama, he ceased speaking and became a minor character rather than the main focus of the film. Fullmer said:

> Everyone agreed that when we didn't have the llama speak, the energy drained out of the movie. If we let the llama speak, it changed the entire tone of the movie.

The documentary is a fascinating and sometimes unflattering look into the workings of Walt Disney Feature Animation after that division's initial success in reviving Disney animated films. Owned by the Disney Company, this documentary has been locked away in the Vault for nearly a decade to avoid the hurt feelings and embarrassments that resulted in a potential epic masterpiece being reconfigured into a less ambitious buddy comedy filled with non-stop gags.

To release the documentary, even as an extra feature on Blu-ray, would be to let skeletons out of the closet to dance around and to admit that the Disney Company may have made some errors in judgment.

# Tim Burton's
# Real Nightmare at Disney

*The story of how young filmmaker Tim Burton
lived with constant fear and depression while
working at the Disney Studios.*

For many young people, being hired to work as an animator at Walt Disney Feature Animation would be a dream come true, but for recently graduated Timothy Burton of Burbank, California, it became a living nightmare.

Burton felt out of place among his fellow animators. His unique, quirky approach to subject matter and drawing was considered unmarketable and a drain on the Disney resources, so he finally was let go. But like most Disney stories, this one also has a "happily ever after" ending where a Burton project became a Disney film classic.

Timothy William Burton grew up virtually right next door to the Mouse House. Born in Burbank on August 25, 1958, Burton has a brother and two parents from whom he's always felt distant. His father, a former ballplayer and park-league coach, urged him to go outside and play baseball. When his mother, who owned a boutique specializing in items decorated with cat motifs, also suggested he go out and play, Burton would go to a nearby cemetery.

Burton did feel an affinity for Edgar Allan Poe, Vincent Price, and the classic monsters from many horror movies. His earliest ambition was to grow up and be the actor who donned the costume to play the monstrous Godzilla.

For Burton, drawing was his sanctuary. In the ninth grade, his artwork adorned the garbage trucks of Burbank, since he had won first prize for designing an anti-littering poster. He recalled:

> I came [to Disney] when I was thirteen, just to visit and ask what I would have to do to work here. They told me the standard stuff about going to school. I hated school.

By the time he was eighteen, Burton had written and illustrated a children's book about The Giant Zlig, a huge, frightening, blue monster who terrorized other creatures. He described the setting of the book:

> There is a far away place called the land of Ziv. It's a place where all the monsters live. In this land there are many strange creatures, all different sizes, with many strange features.

From another page in Burton's submission:

> The giant Zlig went walking one day; he told all the others, "Get out of my way! You all better move and let me go through. You all better move or I'll step on you!"

When he submitted this story of a bully's redemption to Disney in the hope of publication, he received a very kind and encouraging rejection letter:

> February 19, 1976
>
> Dear Tim:
>
> Here are some brief impressions of your book, *The Giant Zlig*.
>
> STORY: The story is simple enough for a young audience (age 4-6), cute, and shows a grasp of the language much better than I would expect from one of today's high school students, despite occasional lapses in grammar and spelling. It may, however, be too derivative of the Seuss works to be marketable — I just don't know. But I definitely enjoyed reading it.
>
> ART: Considering that you suffer from a lack of the proper tools and materials, the art is very good. The characters are charming and imaginative, and have sufficient variety to sustain interest. Your layout is also good — it shows good variety in point-of-view. Consequently, I not only enjoyed reading about the Giant Zlig, but I got a chuckle watching him, too.
>
> I hope my comments please you. Thanks for the opportunity to read *The Giant Zlig*; keep up the good work, and good luck.

Very truly yours,

(Signed, Jeanette)

T. Jeanette Kroger

Editor

Walt Disney Productions

Encouraged by his high school art teacher and wanting a career for which he wouldn't need too much more schooling, Burton got an artistic scholarship to the California Institute of the Arts. He studied animation and left in 1979. He was hired to work at Disney Feature Animation after they reviewed his student film, *Stalk of the Celery Monster*, about a creepy dentist named Dr. Maxwell Payne and his assistant. Burton remembered:

> What I feel really good about, really happy about, is that I did not go to film school. I went to CalArts and went through animation, where I got a very solid education. You learn design; you draw your own characters, your own backgrounds, your own scenes. You cut it; you shoot it. You learn the storyboarding process. It's everything, without the bullshit of film school: the competition, the feeling like you're already in the industry — you don't get a chance to create.

However, what did not make him happy was working on a typical Disney animated feature, *The Fox and the Hound* (1981). He was teamed with veteran animator Glen Keane, whom Burton described as "nice. He was good to me; he's a really strong animator and he helped me." But all the help in the world wasn't enough, and Burton later claimed:

> I couldn't draw those four-legged Disney foxes. I just couldn't do it. I couldn't even fake the Disney style. Mine looked like roadkills.

Burton was then assigned to drawing the distance shots, where his lack of ability in the approved "Disney style" of drawing would be less noticeable. He lamented:

> I was employed on *The Fox and the Hound* for about a year, but I just couldn't do it. I'd gone to Cal Arts, which had sort of a program, training people for Disney, but I couldn't get the style. It was too soft for me. I tried very hard, but — It was so weird. I had an office at Disney, and I could look out the window, and see the hospital where I was born, St. Joseph's, and the cemetery where my grandfather is buried,

Forest Lawn. It was like the Bermuda Triangle. I was working on *The Fox and the Hound*, and it was pretty quickly obvious that I was not cut out for it. It was, like, oh man, I couldn't do it. I couldn't handle it.

At Disney, I almost went insane. I really did. I don't ever want to get that close to that certain kind of feeling that I had. Who knows what a nervous breakdown is? Or who knows what going off the edge is? I don't want to get that close again. Number one is, I was just not Disney material. I could just not draw cute foxes for the life of me. I couldn't do it. I tried. I tried and tried. The unholy alliance of animation is you are called upon to be an artist, but on the other hand, you are called upon to be a zombie factory worker. And for me, I could not integrate the two. Also, at the time they were making kind of shitty movies. And it took them five or six years to make a movie. There's that cold, hard fact: Do you want to spend six years of your life working on *The Fox and the Hound*? There's a soul-searching moment when the answer is pretty clear.

Burton's behavior was odd. He slept ten hours at home and another four at work, sitting up straight in his chair with his pencil ready to move if anyone came in while he was sitting there. It was a sign of depression. Co-workers might find him hiding in a closet or under his desk.

In an attempt to identify an appropriate use for the talented Burton, Disney decided to make him a concept artist and team him with another young animator, Andreas Deja. Burton wrote:

They were very nice to me. They said, "We're doing this movie, *The Black Cauldron*", so I just sat in a room for a year and came up with ideas and stuff, just drew any idea I wanted to, and it was great. It was like weird characters, weird props, weird furniture, just sitting in a room doing whatever I wanted. But at some point I realized they had no intention of using any of it. It was like that TV show, *The Prisoner*. It was all very pleasant, all very nice, everyone's smiling and being very supportive. But it's like you realize early on that it's like a vacuum, a black hole. When I was at Disney, animation was in a terrible state. I just wanted to get out. The talent was there, but they didn't have the foresight to see that people have a sense of quality and would respond to it.

It was really not a collaboration between Burton and Deja.

Their styles and personalities were very different. While some of Deja's designs made it into the final film, none of Burton's did. Burton's work for the project was typical Burton: very dark and scratchy and angular. However, his work caught the attention of producer Julie Hickson and the head of creative development at Disney at the time, Tom Wilhite.

It was Wilhite who came up with sixty thousand dollars so that Burton could develop a somewhat autobiographical children's book he had been working on about a boy who wanted to grow up and be Vincent Price. After three years at Disney, Burton would finally get to work on a project that was truly his vision, a stop-motion short entitled *Vincent* (1982).

Burton was able to secure the services of Vincent Price himself as the film's narrator. Price loved the poem and understood what Burton wanted to accomplish. For Burton, it was a joy meeting his idol, who lived up to all his expectations, and more.

Burton's next project was *Hansel and Gretel*, a short live-action film for the Disney Channel done with an all-Japanese cast. Burton made the children's father a toymaker so that he and Rick Heinrichs, who he had worked with on *Vincent*, could have fun creating unusual toys that were showcased on a Disney Channel special hosted by animation historian John Culhane. *Hansel and Gretel* was shown only once (Halloween Night 1983) on the Disney Channel, and has never been re-issued.

Burton also did some concept work for the never-produced live-action film *Toys*, and for another project, *Trick or Treat*, that would have dealt with kids on Halloween and a haunted house. Before he left Disney in 1984, Burton also directed the black-and-white live-action short *Franken-weenie*, a twist on the classic *Frankenstein* horror film in which a young boy brings his dog, Sparky, back to life.

Originally, the film was scheduled to go into production early in 1984 to accompany the summer 1984 re-release of *The Jungle Book*. Disney decided instead to delay shooting until later that summer and have the film be shown with the Christmas 1984 re-release of *Pinocchio*. Burton enthused:

> We'll have a beautiful black and white film with one of the best color movies ever made. When I look at stuff we asked

them to make from the designs, I don't think we could have gotten it from any other studio.

Two test screenings in September 1984 with mothers and young children earned the short a PG rating from the MPAA (Motion Picture Association of America). Mothers were concerned that the film would encourage their children to play with electricity, among other fearful concerns, including the general "intensity" of the film. Burton said:

> It freaked everybody out that *Frankenweenie* got a PG rating, and you can't release a PG film with a G-rated film. I was a little shocked, because I don't see what's PG about the film: there's no bad language, there's only one bit of violence, and the violence happens off-camera. So I said to the MPAA, "What do I need to do to get a G rating?", and they basically said, "There's nothing you can cut; it's just the tone." It was supposed to be released with *Pinocchio* and I think *Pinocchio* has some intense moments. I remember getting freaked out when I was a kid and saw it. I remember kids screaming.

*Frankenweenie* had a very short limited theatrical run in Los Angeles in December to qualify for Academy Award consideration. It did receive a small release in the United Kingdom on a double bill with Touchstone Pictures' PG-rated *Baby: Secret of the Lost Legend* in 1985. The film finally appeared on videotape in 1992 to take advantage of Burton's new reputation as a big box-office filmmaker. The short is one of the extras on *The Nightmare Before Christmas* Blu-ray as well. Burton recalled:

> It was right at the time when the company was changing [Michael Eisner and Frank Wells were now in charge]. I remember being frustrated that the old regime was out, the new one was in, and again a thirty minute short is not a high priority. [The feeling was] "Oh, this is great but we have no plans to release it. Ever." By that point I was really tired of Disney. It was a case of doing a bunch of stuff that nobody would ever see. It was kind of weird.

Of course, a new administration had little interest in promoting the accomplishments and projects of the preceding administration. Also, the Disney Company reviewed the situation and decided the amount of time and money invested in Tim Burton did not produce anything of financial value to the company, and let Burton go.

In 1984, actor Paul Reubens was looking for a director for a film idea he had been developing for many years. Horror author Stephen King had seen *Frankenweenie*, and strongly recommended it to Bonni Lee, an executive at Warner Bros. Lee then showed the film to Reubens.

(King had covered similar ground of bringing a beloved childhood pet back to life with the release of his novel *Pet Sematary* in 1983, which is one of the reasons he had been interested in the short Burton film.)

Reubens arranged a meeting with Burton, and the two men immediately bonded, opening up a new creative career for Burton as a director of live-action feature films. Burton's success with *Pee-wee's Big Adventure* (1985) led to other films like *Beetlejuice* (1988) and the hugely impressive *Batman* (1989), starring Michael Keaton.

Burton tried to purchase back from the Disney Company a project he had developed there called *The Nightmare Before Christmas*. Disney counter-offered for Burton to produce the film for them.

In the early 1980s, while working at the Disney Studios, Burton had created a poem-story about a Halloweenland. Henry Selick first encountered Tim Burton and his *The Nightmare Before Christmas* project at Disney when Burton proposed it as a 30-minute television holiday special, perhaps narrated by Vincent Price. Selick, who had animated on *The Fox and Hound*, was also having difficulty adapting to the "Disney Way", and left Disney around the same time as Burton.

After leaving Disney, Selick did storyboarding in collaboration with Portland, Oregon, animator Will Vinton on the feature film *Return to Oz* (1985). "Storyboarding was how I learned to direct, and I worked on *Oz* for about a year," said Selick.

Burton was more than content to write and produce *The Nightmare Before Christmas*, and to let his old acquaintance Selick direct the film. As Burton put it:

> I'm very happy with the way it worked out. It was very comfortable for every one of us. When I was in animation, I had to get out because I didn't have the patience for it. To me, the artistic spirit is very spontaneous — when you get a

thought that's very creative or exhilarating, and then you apply it to this long drawn out process, it's very difficult. And this type of animation [stop motion] is even more difficult because it takes so long. What keeps you going through making a movie like *Nightmare* is the energizing feeling you get when each of those shots comes through.

With the attention for the film and Burton's popularity, the Disney Company looked at possible ways to integrate Burton's vision into the Disney theme park experience. In 1996, Imagineer Chris Merritt submitted a proposal for a traditional Disney dark ride inspired by *The Nightmare Before Christmas*.

Visitors would enter through the tree/portal to Halloween Town, and board a coffin sleigh for a trip through the land of Halloween into the Professor's laboratory and then through Oogie Boogie's lair, resulting in a whirlwind trip across a familiar snow-covered graveyard, where Jack finally gets his girl before the sleighs return to the world of the living.

While that concept never got off the drawing board, a different proposal for combining the Haunted Mansion attraction with an overlay of elements from *The Nightmare Before Christmas* film took almost three years to get approval. The original concept had been to theme the Haunted Mansion to Dickens' *A Christmas Carol* and its Christmas ghosts.

On October 3, 2001, Haunted Mansion Holiday opened and quickly became popular with many guests. The storyline is that this experience takes place after the events in the film. Jack Skellington discovers the home of the Happy Haunts and, to spread holiday joy, he shares some of his original "dark" Christmas presents and decorations that he delivered to unsuspecting human children in the movie.

At the NFFC/Disneyana Fan Club convention in 2003, Tim Burton was asked whether there were plans for a Broadway version of *The Nightmare Before Christmas*. "No," he replied, with a straight face. "We thought we'd go right to the ice show."

# Disney John Carters That Never Were

*The story of how it took the Disney Company over twenty-five years to produce a live-action feature film about the Edgar Rice Burroughs hero and came away with a box office bomb.*

Upon its release in March 2012, *John Carter,* a live-action Disney feature film directed by Pixar's Oscar-winning Andrew Stanton, received mixed critical reception and did poorly at the domestic box office. It was labeled by the entertainment industry as a huge box office bomb.

On May 8, 2012, the Walt Disney Company released a statement on its earnings which attributed the $161 million deterioration in the operating income of their Studio Entertainment division to a loss of $84 million in the quarter ending March 2012 "primarily" to the poor performance of *John Carter* and the associated cost write-down. *John Carter* was on course to lose an estimated $200 million.

The film's perceived failure led to the almost immediate resignation of Rich Ross, Chairman of Walt Disney Studios.

It is not unusual for a film, even a high budget film with a prominent, talented production team, to not connect with an audience and to perform poorly. What was odd was that the Disney Company had been developing a film to showcase the adventures of John Carter for a quarter of a century, and were still unable to make it work.

The first serialized magazine story that legendary writer Edgar Rice Burroughs sold (for $400 in 1911) was *Under the*

*Moons of Mars*, later published in 1917 as the novel *A Princess of Mars*. This was the first John Carter story, and it appeared in print several months before Burroughs' more famous first Tarzan story.

In the tale, Civil War veteran John Carter, while fleeing from Indians, hides in a cave and has an out-of-body experience. His spiritual self is drawn to the planet Mars (which Burroughs calls Barsoom), where he encounters a strange civilization with many odd creatures and finds himself in constant peril.

For example, there are fifteen-foot-tall green savages with four arms called Tharks, who are equipped with swords and firearms. There was once a magnificent civilization on Barsoom, but decades of conflict transformed it into a war-torn barbarian wilderness with occasional remnants of its former glory.

There are also some more human-looking inhabitants, and Carter woos and wins the heart of a feisty, red-tinged Martian princess named Dejah Thoris, who seems to have an aversion to covering her body with clothes.

Before his death in March 1950, Burroughs had churned out a total of eleven novels about Carter's adventures on Mars.

The story of John Carter has captured the imaginations of many young boys for more than a century, but the time and cost to produce the story in a live-action film was prohibitive for many decades because of the necessary special effects.

In 1935, with the blessing of Burroughs himself, animator Bob Clampett, later the creator of the popular Beany and Cecil characters, attempted to produce a series of nine-minute theatrical cartoons inspired by John Carter's adventures on Mars.

Clampett produced a short sample reel based on an original story of Martians living in the mouth of a volcano. Clampett rotoscoped human action in an attempt to give the animated figures a more realistic sense of movement. Burroughs had already contacted MGM, the studio producing the live-action *Tarzan* movies, about purchasing the new series.

In 1936, after reviewing the full-color test reel that included John Carter in an exciting sword fight and a Thark

riding on a Thoat, MGM declared that the subject matter would make it a "tough sale" to audiences who would be unable to accept the outrageous idea of an Earthman on the planet Mars. They suggested doing an animated Tarzan series instead.

Clampett told me in an exclusive interview:

> I wanted to do something quite imaginative, with tongue-in-cheek humor throughout. We would oil paint the side shadowing frame-by-frame in an attempt to get away from the typical outlining that took place in normal animated films. In the running sequence, for example, there is a subtle blending of figure and line which eliminated the harsh outline. It is more like a human being in tone. We were working in untested territory at that time. There was no animated film to look at to see how it was done.

It would be fifty years before the next serious attempt to bring John Carter and the world of Mars to the theatrical screen.

In the 1950s, stop motion effects genius Ray Harryhausen had briefly expressed interest in making a film based on the Carter tale, but disliked the script. However, in 1981, the concept inspired him to propose *Sinbad's Voyage to Mars*, a film that would combine elements from the Burroughs tales with the Sinbad franchise of movies Harryhausen had made in the 1970s.

In 1986, the Disney Company made a serious attempt to translate the story to the live-action screen. Disney optioned the rights from producers Mario Kassar and Andrew Vajna, who — operating as the production company Carolco — had been responsible for a series of highly successful action films like *Terminator 2: Judgment Day* and the first three *Rambo* films. Chairman of the Walt Disney Studios Jeffrey Katzenberg was a huge advocate for making the John Carter film, hoping it would start a franchise similar to the *Star Wars* trilogy, with which it shared many of the same visual and story elements.

Once it had obtained the rights, Disney assigned writer Charles Pogue to the project, after reviewing his work on another film he was writing for the company. Pogue had recently scripted the screenplay for David Cronenberg's

remake of *The Fly*, and would later write the screenplay for *Dragonheart*. Pogue also had been developing a treatment for *Thief of Baghdad* with writer/producer David Kirschner.

Pogue told interviewer Edward Gross:

> David and I really worked well together. We came up with a storyline that was, we thought, fantastic and brilliant. I thought it was going to be the greatest script I would ever write. Unfortunately, Disney didn't want to do it, so it's sitting on a shelf waiting for a more opportune time.

Instead, Disney offered Pogue the option to work on a list of properties it was eager to develop. Pogue immediately selected the *John Carter of Mars* project. He explained:

> One reason this project appeals to me is that it's not high-tech space opera. I refer to it as an interplanetary swash-buckler adventure. ... He [John Carter] has his own code of honor, so while he's going through the whole Martian experience, he's behaving as only a gentleman could, but he keeps tripping up. The story has a wonderful "fish-out-of-water" thematic quality, with Carter barging through this archaic society and working his way to the top by breaching every rule in the book.
>
> What I would like to do with this novel is to bring, if not the literal adaptation, then at least the spirit and tone of Burroughs, to the screen. We all know in 1987 that there's nothing on Mars, and that's another reason why I think it's important to keep the hero in the 1800s when people still believed that there was life there or could be life. This is, essentially, Errol Flynn on Mars. He's a very human character thrust into a very strange and bizarre world. Basically, it's what movies should be.

Pogue submitted his script in 1987. A year later, the Disney Company hired another writer, Terry Black, to tackle the screenplay. Black had recently written a zombie and policeman buddy action film entitled *Dead Heat* (1988). He was also the brother of Shane Black, who had just written the screenplay for *Lethal Weapon* (1987). Terry Black had read all the Burroughs *Mars* books when he was in junior high and was eager to try his hand at one of his dream projects.

In 1988, he told an interviewer for the *Los Angeles Times*:

> Three-quarters of a century and the book is still popular,

which says something. Even at that, the studio wanted to change the whole story around. At one point, they wanted me to throw out the whole book — which I thought was foolish advice. Not everything they said was stupid.

They wanted the story to be more dramatic. Basically, the book has kind of a leisurely pace, especially in the beginning, and if you're going to tell the story in two hours, you have to heighten, exaggerate and make it bigger than life. In the book, John Carter learns the Martian language over a period of several months. In the movie we just made up this time machine that instantly re-educates his speech centers so he can talk Martian.

The stories are good enough. The only reason [they haven't been made] is because it would be so fantastically expensive to animate all the creatures and do the special effects. Actually, they [Disney] want this to be the next *Star Wars*.

Black turned in his screenplay and, roughly two years later, Disney brought on a new screenwriting team to take another crack at the story: Ted Elliott and Terry Rossio, who together would write all the *Pirates of the Caribbean* movies, *The Mask of Zorro*, *Shrek*, and Disney's *Aladdin*, but who then had one sole writing credit, *Little Monsters*. That film starred Fred Savage as a young boy who discovers a monster under his bed, but it was enough to convince the Disney Company to give them a shot at the John Carter project.

Their script, called *The Chronicles of John Carter: Edgar Rice Burroughs' A Princess of Mars*, and dated March 12, 1990, began with a young Burroughs arriving at the estate left to him by his uncle, John Carter.

The estate includes a beautiful house, a mausoleum (where Carter has supposedly been interred), and an observatory. In the observatory, Edgar discovers his uncle's handwritten manuscript describing his adventures on Mars.

After the Civil War, John Carter and his best friend, James Powell, have gone West to seek their fortunes as miners. After a lengthy battle with claim jumpers, the two friends escape to Superstition Mountain, where Powell is killed and Carter is struck by a flat plane of light that makes him disappear.

When he reappears, he is inside an atmosphere factory on Barsoom where one man desperately tries to keep the

factory from failing, since it supplies the air for the planet. Learning the true urgency of the situation when the factory is attacked, Carter goes to seek additional help, but runs into a tribe of four-armed, seven-foot-tall Tharks. Proving his worth in a fight, he is made a member of the tribe.

At the same time, the Princess of Helium, Dejah Thoris, is trying to escape Zodanga's new ruler, Sab Than, who is secretly behind the attacks on the atmosphere factory while implicating the innocent Tharks. Sab is a real charmer who is able to manipulate his people's fear of the Tharks. Dejah pleads with the Tharks to stop their attacks, and in the process, meets John Carter. The two then go off to save Barsoom.

Thoris is not a warrior princess, but a regal, intelligent woman willing to sacrifice herself for the good of her people. Carter is a man of action who finds himself in love for the first time in his life.

There is a climactic battle on a Zodangan cruiser followed by a chase in a flyer over Zodanga, with Dejah at the controls. The script ends with an incredulous Edgar Rice Burroughs discovering that his Uncle John Carter's casket is empty, and then cuts to a scene of Dejah on Mars with Woola (Carter's pet calot) looking skyward at a shooting star.

In August 1990, Disney had enough confidence to announce a director for the film, John McTiernan, who had just finished directing three successful action films in a row: *Predator*, *Die Hard*, and *The Hunt for Red October*.

Beginning in 1987, illustrator William Stout worked for Walt Disney Imagineering for a year and a half as a conceptualist, designer, and producer for Disneyland, Euro Disneyland, Tokyo Disneyland, and Walt Disney World. Stout was a huge Burroughs fan, who at the time had read all the *Mars* books at least three times each.

In a 2003 interview with writer John Arcudi, Stout said

> I was first approached to work on *Princess of Mars* in early 1990. I was called by Hollywood Pictures [a subsidiary arm of Disney] to show my work and be interviewed. That was probably the single worst interview I've ever had in my life.

Stout felt the producers were clueless about Burroughs and his appeal. For example, they didn't want any of the iconic creatures from the Burroughs story but something "different".

Stout was thankful he didn't get the job. About a month or two later, Stout was informed that the producers had been let go, and that McTiernan was now in charge. Stout had done some design work for McTiernan on the film *Predator*. He recalled:

> Two days into that job had me in the middle of a huge depression. I was designing suits for camels and elephants. That's what the creatures were going to be. They were going to use camels and elephants in creature suits. I've worked with animals in film — it's difficult to work with animals under the best conditions. Having an animal wear a costume makes a big problem worse — it does not ingratiate you to the animal. Plus, the fact that there was no way that you could get any of this stuff to look like the Burroughs stuff.

McTiernan also considered making Carter more masculine by having him come from the rugged environment of Alaska, where he would have had to struggle against nature. Stout had to argue the many reasons why it was important that Carter hailed from Virginia, such as his experience as an officer in the Civil War and his background as a Southern gentleman.

Stout envisioned the city of Helium — because of its decades of fighting — as similar to the city of Beirut, where sand-covered ruins were common the farther out a person got from the main city. Stout reasoned that the outskirts would be attacked first, with no maintenance being done because every citizen was a warrior. He pitched the idea that the Tharks, as a nomadic culture, would carry everything with them, and have their tusks decorated with "scrimshaw-like, Maori-like carvings". He remembered:

> It went beyond what Burroughs had described without really violating what Burroughs had described — just adding to the richness of it. Prior to my involvement with the film, as an ERB illustrator I'd never thought of that stuff with the same amount of depth.

However, either McTiernan or Disney, or both, decided there was not enough humor in the Elliott-Rossio script, and so writer Bob Gale was brought in to revise and punch up the story. Gale was basking in the accolades for his scripting on the *Back to the Future* trilogy. Gale's version (dated January 1991) was considered a "fourth draft", and is based not only on the original Burroughs book but also on the Elliott-Rossio script. Some of the changes were minor, like increasing

Burroughs' age from his twenties to thirty-five, which is when he started writing the original serialized story. The claim-jumper section is shortened considerably. Carter is trapped in a cave-in. An orb of blue light takes him to the Atmosphere Factory, where the Keeper gives him a medallion to take to the Great Oracle of Helium and let them know about the dangers.

In an attempt to add physical humor, Carter is more uncoordinated at first. He is forced to swallow a "jukal worm" that helps him learn Barsoomian languages. He joins the Tharks and teaches them the Southern song "Camptown Races", which they will sing in a final battle charge in the film. As an example of the level of "humor", the Tharks mispronounce Carter's home state of Virginia as "Vagina".

The villainous Sab Than is now a scarred, axe-wielding psychopath who slaughters Thark children. The Zodangans have been attacking Helium for weeks and had planned to hold Dejah for ransom. There is no longer any secret conspiracy involving the Atmosphere Factory.

Dejah is put on trial by the Tharks but rescued by Carter, after which they have a romantic interlude. Dejah then is captured by the Zodangans and agrees to marry Sab Than to save her people. Carter is captured and forced into a gladiatorial combat with Tars Tarkas, the mighty Thark.

The final conflict occurs at Dejah's home of Helium, where the wedding is to take place. Carter and the Tharks arrive. Carter kills Sab and goes back to the factory to change some tubes to keep it running. In the process, he is zapped back to Earth, and the ending is the same as in the original Elliott-Rossio script. Stout remembered:

> There were several different scripts. One had John Carter as a sort of wise-cracking guy from Brooklyn. It's much easier to write humor if you're writing jokes. It's much harder to do what Burroughs did — he had humor all through the story in the form of reflective irony. I fought against John Carter as a wisecracker.

In 1992, director McTiernan brought in another writer, Sam Resnick, who had just finished scripting a well-received, made-for-television movie that McTiernan had produced about Robin Hood, starring actor Patrick Bergin.

Actors Tom Cruise and Julia Roberts were offered the two leading roles. Cruise apparently did not care for the script that he was shown.

McTiernan became convinced that, for the film to be successful, the disguised elephants and camels, as well as most of the other effects, needed to be done in CGI (computer-generated imagery). However, in 1990, CGI was in its infancy, and both highly expensive and time-consuming. In addition, CGI was not as advanced as it is today in terms of creating realistic, organic creatures.

Several sources have claimed that Disney estimated that the final budget for the project, when calculated to include the salaries for McTiernan and the stars, plus the money necessary to create all the special effects, was nearly $120 million, which would have made the film one of the most expensive ever made.

McTiernan had a "pay-or-play deal", meaning that if a project is cancelled or not put into production by a certain date, he'd get paid anyway. The funds were not in place to start production, so McTiernan decided to take his money and walk away. He went on to direct the feature film *Last Action Hero* (1993), a disaster at the box office.

Carolco, the production company that had brought the project to Disney and had a string of successful films, was on the verge of bankruptcy by 1994, thanks to such disastrous releases as *Cutthroat Island* and *Showgirls*, high business expenses, and the owners' lavish lifestyles. The company was no longer able to support the production.

Stout said:

> And before I forget, in regards to *John Carter of Mars* — it's already been made into a movie; a really successful one. So why do we need to make another? That film's called *Return of the Jedi*. Princess Leia is dressed as Dejah Thoris throughout the film; you've got Martian flyers as ERB described them; the main characters sword fight throughout the movie. If you look at it, it's the essence of *John Carter*. So if you make a John Carter movie, your audience, who are mostly unaware of the Burroughs books, is going to think you're ripping off a *Star Wars* film.

A year later, Disney made one final attempt to take a different approach with two new screenwriters. They brought in

novelist George R. R. Martin, best-known today for the series of novels that inspired HBO's television series *Game of Thrones*. The first volume in that series was published about three years after Martin's work on the John Carter project.

Disney also brought in science fiction novelist Melinda Snodgrass, who had recently finished writing several episodes of *Star Trek: The Next Generation*, and had served as story editor for that series during its second and third seasons. Along with Martin, she is the co-editor of a series of popular science fiction/superhero anthologies called *Wild Cards*.

Martin made clear that he had little affection for Burroughs' John Carter, and felt that his reading it for the first time when he was in his forties did not help capture the sense of wonder that it might have on a younger reader.

Finally, in 2000, Disney announced that it was dropping the project. Paramount bought the film rights in 2002, and then one year later Robert Rodriguez signed on to direct, with Frank Frazetta proposed as an artistic consultant.

However, Rodriguez was embroiled in controversy with the Directors Guild of America, and left the organization. Paramount then hired Kerry Conran to direct. He was replaced late in 2005 by Jon Favreau, who intended to do a film based on the first three Burroughs novels. By August 2006, Paramount chose not to renew the film rights to the project, and instead focused on re-booting the *Star Trek* franchise.

In 2006, with still two more years to go on finishing the Pixar animated feature *WALL-E*, director Andrew Stanton was on the phone with the head of the Disney Studios, Dick Cook, telling Cook that he should pick up the John Carter project, and that he wanted to be considered as the director. A month later, the Disney Company bought the rights to the first three books.

In an interview with Devin Faraci, Stanton claimed:

> I was pretty hardball. To be honest nobody ever fought me, but it was the fan in me that gave me the guts. That, and I have a day job. I just felt like if anybody had a chance of making this without it being fucked up by the studio, it might be me. They're too afraid of me — they want me happy at Pixar. So I thought I should use this for good, and make the movie the way I always thought it should be

made. If at any one of these points if they were going to push back, I would have pulled out. It's the best way to buy a car — I don't mind walking away. So it pretty much got me through to the end. I never saw a studio person on the set until the reshoots.

It was rumored that the budget kept ballooning to nearly $300 million with re-shoots to clarify the story. Ultimately, the cost would have been irrelevant if worldwide revenues had been significant enough to turn the Edgar Rice Burroughs adaptation into a hit franchise. Instead, the story of a man who could take huge, effortless leaps landed with a dull thud, despite nearly twenty-five years of work to make it into Disney magic.

# Ward Kimball and UFOs

*The story of how Walt Disney almost made a television show about Unidentified Flying Objects, and how a possible U.S. military conspiracy prevented it.*

On March 9, 1955, Walt Disney introduced the television show *Man in Space* with these words:

> In our modern world, everywhere we look we see the influence science has upon our daily lives. Discoveries that were miracles a few short years ago are accepted as commonplace today. Many of the things that seem impossible now will become realities tomorrow. One of man's oldest dreams has been the desire for space travel — to travel to other worlds. Until recently, this seemed to be an impossibility, but great new discoveries have brought us to the threshold of a new frontier — the frontier of interplanetary space.

Back in the 1950s, renowned scientist Wernher von Braun believed he could transform the public's fascination with science fiction into an interest in science fact that might speed development of a viable American space program.

*Collier's* magazine (which had a weekly circulation of three to four million readers) offered von Braun and other scientists like Heinz Haber and Willy Ley an opportunity to write a series of "science factual" articles about the real possibilities of space travel. Disney's legendary animator and director Ward Kimball eagerly devoured those articles.

While Walt Disney had nature films to fill the "Adventureland" slot of his new weekly *Disneyland* television program as well as animated cartoons for the "Fantasyland" slot and some Western material for the "Frontierland" slot,

the Disney Studios had not produced anything that could be used for the "Tomorrowland" segment.

Disney Legend Ward Kimball was in charge of developing a series of space shows for the "Tomorrowland" segment. He contacted von Braun to act as a consultant, and the scientist leapt at the chance. Von Braun realized that there were fifteen million Americans with television sets, and that this was a perfect opportunity to "sell" the average American on space exploration. As he once told an enthralled audience:

> You must accept one of two basic premises: Either we are alone in the universe, or we are not alone in the universe. And either way, the implications are staggering.

Mike Wright, staff historian for the Marshall Space Flight Center, said of Von Braun:

> To make people believe that space flight was a possibility was his greatest accomplishment. Von Braun brought all of this out of the realm of science fiction.

In July 1947, a controversial event took place near Roswell, New Mexico. In addition to the claims of a crashed UFO, alien bodies were said to have been recovered from the site. The U.S. Air Force and the federal government have denied repeatedly over the decades that there was anything extraterrestrial about the event, and have claimed that misidentified debris from then classified Air Force projects had caused the initial confusion.

Dr. Wernher von Braun and his team of fellow German scientists were based nearby at the White Sands Test Facility launching captured German V-2 rockets in an attempt to develop an American rocketry program. Reportedly, Von Braun and his associates were taken to the Roswell crash site.

During World War II, the Germans had developed flying craft that were saucer-shaped, and had experimented with the concept of anti-gravity. Von Braun confided in Kimball what he claimed to have seen at Roswell.

As Kimball remembered it, Von Braun and some of his associates were taken to the supposed crash site after most of the military personnel had left the area. They did a quick tour and described the craft debris as very thin, light, and aluminum colored, like chewing gum wrapping, but the craft itself seemed almost biological in nature.

Von Braun also claimed to have seen small creatures, which he described as reptilian, very frail, with large eyes and skin the texture of rattlesnakes like those he had seen at White Sands.

Kimball, known for his impish sense of humor and love of pranks, may have embellished that account when he shared the story decades later. Von Braun may have had a bit of fun at the expense of Kimball's enthusiasm as well. However, Kimball did develop a close friendship with Von Braun.

Von Braun would spend entire days working with different government contractors in the Los Angeles area on the Redstone rocket program. Then, around 5:00 PM, he would go to the Disney Studios to work with Kimball and his crew on the "Tomorrowland" space segments, sometimes until 3:00 or 4:00 AM the next day. Kimball would often drive von Braun back to the Huntington Hotel in Pasadena, occasionally noticing that his car was being followed by an unmarked car all the way. Von Braun intimated the car was filled with FBI agents keeping a close eye on him.

It was during these drives that Kimball and Von Braun would discuss many things, including the Roswell crash.

In the 1950s, the United States was gripped by flying saucer mania, with multiple sightings as well as a flood of related movies from Hollywood. The U.S. Air Force began an official investigation, lasting roughly twenty years, that involved more than 10,000 UFO reports, but concluded that, with very few exceptions, all the reports could be attributed to explainable phenomena or other misinterpretations.

When Walt Disney needed segments for his weekly Disney television show in 1954 promoting Disneyland, animation director Ward Kimball was between assignments, but he was still receiving his high weekly salary. He needed a new project to bill off his time. Walt also felt that Kimball was a "modern thinker" more in touch with contemporary trends than were others on the Disney staff.

In a summer 1996 interview that appeared in issue #24 of *The "E" Ticket* magazine, Kimball said:

> [One thing that] was my interest at the time was the UFO phenomenon. When Walt came to me asking what we should do with the Tomorrowland programs, he said, "You're interested in UFOs and all that stuff." And I was. I had stacks

of books and magazines all about UFO sightings and I knew someday I would do something on the subject. Even while I was the doing the first three television space shows, this was my idea for the fourth Tomorrowland program.

An estimated 42 million viewers saw the first Disney "Tomorrowland" space show, *Man in Space*, when it premiered in March 1955. It was followed by *Man and the Moon* in December 1955 and *Mars and Beyond* in December 1957. These three films are often credited with popularizing the federal space program in the 1950s.

The films influenced many people who later became aerospace engineers and even top NASA officials, and they had a significant cultural impact on the space program. Newspaper articles half-seriously suggested that the United States should turn over the space program to Walt Disney, since he had a plan and a vision.

In March 1961, when Walt talked with reporters about his new *Wonderful World of Color* show on NBC TV, he said that he wasn't going to make any more of the "Tomorrowland" space shows because they were just too expensive.

Donn Tatum, in an interview with Richard Hubler, stated:

> Our experience was that they [the space shows] don't have as broad an appeal audience-wise and they are expensive to do and generally speaking the networks and the advertisers, while they didn't have any direct control over what we did, they would prefer things that got a bigger rating.

However, there had been plans for a fourth "Tomorrowland" space show, and it came very close to being made before it was shut down due to the U.S. military's lack of cooperation.

At the very end of *Mars and Beyond*, a trio of flying saucers briefly zoom across the screen. Technical consultants Willy Ley and Heinz Haber had been adamant when they first started working on the Disney space shows that there should be no mention of UFOs. They felt it would undercut the validity of the other material being presented, and they were not pleased.

Kimball did indeed have a long fascination with Unidentified Flying Objects. One of Kimball's 1950s cartoons for his "Asinine Alley" panel about the trials and tribulations of

early motorists in *The Horseless Carriage Gazette* depicts a flying saucer with an intricate hook stealing an old-time automobile, while the helpless driver is held at raygun-point by a helmeted alien.

Disney animation director Jack Kinney was originally assigned to direct the Disney TV space programs, but was pulled from the project because his approach was too traditional. As Kimball told Disney historian Michael Barrier:

> Jack was not necessarily interested in the fact that we were going out into space, and I was always a UFO fan anyway.

Kimball was given the job and a "blank check" for expenses from Walt Disney to do the series right.

Kimball had placed the flying saucers in the "beyond" section of the third television show for several reasons. That episode of the space show was more speculative than the previous "science-factual" episodes. He also realized that audiences wanted at least a glimpse of a flying saucer, especially with the UFO-mania of the time. However, Kimball hedged his bets because, earlier in the show, this spacecraft had been introduced as a possible future "electromagnetic drive spaceship". Since, in the last scene, Mars had been colonized, it could be assumed that these vehicles were of human origin.

In his interview with *The "E" Ticket*, Kimball remembered:

> Even while I was doing the first three television shows, this [UFOs] was my idea for the fourth Tomorrowland program ... that's why you see the animated UFOs taking off at the end of *Mars and Beyond*. I had talked to Walt about this fourth show and what I was thinking about, and he said, "Great, but we've got to get convincing footage!" We researched some of the incidents where people had taken actual films of flying saucers, and the trail led us to the Air Force establishment. We were told they had thousands of feet of so-called "alien objects" footage, but that the material was classified.

Kimball regaled an audience at the July 1979 MUFON Symposium in San Francisco with his speech about Disney and UFOs. Founded in 1969, the Mutual UFO Network (MUFON) is an American nonprofit organization that investigates cases of reported UFO sightings.

Kimball claimed in his speech that, sometime in the mid-

1950s, Walt Disney was contacted by the U.S. Air Force (USAF) to cooperate on a documentary about UFOs. The USAF offered to supply actual UFO footage, but once work had begun on the project, supposedly withdrew its offer.

Kimball also claimed that he had spoken with the USAF liaison for the project, an Air Force colonel who told him that there was plenty of UFO footage, but emphasized that Disney was not going to be given access to any of it.

After his speech, Kimball showed an episode from *The Mouse Factory*, a syndicated Disney television series that ran from 1972-1974, entitled "Interplanetary Travel". The episode was hosted by comedian Jonathan Winters, who dressed up as a variety of alien creatures. Kimball had produced and directed the series, but the eager attendees believed it contained lost excerpts from that proposed USAF documentary.

Kimball was deeply interested in flying saucers. In the December 10, 1958, issue of the *Los Angeles Examiner* newspaper, there was a short article about an interesting meeting of thirty experts (astronomy professors, engineers, photographers, a representative from Caltech's Jet Propulsion Lab, and others) at the home of Disney artist Robert Karp (writer of the Donald Duck comic strip) in Encino, California. Also in attendance was Ward Kimball. The final paragraph of the article stated:

> Kimball told the group of the Navy's concern over the asserted mystery disappearance of several of its jet planes and pilots off the coast of Florida in recent years. He said that a Navy officer at the Pentagon had told him of the Navy's concern and the inference was that "saucers" might have been responsible for the "no evidence" disappearance of the aircraft.

Disney producer Harry Tytle recalled his first responsibilities on the weekly *Disneyland* television show:

> With Tomorrowland as our toughest subject, one of my first television responsibilities was to procure outside film for use on our shows devoted to outer space. Thanks largely to WWII, my contacts were numerous. The first contact was Major Mark Miranda with the Air Forces Information Services, which controlled seventy million feet of historical film! I also worked with and received film from Douglas Aircraft, the American Rocket Society, Lockheed, our English and French offices, Aerojet, the British government, and Germany to name a few.

Miranda was the military liaison who had prevented the development of a fourth Disney space show about UFOs. In an interview with Disney archivist Dave Smith, Kimball said:

> I remember when Al Meyers and [Edward] Heinemann, two big shots in Douglas Aircraft, plus George Hoover, who was head of the office of Naval Research, all came to me and wanted Disney to do a UFO picture. Far-out thinkers, all of them, coming to me and wanting to do a UFO program. They all knew that UFOs were for real. They had proof; they had everything. And I said, "Sure." I'd been collecting material on UFOs for years anyway, and I had a cupboard full of stuff there. Every report and all the books, you name it. I was a student of Charles Fort [an early investigator of unexplained phenomena], and that was my dream to end the series with Number Four.

In 1996, Kimball told the Janzen brothers:

> We researched some of the incidents where people had taken actual films of flying saucers, and the trail led us to the Air Force establishment. We were told they had thousands of feet of so-called "alien objects" footage, but that the material was classified.

He elaborated further in his interview with Smith:

> Walt sort of went along with it. But we never had any payoff footage. You've got to end up that last ten minutes with some real stuff. Our disappointment came when we talked to Colonel Miranda from the Wright-Patterson [Air Force Base]. Bill Bosché [who is credited as a writer on the Disney space trilogy] never believed in UFOs. So we're having lunch with this Colonel Miranda over in the commissary, and he had all the footage shot from fighter pilots, everything, and most of it classified. He told us what we could have for our picture and what we couldn't have. And so Bosché thinks he's kind of put me in my place. He gets a smile on his face and he says, "What about flying saucers? I don't suppose you have anything on that?" [Miranda got] serious, "Oh, hundreds of feet!" Old Bosché looked like he'd faint.
>
> [Miranda] says, "We've got all sorts of film that we can't show you, it's secret, and it's going to remain classified until we can take one apart and analyze it." And [Bosché] says, "Well how come?" And that's when he taught us our lesson, he says, "Look! Everyone would ask the Air Force, 'What are these things?' And if we couldn't answer that question, we would be

in trouble. We could have a war start. They would accuse the Russians of doing it; they're ahead of us." He went through a whole line of reasons why this couldn't be divulged.

[Miranda] says, "We have shots taken from gun cameras; we have beautiful footage. We've got 'em all shapes and size, port holes, lights ... We don't know what they are yet. Until we can dissect it, and give a reasonable explanation without our society coming unglued, we can't. It's going to remain classified."

Getting back to Heinemann, and Meyers, and Hoover ... The day they were sitting there, Heinz Haber walked in. He was done with Ham [Luske] working on the [*Our Friend the Atom*] show. He knew them, and they said, "We're trying to get Ward here hooked on doing a show about UFOs." And, gee, that shocked Haber. He just thought that was ridiculous, science fiction. And so they listened to him, and Hoover said, "You know, we happen to know they're out there. We have photographs, we have this, and we have that." By the time they were through, he [Heinz Haber] went out there talking to himself. But I still thought he didn't believe anything they said. They said "there are a lot of theories we have now that are disproved already, that are still secret."

It would have been a wonderful show. And I had everything up to the last ten minutes. I had the rendering, and we had these drawings that people have made, the spaceships that had passed for a good part of a day over the Egyptian army in Egypt in 2000 B.C. They described the stench and the fumes, the whole thing; it was even done in hieroglyphics. We wanted to bring that to life. Great thing, you know. Pictorially, it was a wonderful thing to do. But we didn't have that last ten minutes.

Kimball summarized it for the Janzen brothers:

We ran into a brick wall, dressed in khaki uniforms. I went to Walt with the fact that we couldn't get "smoking gun" footage of UFOs and we both agreed that was the end of it.

Walt was also probably aware that, while the first show had cost $250,000 to produce, by the time of the final show featuring Mars, the costs had risen to $450,000 as a result of the original animation necessary to fill in the gaps for missing live action. The UFO show would have been even more expensive because of the need to generate new footage.

There is one final Kimball UFO story that he told to underground comix [sic] artist Robert Crumb, famed for such comic creations as Fritz the Cat and Mr. Natural.

Wilbur Wilkinson and Karl Hunrath disappeared November 11, 1953, after setting off from the Gardena Airport in Los Angeles County in a rented plane to make contact with a supposedly grounded UFO in the Mojave Desert. They had roughly three hours of fuel, but neither the men nor the plane were ever found again, despite an extensive search.

Robert Crumb wrote in 1975:

> Bob Armstrong, Al Dodge and myself were visiting Ward Kimball. He told us an interesting story. Back in the Fifties, they were working on a series about rockets and outer space technology for the *Disneyland* TV show. I remember seeing those shows when I was a kid. There was a scientist named Wilkins who worked on the project. Wilkins started bringing around this guy called "Huunrath", supposedly a colleague of his. Kimball said at first no one took much notice of the guy Huunrath. He was just unobtrusive. Later, people started asking "Well, just who is this Huunrath?" He was kind of strange. He didn't say much. He walked kind of stiffly and he wore a suit and tie that were ill-fitting. Then Wilkins and Huunrath disappeared and people tried to remember what they could about Huunrath.
>
> Ward recalled that once at a dinner party at his house oatmeal cookies were served for dessert. Huunrath picked up a cookie and was turning it over in his hands and studying it very closely. Then he bit off a little piece, chewed on it awhile and asked Ward's wife what the cookie was made of. The last time anybody saw Wilkins, he said he and Huunrath were going "where there was no death or taxes". Then he laughed! Ward Kimball was very serious when he told us this story. He was amused, yet he thought it was strange.

Of course, this is one of the reasons that hearsay is not allowed in a court of law, because when someone repeats something they were told, especially after a period of years, things can get a bit muddled. Obviously, Crumb meant "Wilkinson" rather than "Wilkins" when recounting the story, and he also misspelled Hunrath's name.

In addition, Wilkinson couldn't have been a consultant on the Disney space programs if he had disappeared in November

1953, because Ward didn't even propose a rough outline of the first space show to Walt until April 17, 1954, and the first official consultant, Willy Ley, came on board roughly two weeks later.

While Wilkinson didn't consult on the Disney space shows, Ward did hold parties to discuss flying saucers, and invited a variety of enthusiasts to participate. Both Wilkinson and Hunrath were well enough known in those circles to receive invitations, and perhaps some of those discussions influenced Ward's later approach to the possibilities of outer space.

Walt never commented about any personal belief in extraterrestrials, but he always kept an open mind about all possibilities.

In a 1998 interview with Disney historian John Canemaker, Kimball made his belief clear:

> In the Fifties I was collecting lots of UFO sightings. I really believe, to this day I do, that something is out there. We don't know what.

# Walt's Fantasy Failure: Baum's Oz

*The story of how even Walt Disney couldn't generate enough magic in his lifetime to make a sequel to Dorothy's trip to Oz.*

The Disney Company has announced that in 2013 it will release a film (directed by Sam Raimi) entitled *Oz: The Great and Powerful* as a prequel to the well-known "Wizard of Oz" story from the iconic 1939 movie. The Disney Company has also announced its belief that the film will do as well commercially as Tim Burton's *Alice in Wonderland* (2010).

This film is not the first time Disney has tried to revisit L. Frank Baum's world of Oz. In 1985, the Disney Studios produced *Return to Oz*, directed by Walter Murch, to take advantage of its rights to several of the Baum books, and also because the books were soon to enter the public domain. The non-musical film received mixed reviews for its dark tone, and was considered unsuitable for children.

Even Walt Disney himself, noted for inspiring his staff to transform beloved folktales into cinematic treasure, was unable to bring the story of Oz to the screen during his lifetime.

In January 1934, Samuel Goldwyn acquired the rights to Baum's first Oz book for approximately $60,000. He planned to make a film version of *The Wonderful Wizard of Oz* as a vehicle for his popular comic actor Eddie Cantor, who basically would "dream" his way to the merry old land of Oz and participate in some lively modern musical numbers and comedy.

Then, the film world was turned upside down in 1938.

Walt Disney's gamble on *Snow White and the Seven Dwarfs*, released in December 1937, paid off big with $8.5 million dollars that first year, making it the highest-grossing Hollywood film of all time. That record-breaking gross would be broken two years later with the release of *Gone With the Wind*.

Anticipating *Snow White's* success, Walt had already tried to negotiate for the rights to properties like the Uncle Remus stories, *Peter Pan*, and *Alice in Wonderland*. He was not necessarily looking for his next film project but to keep those stories away from his competitors. He had earlier opened discussions with Baum's widow, Maud, concerning the copyright status of the stories and the possibility of obtaining the rights.

Louis B. Mayer at MGM bought the Oz rights from Goldwyn for $75,000. With the success of *Snow White and the Seven Dwarfs*, Hollywood studios rushed to option similar musical fantasies in hopes of a similar big box office bonanza, and there was even talk at MGM about bringing in Walt Disney as a consultant for *The Wizard of Oz*, then in pre-production.

In the late 1930s, Ruth Plumly Thompson, who wrote twenty-one more novels about Oz after Baum's death, worked as an editor at the David McKay Company, where she was ghostwriting some Disney-related hardcover books, including one where she did receive a writing credit: *Peculiar Penguins* (1934). Reportedly, Thompson contacted Roy O. Disney about the Disney Studios adapting some of her Oz stories as animated cartoons, but Mrs. Baum did not support this proposal.

Walt kept thinking about the many possibilities of the rich characters and settings of the land of Oz. On November 16, 1954, he purchased the rights to eleven of the fourteen Oz books from L. Frank Baum's son, Robert S. Baum (who was in charge of the estate of his mother, Maud Gage Baum, after her death in 1953).

Those books were:

- *Ozma of Oz*
- *The Road to Oz*
- *The Emerald City of Oz*

- *The Patchwork Girl of Oz*
- *Tik-Tok of Oz*
- *The Scarecrow of Oz*
- *Rinkitink in Oz*
- *The Lost Princess of Oz*
- *The Tin Woodman of Oz*
- *The Magic of Oz*
- *Glinda of Oz*

It was a timely purchase for Walt, since MGM's *The Wizard of Oz* was first broadcast on CBS television two years later on November 3, 1956, stirring up new interest in the film and in the world of Oz. More than 44 million viewers enjoyed that televised showing. The first book, *The Wonderful Wizard of Oz*, entered the public domain in 1956, sparking many new editions from a variety of publishers.

Also in 1956, Disney released the lackluster live-action *Westward Ho, the Wagons!* that featured several Mouseketeers (Karen Pendleton, Cubby O'Brien, Doreen Tracey, and Tommy Cole) in small supporting roles. Walt started to look at another film project where he might use the talents of some of the Mouseketeers who were under contract to the Studio. The marvelous Land of Oz and its many colorful characters seemed to be a viable option.

In 1956, Walt acquired the rights to another of the Baum books, *Dorothy and The Wizard of Oz*, from Lippert Pictures (which produced lower budget films like *Rocketship X-M* and *King Dinosaur*) at a cost that nearly equaled the purchase price of the other eleven books combined. Walt wanted to prevent another studio from rushing into production a low-budget film that might hurt his plans for an Oz film.

Walt's original intention was to produce the Oz film as a two-part episode for his weekly television show, and then combine the parts for a theatrical release. Walt developed other projects, like *Johnny Tremain* (1957), in the same manner, as it allowed him to justify increased production costs.

In April 1957, the Disney Studios hired Dorothy Cooper to write a story outline for a two-part television show, *Dorothy*

*Returns to Oz*, using material from the Oz books. This assignment evolved into a full screenplay, *The Rainbow Road to Oz*, based primarily on the book *The Patchwork Girl of Oz*. Cooper finished the screenplay in August 1957.

With fellow screenwriter Dorothy Kingsley, Cooper wrote her first screenplay, the MGM musical *A Date with Judy*, in 1948, followed by four more MGM musicals. In the 1950s, Cooper began to write for television, where her credits include the pilot script and many award-winning episodes of *Father Knows Best* in 1954, three years before the Disney project.

(In October 1956, she married Dr. Robert Foote, so technically she was Dorothy Cooper Foote. The University of South Dakota has all her papers. She passed away in 2004.)

Even as Cooper was writing the screenplay, Walt realized that to do the material justice, he had to  expand it from a television project into a feature film, just as he had done with *Johnny Tremain*.

So, on July 24, 1957, the Disney Studios announced to the newspapers  that *The Rainbow Road to Oz* would be Walt Disney's first multi-million dollar live-action musical feature film, with production scheduled to begin in November.

*Boxoffice* magazine for September 14, 1957, listed the planned Buena Vista releases for 1957, including *The Rainbow Road to Oz*, Disney's first live-action musical with an all-star cast, including the most popular of the talented and famous Mouseketeers.

Walt intended to cast performers who had been on the *Mickey Mouse Club*, such as Annette Funicello, Darlene Gillespie, Bobby Burgess, Tommy Kirk, Kevin Corcoran, Tim Considine, and Jimmie Dodd, to play key roles in the finished film, according to a newspaper interview he did with Hollywood reporter Louella Parsons.

Since the film was to be a vehicle for the Mouseketeers, Walt assigned the staff of the *Mickey Mouse Club* television series to work on it. Bill Walsh would produce and Sid Miller would direct, just as they did for the television show.

Lillie Hayward, who would later collaborate with Walsh on co-writing some famous Disney live-action films, was given an opportunity to revise the Cooper script. Hayward had written the screenplays for four popular *Mickey Mouse*

*Club* serials, and had just finished work on one of them, *Annette*. When her revision still didn't meet Walt's expectations, it was given to Walsh.

Walsh, a good writer who had already done some writing on the *Davy Crockett* series and would later write Disney live-action films like *The Shaggy Dog* (1959), *The Absent Minded Professor* (1961), *Mary Poppins* (1964), and *The Love Bug* (1971), was tasked with rewriting the screenplay. A 115-page copy credited to Walsh and dated October 15, 1957, still exists.

Always a master showman and publicist, Walt tried to generate interest in the project by featuring a short segment on the September 11, 1957, episode ("The Fourth Anniversary Show") of his weekly television show.

The second part of the show has the Mouseketeers clamoring for information about Walt's plans for future shows. Walt enthusiastically introduces characters like Andy Burnett and Zorro, who would be featured in the upcoming season.

On behalf of the Mouseketeers, Darlene Gillespie gives Walt a large book with the title *The Rainbow Road to Oz* emblazoned on the entire front cover.

"It's actually more of a shooting script," she says, with a smile.

"Now, I am going to make a picture out of the Oz stories, but I always figured to make it as a cartoon," Walt states.

Mouseketeer Cubby innocently counters with "but it takes you seven or eight years to make a cartoon feature, doesn't it?" Cubby is probably referring to the still-in-production *Sleeping Beauty* that had dragged on for years.

The Mouseketeers insist that they need to think about their future, since none of them are getting any younger.

To help convince Walt, the Mouseketeers have prepared a few informal sample sequences. When Walt opens the book, he finds model sketches for the Scarecrow ("Remember the problem he had getting a set of brains? Well, in our story he has trouble keeping them," Darlene says.), the Patchwork Girl, Ozma the Lost Princess of Oz looking a lot like Annette, Dorothy looking a lot like Darlene, and a sketch of the Cowardly Lion drawn by legendary storyman Bill Peet.

Peet and his good friend, fellow Disney storyman Joe

Rinaldi, produced hundreds of character and story sketches for the proposed film project. Other sketches by the two artists exist, including one of a full-figured, elegantly gowned Ozma with a crown and an Oz headband standing on a balcony with a unique Ozian wand. The notation on the drawing states: "Ozma on balcony with Dorothy waves wand — wand glows."

In the first scene, the Scarecrow (performed by Bobby Burgess, but reportedly voiced by Bobby Van and Doodles Weaver) and Patches the Patchwork Girl (played by Doreen Tracey and voiced by Gloria Wood) meet for the first time. Color photos show the Patchwork Girl's costume composed of red, blue, yellow, and green, with some patterned material also in those colors. It was obviously inspired by artist John R. Neill's original illustrations and coloring scheme for the character from the 1913 novel.

The Patchwork Girl twirls merrily and apparently thoughtlessly down the Yellow Brick Road, stopping to pick a patch hanging off a nearby tree filled with patches and adding it to her dress. The Scarecrow, drooped over the fence, wakes up when he hears her sing and hops over the fence to join in. After the song, they do a little dance and both end up on the ground.

The song they sing is "Patches", written in June 1957 with lyrics by Tom Adair and music by Buddy Baker. Adair was a writer and lyricist for the *Mickey Mouse Club* television show, and Baker was the musical director.

> *Corduroy, poplin and percale.*
> *Looks like a walking rummage sale.*
> *Rags and tags and ribbons so bright and gay.*
> *With laughter and song,*
> *she'll go dancing along,*
> *her happy little patchwork way.*

In the next sequence, the Cowardly Lion (adult Mouseketeer Jimmie Dodd almost completely unrecognizable in the makeup) has become the King of Oz, but a mysterious magic spell had turned him into a cruel and conceited monarch. The Scarecrow, the Patchwork Girl, Dorothy, Ozma, farmhand Zeb (Lonnie Burr), Cubby O'Brien

as another farmhand, and Karen Pendleton as another princess try to break the spell by performing "The Oz-Kan Hop", a lively song-and-dance number that is "part Kansas and part Oz":

> Take the beat, beat, beat of a Kansas rain
> when it taps out a rhythm on your window pane.
> Then from Oz get a tune that just won't stop.
> Mix them up and then you've got the Oz-Kan Hop.

As Dorothy sings, there are mixed dance combinations so that it becomes part Kansas square dance and part Oz quadrille (a dance performed by four couples in a square formation).

Dorothy and Zeb dance, followed by the comic eccentric dancing of the Scarecrow and the Patchwork Girl, and finally Ozma does a ballet solo where everyone except the uninterested Lion wearing his long red robe joins in for the big finish.

When Walt finally agrees that he will make the film, the iconic Mickey Mouse Club curtains part to reveal a huge birthday cake for the celebration. The costumed performers, interspersed with other Mouseketeers, dance around the rainbow-colored cake and up a ramp to the enormous candles at the top while singing the title song, "The Rainbow Road to Oz":

> Up we go, the rainbow covered skyway.
> Up we go, the rainbow road to Oz.
> See it glow, the quilty-colored highway.
> Up we go, to reach the land of Oz.

This song was written on June 11, 1957, with lyrics by Sid Miller and Tom Adair, and music by Buddy Baker. More than a dozen songs were written for the film, with some like "Why Don't They Believe?" (Miller/Adair, with music by Baker) and "The Lost Princess Waltz" (Adair, with music by Baker) being written as late as December 1957.

Two other songs from the proposed film, "The Oz-phabet" and "The Pup Pup Puppet Polka" (both by Adair and Baker), appear on the 1969 Disneyland Records release *The Cowardly Lion of Oz*, along with four other songs by Adair and Baker that may also have been intended for the film: "Livin' a Lovely Life", "Trouble in Oz", "Just Call Smarmy", and "If You'll Just Believe".

Noted Disney musicologist Greg Ehrbar wrote:

> There is no evidence that the story on this record has any relationship to the screenplay of *Rainbow Road*, nor does it resemble the Ruth Plumly Thompson book of that title, even though the album cover credits the book as the source.

The total budget for the three sets used in the television show came to about $6000. Art direction was credited to Bruce Bushman and set decoration to Emile Kuri. A tree with colorful patches hanging from its branches and another tree with brightly colored helium balloons instead of leaves, as well as a simple wooden fence and one hundred and twenty feet of Yellow Brick Road, were all that was needed for the first number.

The Cowardly Lion's throne room was just a standard throne (with the carved word Oz on its back almost completely obscured because the Lion never got up to reveal it) and some minimal decorated poles and generic landscaping along the side of the set. The final song was performed on a giant, decorated, wooden cake prop, approximately twenty feet in diameter and seven feet, nine inches high.

In her autobiography, Annette Funicello wrote:

> We were so excited. What child wouldn't be thrilled to be "working" in Oz? I was to play the part of Ozma, complete with a beautiful gown and glittering crown and scepter. For me, the best part was that I got to wear a long, flowing fall. I'd always dreamed of having long hair and I so loved the feel of it against my neck that I begged the hairdresser to please, please, please let me wear the wig home. At first, she said "no", citing studio rules, but I wouldn't stop begging, and so she relented. I remember sleeping in the wig that night, twirling long strands in my fingers as I drifted off to sleep.
>
> Everyone had high hopes for our film. We had no idea then that this [the television show sample] was all of *The Rainbow Road to Oz* the public would ever see. For various reasons, about which we can only speculate, the Oz film was not completed despite Mr. Disney's deep and enduring interest in the concept. By the time we learned that *The Rainbow Road to Oz* had met a dead end, there was other shocking news: *The Mickey Mouse Club* was closing its doors.

While it had been announced that filming on *The Rainbow*

*Road to Oz* was to begin in November 1957, things kept dragging so that by February 1958, rumors began circulating that Disney had killed the project.

However, contrary to other printed sources, the project was not dead. An announcement in the "Passing Picture Scene" column by A.H. Weiler from the *New York Times* (December 3, 1961) stated:

> The indefatigable Walt Disney, who will be represented on the Music Hall's screen on December 14 with *Babes in Toyland* is in association with his studio staff, working on a feature film that he does not expect to release before 1963. This is *The Rainbow Road to Oz* and it will involve not only "a multimillion dollar budget", a spokesman for the producer said "but also months of writing, technical preparation and casting." "*The Rainbow Road to Oz*," our informant added in explanation, "will be a live-action feature which takes up where *The Wizard of Oz* left off. Dorothy will return to the land of Oz and she'll be involved with a variety of characters, such as the nephew of the Wicked Witch. No casting as yet. In the meantime, Disney is also in the midst of filming *The Sword in the Stone*. This too, is due in 1963."

While an official reason for the cancellation of the project was never given, several factors probably doomed Walt's journey to Oz. The remaining Oz books would start entering public domain in 1960, and surely generate low-budget film projects from competitors who would take advantage of the goodwill and publicity generated by Disney's more elaborate production.

The inevitable comparison with the classic MGM film would not be a good thing, as neither the performances nor the songs in the Disney version could match that memorable cinema milestone.

Also, the *Mickey Mouse Club*, its popularity waning, was canceled in 1959, so there was no longer a need to showcase the Mouseketeers prominently in the film. The inclusion of the Mouseketeers in the earlier *Westward Ho, the Wagons!* feature film had not helped that movie at the box office, even though at the time of its release, the talented children had been at their peak of popularity.

In addition, actress Darlene Gillespie, prominently cast as Dorothy Gale, was having a strained relationship with Walt

Disney. She had been dropped earlier from a *Mickey Mouse Club* serial, whereupon her parents instituted a nasty letter-writing campaign from her many fans to the Disney Studios, including some unflattering remarks about Walt himself. Walt later explained that Darlene had been removed from the serial to open up her time to begin pre-production on the Oz film.

Most important, Walt was not completely happy with the screenplay, and realized it would be an expensive investment as projected production costs soared ever higher. Walt was not emotionally invested in the project, and felt that he was obligated to the public to make the film, just as he had been with *Alice in Wonderland*, which proved a disappointment to him.

He was also distracted by the creation of the first "E" ticket attractions at Disneyland (the Submarine Voyage, the Monorail, and the Matterhorn Bobsleds), and the release of the troubled animated feature *Sleeping Beauty*.

In an internal thirteen-page memo dated February 16, 1959, sent by Disney Legend Ken Anderson to all cartoon directors, animators, layout, background, and storymen, Anderson discussed a possible "Outline for Oz Feature Cartoon". He wanted suggestions and ideas about turning the story into an animated feature cartoon. Unfortunately, the critical and financial difficulties surrounding that year's release of *Sleeping Beauty* caused Walt to lose interest in producing more animated features, a task he then relegated to his trusted staff.

Perhaps it was a good thing that the film was shelved. Walt's first attempt, just a few years later, at a live-action musical, *Babes in Toyland* (1961), was not well received (even with the charming Annette Funicello appearing in it), although the lessons learned in the process of making that film helped years later with *Mary Poppins* (1964). *Babes in Toyland* had been announced as early as October 1956 in Hollywood trade publications, with *Mickey Mouse Club* director Sid Miller slated to handle directorial duties for that film.

Walt searched for other ways to use the Oz properties he owned, including a means to incorporate them into Disneyland. In 1959, he considered related project called the Rock Candy Mountain. It would be built as the big finale for

the Storybook Land boat cruise attraction that had opened in summer 1956.

This approximately six-story-tall, multi-leveled structure would have had the Casey Jr. railroad tracks navigate around the outside ledge of an over-sized, candy-decorated mountain. The Storybook Land boats would cruise inside the mountain to a watery grotto filled with several scenes from Oz.

The storyline was that it was Dorothy Gale's surprise birthday party, and the boat would glide past the various lands of Oz (like the Tin Woodsman's castle) en route to the birthday party at the end. There were even suggestions that costumes and props for the planned feature film would be incorporated into the scenes. It might have been the first Disneyland attraction to feature simple Audio-Animatronics figures had it progressed any further into reality.

Imagineer Claude Coats was the lead on the project. Coats remembered there were plans for a password that had to be shouted before the people on the boat would be allowed to view the scenes inside.

Imagineer Joe Rinaldi built twenty-two scale models based on character designs by Coats. These models ranged from a somewhat bashful Cowardly Lion and a humorous Wicked Witch (who bore some resemblance to Disney's Witch Hazel bouncing along on her flying broomstick) to a spoon man and Tik-Tok. Some of these maquettes and concept artwork for the attraction still survive.

The original plan was to make a transparent rock candy mountain, similar to a crystal palace, but that premise evolved to include licorice, peanut brittle, fudge, lollipops, gumdrops, candy canes, gumballs, and more, including some ribbon taffy that Walt had specially made for the project.

Imagineer Harriet Burns worked on the three-dimensional model, gluing dozens of hard candies and candy canes to it. Imagineer Jack Ferges worked on the exterior and bought hundreds of hard candies and gumballs.

As he glued them on, he supposedly said "one for the mountain, one for me", so that both the mountain and Ferges were well-filled in a short period of time. Burns used to joke that she worried Ferges would become diabetic if he worked on the project any longer.

Rolly Crump's first assignment at WED (now known as Walt Disney Imagineering) was to work on this project. He helped build some of the models, but was also assigned to create colorful, spinning propeller-like flowers for the entrance to the attraction. It was Crump's hobby of making mobiles and propellers that peaked Walt's interest in moving him from animation to WED.

Like the movie, the attraction was shelved. In later years, Imagineer John Hench said he felt the exterior of the attraction would have displeased guests. Too much candy would have been too much of a good thing, and it would have sickened guests after prolonged exposure to such an image.

"This is all dessert. It's too much," Hench reportedly said. Walt agreed and stopped the project.

The model was later dragged outside into the WED parking lot, where it became a huge temporary bird feeder, providing sweet treats to the local fowl fellows and other animal friends. Primarily, the birds pried the nuts out from the candies. Some of the candies were specialties from around the world.

One of the earlier preliminary models came home with Burns. Her daughter, Pam, still has it, along with the memory of her mom bringing home some rock candy that wasn't used.

Even Walt Disney, something of a wizard himself, was unable to find a way to go over the rainbow and walk down the Yellow Brick Road to a magical new film about the Land of Oz. In 2013, the Disney Company will try to do something that Walt was never able to figure out how to do properly.

# Selected Bibliography

*Hundreds of books, personal interviews, magazine and newspaper articles, and more were utilized in locating and verifying information that appears in this book. Some of these references are identified within the text. Here is an additional short, selected bibliography of some of the resources used.*

## Books

Amidi, Amid: *Cartoon Modern: Style and Design in 1950s Animation* (Chronicle Books 2006)

Barrier, Mike: *Animated Man — A Life of Walt Disney* (University of California Press 2007)

Beck, Jerry: *The 50 Greatest Cartoons* (World Publications 1999)

Cohen, Karl F.: *Forbidden Animation: Censored Cartoons and Blacklisted Animators in America* (McFarland 1997)

Culhane, John: *Walt Disney's Fantasia* (Harry N. Abrams 1983)

Disney Miller, Diane and Pete Martin: *The Story of Walt Disney* (Holt 1957)

Feild, Robert D.: *The Art of Walt Disney* (Collins 1947)

Ghez, Didier ed.: *Walt's People Volumes 1-12* (Xlibris 2005-2012)

Grant, John: *Encyclopedia of Walt Disney's Animated Characters* (Hyperion 1998)

Hanke, Ken: *Tim Burton: An Unauthorized Biography of the Filmmaker* (Renaissance Books 1999)

Heinrich, Thomas and Bob Batchelor: *Kotex, Kleenex, Huggies: Kimberly-Clark and Consumer Revolution* (Ohio State University Press 2004)

Holliss, Richard and Brian Sibley: *The Disney Studio Story* (Crown 1988)

Justice, Bill: *Justice for Disney* (Tomart Publications 1992)

Korkis, Jim: *The Vault of Walt* (Theme Park Press 2012)

Korkis, Jim and John Cawley: *Cartoon Confidential* (Malibu Graphics 1991)

Korkis, Jim and John Cawley: *The Encyclopedia of Cartoon Superstars* (Pioneer Books 1990)

Korkis, Jim and John Cawley: *How to Create Animation* (Pioneer Books 1990)

Leebron, Elizabeth and Lynn Gartley: *Walt Disney, A Guide to References and Resources* (G.K. Hall 1979)

Lehman, Christopher: *The Colored Cartoon* (University of Massachusetts Press 2007)

Maltin, Leonard: *The Disney Films* (Disney Editions 2000)

Maltin, Leonard: *Of Mice and Magic* (Plume 1987)

McGilligan, Patrick and Paul Buhle: *Tender Comrades* (University of Minnesota Press 2012)

Peet, Bill: *Bill Peet: An Autobiography* (Houghton Mifflin Company 1989)

Peri, Don: *Working with Walt: Interviews with Disney Artists* (University of Mississippi Press 2008)

Peri, Don: *Working with Disney: Interviews with Animators, Producers, and Artists* (University of Mississippi Press 2011)

Salisbury, Mark ed.: *Burton on Burton* (Faber and Faber Unlimited 2000)

Sampson, Henry: *That's Enough Folks: Black Images in Animated Cartoons* 1900-1960 (Scarecrow Press 1998)

Smith, Dave: *Disney A to Z: The Updated Official Encyclopedia* (Disney Editions 2006)

Smith, Dave and Steven Clark: *Disney: The First 100 Years* (Disney Editions 2003)

Taylor, Deems: *Walt Disney's Fantasia* (Simon and Schuster 1940)

Thomas, Bob: *Walt Disney: An American Original* (Disney Editions 1994)

Thomas, Frank; Johnston Ollie: *Disney Animation: The Illusion of Life* (Disney Editions 1995)

Trethewey, Richard L.: *Walt Disney: the FBI Files* (Rainbo Animation Art 1994)

Tytle, Harry: *One of Walt's Boys* (ASAP Publishing 1997)

Van Riper, A. Bowdoin: *Learning from Mickey, Donald and Walt* (MacFarland 2011)

West, John G.: *The Disney Live-Action Productions* (Hawthorne and Peabody 1994)

# Interviews

*These extensive interviews that I conducted with the following Disney Legends were particularly helpful in providing some insights and information no longer available.*

- Ken Anderson, Spring 1985
- Floyd Gottfredson, Fall 1979
- Marc Davis, September 1998
- Jack Hannah, May 1981
- Virginia Davis, September 2007
- Bill Justice, Summer 1999
- Peter Ellenshaw, Spring 1997
- Ward Kimball, April 1996

# Acknowledgements

I am taking this opportunity to acknowledge not only the people who directly helped me with this book, but those who have inspired or supported me over the years and who deserve to see their name printed prominently in a Disney-related book. I hope that each one of you buys at least a dozen copies because your name appears in it. The names are not alphabetical so that you have to read them all or most of them if you're looking for yourself or someone in particular.

Many thanks to Bob McLain at Theme Park Press for making this book a reality.

Thanks to my brothers, Michael and Chris, and their families, including their children Amber, Keith, Autumn, and Story, who never really understood what their uncle does or why he does it.

Uncle Jim loves you all very much. Please don't throw away Uncle Jim's Disney collection after he is gone. I look forward to seeing my grand-nieces (Skylar, Shea, and Sidnee) grow up to read this book someday and tell me many years from now that I am wonderful.

Many thanks to: Didier Ghez, Mark Goldhaber, Adrienne Vincent-Phoenix, Lou Mongello, Jim Hill, Werner Weiss, Jim Fanning, Greg Ehrbar, Michael Lyons, Michael Barrier, Paul Anderson, Dave Smith, Kim Eggink, Wade Sampson, John Cawley, Sam Gennawey, Deb Wills, Deb Koma, Cathy Perrone, Jerry Johnson, Henry Hardt, David Zanolla.

Marion and Sarah Quarmby, Tom and Marina Stern, Jerry and Liz Edwards, Marie Schilly, Tommy Byerly, Lonnie Hicks, Michael "Shawn" and Laurel Slater, Kirk Bowman, Jeff Kurtti, Ryan N. March, Brad Anderson, Kaye Bundey, George Grant.

Todd James Pierce, Greg Dorf, Betty Bjerrum, Jeff Pepper, Jerry Beck, Amid Amidi, Michael Sporn, Leonard Maltin, Robin Cadwallender, John Culhane, Scott Wolf, Pete Martin, Bill Cotter, Steve Vagnini, John Canemaker, Mark Kausler.

David Koenig, Kevin Yee, Dave Mruz, Danni Mikler, Tracy M. Barnes, Sarah Pate, Tamysen Hall, Evlyn Gould, Tom Heintjes, Bruce Gordon, David Mumford, Randy Bright, Jack and Leon Janzen, Malcolm and Mary Joseph (and their

children Melissa, Megan, Rachel, Nicole, Richard), Ryan Graham, Pentakis Dodecahedron.

Tim Foster, Arlen Miller, Floyd Norman, David Lesjak, Howard Kalov, Dana Gabbard, Margaret Kerry, Howard Green, Bob Thomas, Kaye Malins, Heather Sweeney, Don Peri, Bill Iadonisi, Dana Gabbard, Christian E. Willis, Lisa Ann Malewich.

And sadly some people that I have foolishly forgotten for the moment. Their kindness and generosity, like that of the people listed here, have lightened my journey through life and made this book possible. I hope all of you, both acknowledged and temporarily missing, live happily ever after.

I also acknowledge all of you who bought this book, have an eagerness to learn and share Disney history, and who are the "Disney expert" for your friends and family. It is important to share the stories and keep them alive, and just as important to avoid repeating misinformation. There are many more tales of Disney history waiting to be discovered by you, and I look forward to reading them in the future.

# Index

# About the Author

Jim Korkis is an internationally respected Disney historian who has written hundreds of articles about all things Disney for over three decades. He is also an award-winning teacher, professional actor and magician, and author of several books.

Jim grew up in Glendale, California, right next to Burbank, the home of the Disney Studios. His third-grade teacher at Thomas Edison Elementary School was Mrs. Margaret Disney, the wife of Walt Disney's brother Herbert.

As a teenager, Jim wrote down the names he saw on the credits of Disney animated cartoons, went to the Glendale-Burbank phone book, and cold-called some of them. Many were gracious enough to ask him to visit them, with the resulting articles sometimes appearing in the local newspapers or in various fanzines and magazines. Over the decades, Jim pursued a teaching career as well as a performing career, but was still active in writing about Disney for various magazines.

In 1995, he relocated to Orlando, Florida, to take care of his ailing parents. He got a job doing magic and making balloon animals for guests at Pleasure Island. Within a month, he was moved to the Magic Kingdom, where he "assisted in the portrayal of" Prospector Pat in Frontierland as well as Merlin the magician in Fantasyland for the Sword in the Stone ceremony.

In 1996, he became a full-time salaried animation instructor at the Disney Institute, where he taught every animation class, including several that only he taught. He also instructed classes on animation history and improvisational acting techniques for the interns at Disney Feature Animation Florida. As the Disney Institute re-organized, Jim joined Disney Adult Discoveries, the group that researched, wrote and facilitated backstage tours and programs for Disney guests and Disneyana conventions.

Eventually, Jim moved to Epcot, where he was a Coordinator with College and International Programs, and then a Coordinator for the Epcot Disney Learning Center. During his time at Epcot, Jim researched, wrote, and facilitated over two hundred different presentations on Disney history for Disney Cast Members and for Disney's corporate clients,

including Feld Entertainment, Kodak, Blue Cross, Toys "R" Us, Military Sales, and others.

Jim was the off-camera announcer for the syndicated television series *Secrets of the Animal Kingdom*, wrote articles for such Disney publications as *Disney Adventures*, *Disney Files* (DVC), *Sketches*, *Disney Insider*, and others. He worked on special projects like writing text for WDW trading cards, as an on-camera host for the 100 Years of Magic Vacation Planning Video, and as a facilitator with the Disney Crew puppet show His countless other credits include assisting Disney Cruise Line, WDW Travel Company, Imagineering, and Disney Design Group with Disney historical material. As a result, Jim was the recipient of the prestigious Disney award, Partners in Excellence, in 2004. Jim is not currently employed by the Disney Company.

To read more stories by Jim Korkis about Disney history, please purchase a copy of his previous book, *The Vault of Walt*, newly revised and available from Theme Park Press. And make sure to visit the following websites which feature archives of Jim's many other stories about Disney history:

- www.MousePlanet.com
- www.AllEars.net
- www.Yesterland.com
- www.WDWRadio.com

Made in United States
Troutdale, OR
06/24/2024

20798266R00156